Publisher's Acknowledgements
Special thanks to **Carolyn
Alexander**, Alexander and Bonin,
New York. We would also like to
thank the following authors and
publishers for their kind
permission to reprint texts:
Charles Merewether, Los Angeles;
Duquesne University Press,
Pittsburgh; **Persea Books**, New
York; and the following for lending
reproductions: **Heiner Bastien
Fine Art**, Berlin; **Annely Juda Fine
Art**, London; **Sean Kelly Gallery**,
New York; **Kunsthaus**, Basel;
Moderna Museet, Stockholm;
Andrea Rosen Gallery, New York;
Arturo Schwarz, Milan; **Rachel
Whiteread**, London.
Photographers: **Per Andes
Allsten**; **Javier Campano**; **Carlo
Catenazzi**; **Joël Damase**; **D.
James Dee**; **Teresa Diehl**; **Julio
Cesar Floris**; **Brian Forrest**; **David
Heald**; **Herbert Lotz**; **Cary
Markerink**; **The Museum of
Modern Art**, New York; **Orcutt &
Van Der Putten**; **Juan Segura**;
Stalworth/Blanc; **Richard Stoner**;
**Sean Weaver/Art Gallery of
Ontario**; **Edward Woodman**.

Artist's Acknowledgements
I wish to acknowledge and thank
those who have collaborated on
the production of this book: Gilda
Williams, Ian Farr, John Stack,
Clair Joy, Stuart Smith and
Veronica Price at Phaidon Press,
and the authors of the essays,
Carlos Basualdo, Andreas Huyssen
and Nancy Princenthal. I would
particularly like to mention Carlos
Basualdo, who spent considerable
time with me in Bogotá, and
Andreas Huyssen, whose writing
has been deeply influential in the
realization of my work. Special
thanks are due to Carolyn
Alexander, Ted Bonin and Jay
Jopling for ensuring that my work
has been realized and seen.

I want to remember Penny McCall
and Monique Beudert. Penny who
was an early supporter of my work
and showed a special solidarity
with the victims of violence;
Monique, whose friendship and
courage will always inspire me.

In Bogotá, there have been so
many extraordinary people who
have helped in the realization of
my work; I would like to mention in
particular Pablo Guerrero, Ramon
Villamarin, Olga Cuellar, Fernán
Gonzalez, Fabio Restrepo, Mary
Sanchez and Mariana Varela. My
sculpture exists, in great part,
because of the support of my
mother and sister, Paulina and

Nancy Salcedo, and the patience,
love and humour of my husband,
Azriel Bibliowicz.

All works are in private collections
unless otherwise stated.

Phaidon Press Limited
Regent's Wharf
All Saints Street
London N1 9PA

First published 2000
© 2000 Phaidon Press Limited
All works of Doris Salcedo are
© Doris Salcedo

ISBN 0 7148 3929 9

Printed in Hong Kong

Design: SMITH

cover, **Unland
the orphan's tunic** (detail)
1997
Wood, cloth, hair
80 × 245 × 98 cm
Collection, Fundaçio 'la Caixa',
Barcelona

page 4, **Untitled** (detail)
1995
Wood, concrete, steel
217 × 114.5 × 39.5 cm
Collection, The Museum of
Contemporary Art, San Diego

page 6, **Doris Salcedo**, studio,
Bogotá, Colombia, 1995

page 38, Installation of untitled
works (detail), Anglican
Cathedral, Liverpool, 'Trace',
Liverpool Biennial of
Contemporary Art, 1999

page 90, **Unland
the orphan's tunic** (detail)
1997
Wood, cloth, hair
80 × 245 × 98 cm
Collection, Fundaçio 'la Caixa',
Barcelona

page 104, **Atrabiliarios** (detail)
1993
Nazareno wood, shoes, animal
fibre, surgical thread
200 × 100 × 8 cm

page 148, **Doris Salcedo**, studio,
Bogotá, Colombia, 1998

Nancy Princenthal Carlos Basualdo Andreas Huyssen

Doris
Salcedo

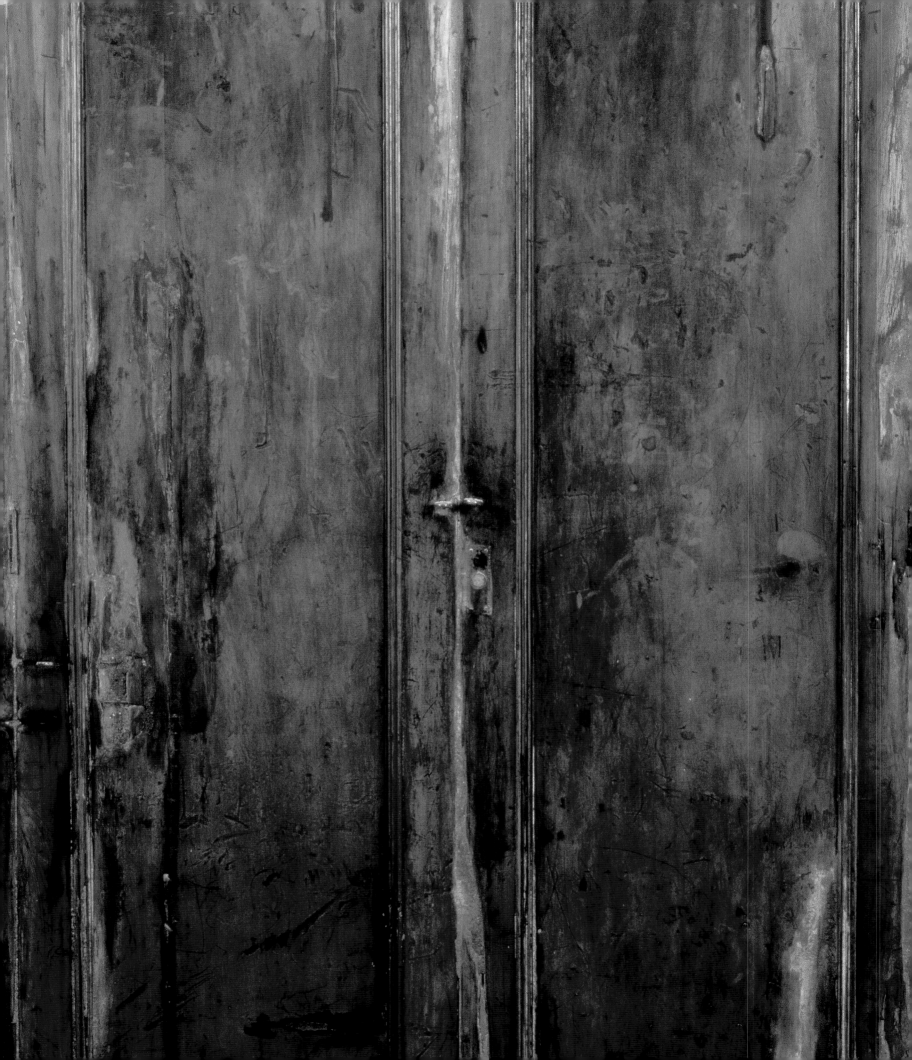

Contents

Contents

Untitled
1983
Wax, steel, textile fibre
15 × 90 × 8 cm

Carlos Basualdo I'd like to ask you about your work both as a student and lecturer. You studied art at the local university in Bogotá, Colombia, at the end of the 1970s. What did your training consist of? Was it specifically geared towards the visual arts, or did it develop through a dialogue with other disciplines?

Doris Salcedo **No, it was exclusively in the visual arts and I started earlier, when very young. My art education in Colombia was interesting in that it took place on the fringes; in a Third World country one suffers from lack of information. Colombia is largely cut off from the rest of the world and this arouses anxiety, which leads us to concentrate on study, making connections with the world outside. So, paradoxically, one can end up gaining access to information and achieving quite a sophisticated education. I feel that I had a very interesting training in art history. My art school didn't have a good sculpture workshop, so I never made any sculpture there. I knew I wanted to make sculpture, however the sculpture being produced during that period in Colombia represented a strain of Modernism that seemed boring to me in comparison with other artistic languages which were being explored in painting, performance and other disciplines.**

Basualdo So you were interested in performance even though this was not an integral part of your training?

Salcedo **I had an extremely thorough training in painting – which I think comes through clearly when you see the surfaces of my works – but I was also interested in theatre. I worked for a short time designing stage sets. It was in the Colombian theatre of that time, with its political overtones, that my interests in art and politics came together. However, this engagement with theatre was just a brief interlude.**

Basualdo At art school, did you have any mentors who played a special part in your training?

> **Salcedo** Among my teachers was the Colombian painter Beatriz González, a highly complex artist who, amidst the clamour of the Colombian art scene, nevertheless managed to devote her time to theoretical study. She now regards herself as half art historian, half painter.
>
> As a painter she did things we hadn't seen before, such as using photographic documentation and real events as important elements in her work. You could see how she went about developing a piece of work, superimposing layers of information that she would bring in from different fields of knowledge, not only from the pictorial. I feel that this model of working was essential for my development as an artist.

Basualdo You've described your interest in theatre and painting, and the way in which your painterly training comes through clearly in the surfaces of your work. Would you say that, from the beginning, your sculptural production has been based on a principle of hybridism?

> **Salcedo** I hope so. I consciously try to achieve this. I cannot say whether this hybrid quality is always clear in the work, but it is intended.

Basualdo In the early 1980s you left Colombia for New York and gained a Master's degree in sculpture at New York University in 1984. During your stay there, did you have any memorable experiences or access to artworks that decisively influenced the way you were to approach your own production?

> **Salcedo** In New York I was able to see the work of Joseph Beuys, and I chose it as a point of departure. I devoted much of my time there to the study of his work. Another important experience was coming to terms with being a foreigner. What does it mean to be a foreigner? What does it mean to be displaced? When I returned to Colombia, I continued to live like an outsider because this gave me the distance that one needs to be critical of the society to which one belongs.

Basualdo Did the way you viewed your own work change as a result of your New York experience?

> **Salcedo** It did change, because I hadn't had the chance to make sculpture until I reached New York. I already had a theoretical framework for what I wanted, or didn't want, prior to sculpting in practice. That in itself made

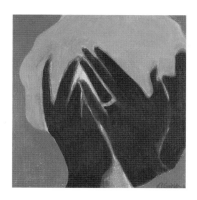

Beatriz González
Self Portrait
1998
Oil on canvas
24 × 24 cm

Untitled
1984
Wood, wax, leather, wire
20 × 120 × 40 cm

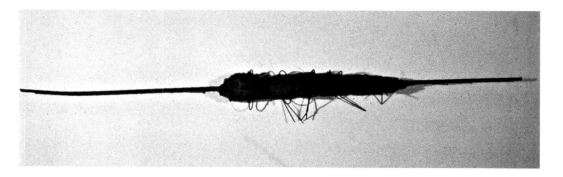

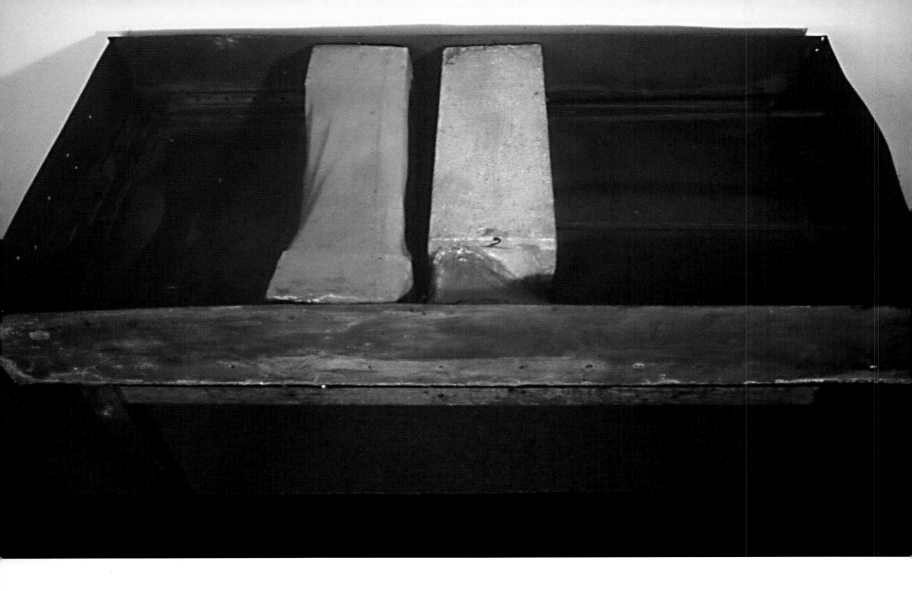

things difficult at the beginning. I wasn't at all interested in the Modernist
sculptural tradition. Before going to New York, I'd spent a year travelling
around the world looking at all kinds of sculpture, from Modernist and
contemporary Western sculpture to monumental works from other cultures.
The latter I found far more interesting than anything else.

Basualdo What exactly was your relationship to the work of Beuys? Were you
taken by his methods of establishing a dialogue with the post-war sculptural
tradition, or were you more interested in his social thinking?

Salcedo **I was enthusiastic about both. Encountering his work revealed to
me the concept of 'social sculpture', the possibility of giving form to society
through art. I became passionately drawn to creating that form, which led
me to find sculpture meaningful, because merely handling material was
meaningless to me. Placing a small object on a base seemed completely
vacuous. That is why Beuys was so important to me. I found the possibility
of integrating my political awareness with sculpture. I discovered how
materials have the capacity to convey specific meanings.**

Basualdo In Beuys' sculpture there is an attempt to re-think monumentality in
terms of the social sphere. Would you say that the very idea of monumentality is
one of the conceptual foundations of your work?

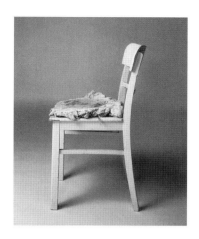

above, **Joseph Beuys**
Stuhl mit Fett I (Fat Chair I)
1963
Wooden chair, fat, thermometer
83.5 × 43.5 × 47 cm

opposite, **Untitled**
1984
Steel, wood, latex
18 × 115 × 70 cm

right, **Untitled**
1986
Wax, steel
28 × 100 × 6 cm

Salcedo **I wouldn't regard my work as monumental, but now that you mention it, that link could be established. The only thing that was important to me was space. In that sense, the influence of Beuys might have been a way to approach the monumental, but my interest in the space of sculpture was in the way it can represent a crossroad, a meeting point.**

Basualdo Would this phenomenological perception of sculpture as a meeting point stand in opposition to the Modernist idea of sculpture as autonomous and self-contained?

Salcedo **Of course. What also fascinated me was a type of knowledge that is greater than oneself; which is so broad spatially, and in terms of its volume and comprehensiveness, that one cannot even grasp its meaning. The task of making such an object exceeds my capacity as a person. Whenever art enters this field of the 'uncanny', or what is beyond the human sphere, it arouses my interest.**

Basualdo What you're describing reminds me of the way you have installed some of the earlier works in the series *La Casa Viuda* (*Widowed House*, 1992–95). By placing a work, for example, in a gallery entrance or passageway, at an angle to the main wall of the exhibition space, it was as if you used the installation to draw viewers' attention first of all to the very nature of the space, by almost causing them to avert their habitual gaze, momentarily delayed from focusing on the object and its detail.

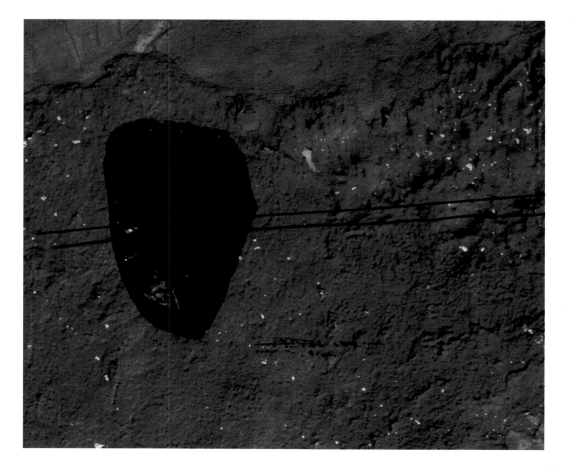

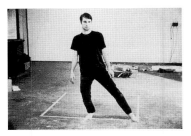

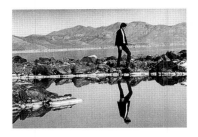

Salcedo **That's exactly what I set out to achieve. That was what prompted me to construct those works and why they were arranged in that way. I myself feel displaced. I believe that contemporary artists are displaced people. There are some beautiful images suggesting this – like Bruce Nauman's photographs and short films of the mid 1960s, where he's circulating around his studio. They convey a disquieting feeling, an anxiety over not being able to do anything or achieve anything in that space. I'm also reminded of a photograph of Robert Smithson walking along the surface of his *Spiral Jetty* (1970). It's as if the centre of the spiral, which suggests the feeling of vertigo, represents his position as a displaced person.**

Basualdo During your time in New York did you come into contact with the work of Gordon Matta-Clark (1943–78)?

Salcedo **Unfortunately I didn't see Matta-Clark's work at that time, only later. It's powerful work; it makes us aware of space, specifically of spaces that are negated, that we can no longer inhabit. Contemporary sculpture can address this issue of uninhabitable space, which is absolutely pivotal to our time. For several decades now we have witnessed in many parts of the world human masses on the move, fleeing from horror, going into exile.**

Basualdo It's interesting that although we've been discussing primarily aesthetic concerns of sculpture, you've made constant references of a political or ethical nature, as if a space could never be conceived of as neutral or depoliticized.

Salcedo **I don't believe that space can be neutral. The history of wars, and perhaps even history in general, is but an endless struggle to conquer space. Space is not simply a setting, it is what makes life possible. It is space that makes encounters possible. It is the site of proximity, where everything crosses over. I feel I am scattered in many different places. As a woman and a sculptor from a country like Colombia (regarded by outsiders as having a pariah status), working with victims of violence and showing my work in different places around the world, I find myself encountering extreme and contradictory positions, both on a large and small scale. This is why I think I am in a privileged position, always at a junction.**

Basualdo Do you think that this position you occupy as an individual influences the aesthetic structure of your artworks?

Salcedo **Yes, it's essential.**

Basualdo To return to your early years, after receiving your MA in New York, you returned to Bogotá and became a lecturer in sculpture and art theory at Colombia's national university during the mid to late 1980s, for a time also serving as Director of the school of plastic arts at the Instituto de Bellas Artes in Cali. By 1992 your work had become well known internationally. Were these two developments related, in the sense that the period of teaching which preceded your appearance in the international arena might have enabled you to reflect on your production and your positioning?

Untitled
1989–92
Cloth, concrete, steel
13 × 34 × 17 cm
No longer extant

Bruce Nauman
Dance or Exercise on the Perimeter
of a Square
1967–68
16mm film
10 mins., black and white, silent

Robert Smithson
Spiral Jetty (detail)
1970
Rocks, earth, salt crystals, water
6,783 tonnes of earth
l. 450 m
ø 450 cm
The artist walking on the work,
Great Salt Lake, Utah

Salcedo **To some extent they are related. When I'm working it's not only my own experience that counts; the experience of the victims of violence I have interviewed is an essential part of my work. Dialogue is crucial in this process; it is what allows me to know the experience of the Other, to the point at which an encounter with otherness in the field of sculpture is possible. Thus my work is the product of many people's experiences. A parallel can be traced between my working process as an artist and teaching, which is usually at least as positive for the teacher as it is for the students, because it's a dialogue, and learning is the product of this encounter. Like sculpture, it's a meeting point.**

Basualdo It's interesting that when talking about teaching you stress the fact that it implies, through dialogue, a confrontation with the Other. In a way, this is a structuring leitmotif in your discourse on the artwork. Do you feel that teaching is the ground that enables you to formulate this relationship with the Other more clearly?

Salcedo **No, it's the other way round. My awareness came first, and that gave shape to my teaching. In a country like Colombia, life is constantly interrupted by acts of violence. There is a reality which is intrusive, that**

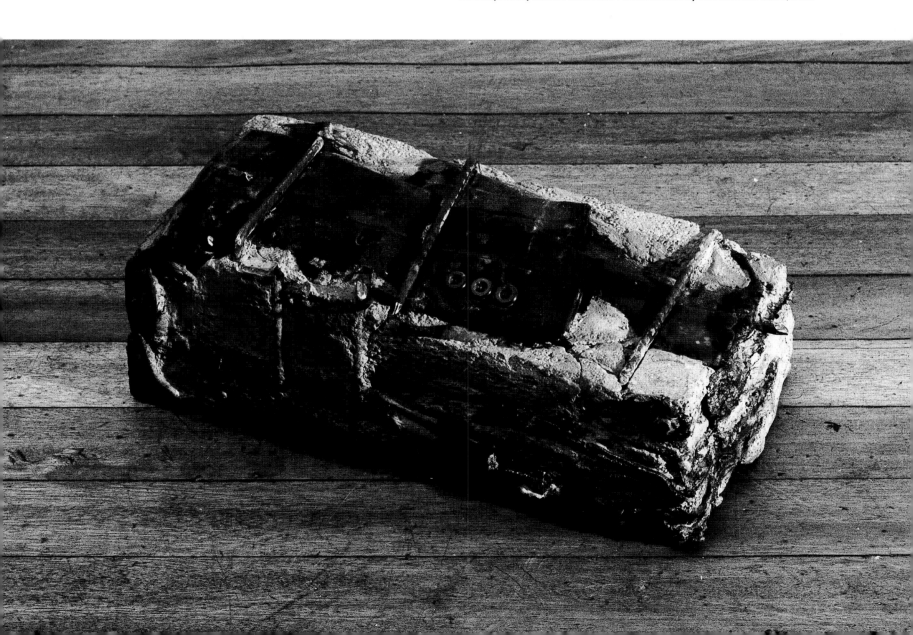

disrupts the way you wish to live. In other words, life imposes upon you this awareness of the other. Violence, horror, forces you to notice the Other, to see others' suffering. When pain is extreme there is no way to avoid it. In the First World you can walk past a homeless person on the street and either give him or her a coin or do nothing and expect the State to take care of this person, without losing any sleep over it. But in the Third World, when you encounter five hundred homeless people and there is no 'paternal' State, you have to notice them. This presence becomes part of the environment, part of the air you breathe. It is always with you. You can't get it out of your mind; there is no way to avoid it. So, having been born in Colombia is what makes me look at the Other. I have no choice.

Basualdo This must affect your relationship to the artwork: you mentioned how you experience your work through its 'otherness' – the feeling that it never quite belongs to you.

Salcedo **All the works I've made so far contain first-hand evidence from a real victim of war in Colombia. I have sought out such victims, interviewed them and attempted to be as close to them as possible. I try to learn absolutely everything about their lives, their trajectories, as if I were a detective piecing together the scene of a crime. I become aware of all the details in their lives. I can't really describe what happens to me because it's not rational: in a way, I become that person, there is a process of substitution. Their suffering becomes mine; the centre of that person becomes my centre and I can no longer determine where my centre actually is. The work develops from that experience. So the elements I work with are those which would be available to that person. From this point of view, the piece forms itself.**

Basualdo The methods you're describing must have given rise to the first series of *Atrabiliarios* (1991–96) in 1991. Was that the point of departure in your working method?

Salcedo **No, there were two previous untitled works made in 1987 and 1989. A few months after I returned to Colombia in 1985, having spent a year in Europe and two years in New York, the Palace of Justice in Bogotá was occupied by guerilla forces. The violence that ensued ended in a horrific tragedy. It was something I witnessed for myself. It is not just a visual memory, but a terrible recollection of the smell of the torched building with human beings inside … it left its mark on me. I began to conceive of works based on nothing, in the sense of having nothing and of there being nothing. But how was I going to make a material object from nothing? So I began to look for source material, rummaging through waste, and Third World waste is extreme like our reality. I retrieved a number of discarded objects from a hospital in Bogotá and began to produce works from them. These were the works that preceded *Atrabiliarios*.**

Basualdo So you were first prompted to make a work out of nothing: *Atrabiliarios*, with its wall cavities into which shoes are placed, then half-concealed by a sewn-on screen of animal fibre, involves activating negative space, and the gesture of excavation. It's interesting to see how this element in the work relates to other post-war sculptural experiences, like Matta-Clark's.

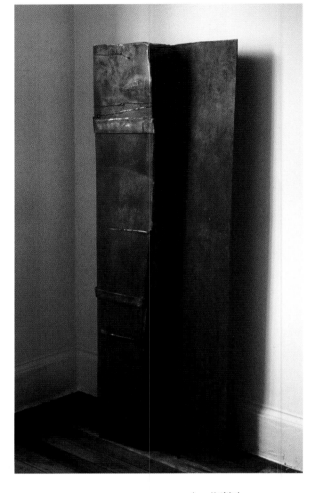

above, **Untitled**
1987
Textile fibre, steel, shoes
150 × 75 × 12 cm

opposite, **Untitled**
1989
Shoes, animal fibre, surgical thread
Dimensions variable

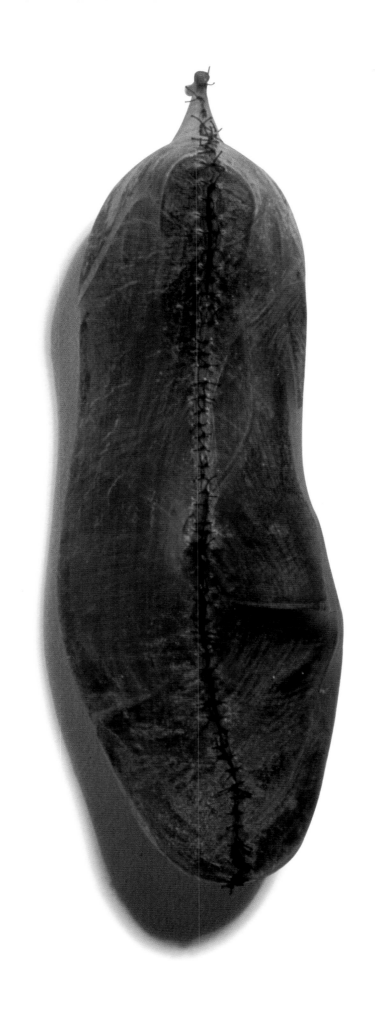

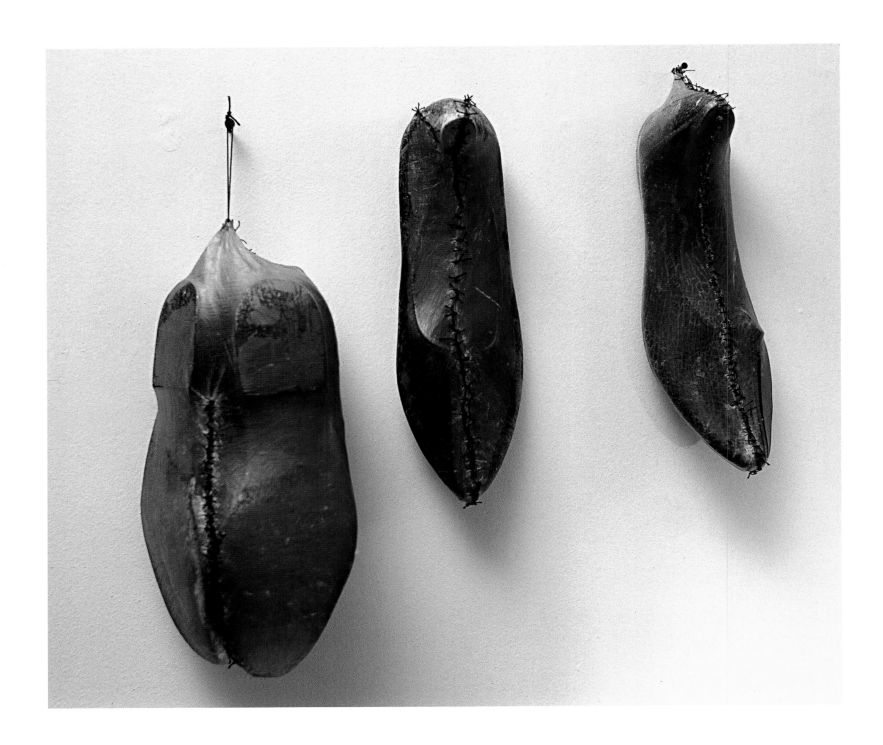

Salcedo *Atrabiliarios* was based upon the experience of people who
went missing. When a beloved person disappears, everything becomes
impregnated with that person's presence. Every single object but also every
space is a reminder of his or her absence, as if absence were stronger than
presence. Not a single space is left untouched, and there isn't a single area
of one's life left untainted by sorrow. This mark of pain is so deeply inscribed
in the expectancies of victims' families that what I did was almost a literal
transposition of their feelings to a real space. Furthermore, it was vital to
construct the work in spatial terms, to act as a meeting point for those of
us who had lived through such ordeals. The experience had to be taken to
a collective space, away from the anonymity of private experience.

Untitled
1989
Shoes, animal fibre, surgical
thread
Dimensions variable

Basualdo You seem to be pointing to a social dimension of space that is insepar-
able from space's strictly aesthetic dimension, as if they were inextricably linked.

Salcedo **Yes, to me they are one and the same thing. Of course, everything
happens to us in spatial terms. To place the invisible experience of marginal
people in space is to find a place for them in our mind. I think of space in terms
of place, a place to eat or a place to write, a place to develop life. So there is
no way of isolating living experience from spatial experience: it's exactly the
same thing. Certain types of contemporary work underscore this aspect of
sculpture as a topography of life.**

Basualdo You mention 'underscoring' as if alluding to a form of reiteration.
Your use of reiteration is quite different from the way it is used in Minimalist
sculpture. In your work, for example, reiteration seems related, in the activity
of recovering negative space, to the act of digging, with all the associations this
evokes. This is paralleled by other recurring features in your work, such as
absences, created by the marks and traces of that which is no longer present.
This seems to connect with the marginalization that you described as the
bedrock of your gaze.
 Another type of displacement comes into play in your use of the readymade,
which is different from the Duchampian model. Duchamp claimed that the
readymade has to be aesthetically neutral, but your found objects are far from
neutral. What specifically prompted the choice of the shoes in *Atrabiliarios*?

Salcedo **In this case, the choice of the objects had nothing to do with
an artistic decision. While researching specific cases of disappearance
I discovered that the only feature common to all cases, which enabled
the identity of the missing people discovered in a common grave to be
determined, was each person's shoes. The shoes also represent traces of the
trajectory that led the victim to such a tragic death. I worked with facts and
with the experience of the families. As I said before I do not believe in artistic
freedom. I do what I have to do or what I can possibly do.**

Basualdo Another aspect of the artwork is its relationship to the public
and private spheres. You have described space as a point of intersection.
If I understand this correctly, it is perhaps less a space for communication than
for community, for sharing something akin to a secret, and therefore to silence,
not something on the level of verbal communication. Would you say that, for
you, the spectator is never an isolated person but always already a member
of a continuum, a possible community?

Salcedo **Yes, undoubtedly. I envisage different moments of communication
in the development of the work. At first, as I investigate the various acts of
violence, a form of communication – or more precisely, a form of communion
– is established with the victim. This endures throughout the whole process
of making the work. I make the piece for the victim who makes him- or herself
present in my work. This process involves a dynamic of its own. Once the
piece is finished, it becomes completely autonomous from me. It is this
autonomous creation that establishes a dialogue with the spectator who is
open to it. The viewer may find something in the work that triggers his or her
own memories of sorrow, or some personal recollection. It is during this**

unique moment of beholding that the viewer may enter, as I did, into communion with the victim's experience. The artwork fully manifests itself at that moment.

Basualdo Not only in *Atrabiliarios* but also in the series *La Casa Viuda* there is a strong phenomenological aspect to the encounter with the work. The sense of anthropomorphization is heightened in, for example, the piece of clothing that is attached to the underside of the chair in *La Casa Viuda I* (1992–94). This has parallels with the work of certain Surrealist artists such as Meret Oppenheim. Were they an influence on your work?

Salcedo **No, surprisingly enough. I have only recently made approaches towards Surrealism, which to some degree I had rejected. I was far more interested in Minimalist aesthetics and in the work of Duchamp. I found the openly narrative aspect of Surrealism separated it from reality, from real time and space. Obviously a relation could be established; there is the fact that I'm rather old-fashioned in that I like telling stories, and in *La Casa Viuda*, each of the pieces tells its own story, articulated by images relating to real events. They rely heavily on words the victim used while telling his or her experiences, in some instances, and on objects given to me in others. That is what endowed them with their peculiar form. If there are any marked formal differences between *Atrabiliarios* and *La Casa Viuda*, it's because each of the pieces is based on a specific testimony. So the work is defined by the nature of the victim's ordeal.**

Basualdo I mentioned Surrealism because historically it has worked with ideas relating to the unconscious. I felt that the marks alluding to the presence of the body, and that movement towards the work's anthropomorphization, always seem to be pointing to an absence. In the context of your work, we could refer to what is missing as 'the body', but we might just as well refer to it as 'the Other', or 'the unconscious'. There is an affective dimension that apparently comes into play in the very fabric of the work, and I assume that is what you are referring to when you mention the 'communion' between the victim and yourself and ultimately between the viewing public and the victim, through the artwork. I'm fascinated by this paradoxical placing of the body as the unconscious element, which enables an affective connection with the audience.

below, l. to r., **Meret Oppenheim**
My Nurse
1936
Metal plate, shoes, string, paper
14 × 21 × 33 cm

André Breton
Gant de Femme
c. 1926
Bronze
3 × 22 × 11 cm

Brassaï
Sculptures Involuntaires
(Involuntary sculptures), from
Minotaure
1933
Magazine illustration, text and
photographs of found objects
31.5 × 23.5 cm

opposite, **La Casa Viuda I**
1992–94
Wood, fabric
258 × 39 × 60 cm
Collection, Worcester Art Museum,
Worcester, Massachussets

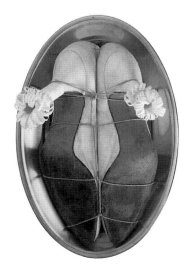

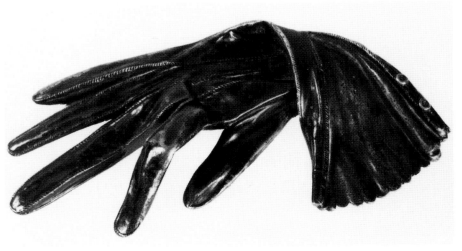

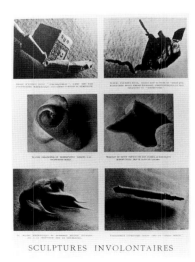

SCULPTURES INVOLONTAIRES

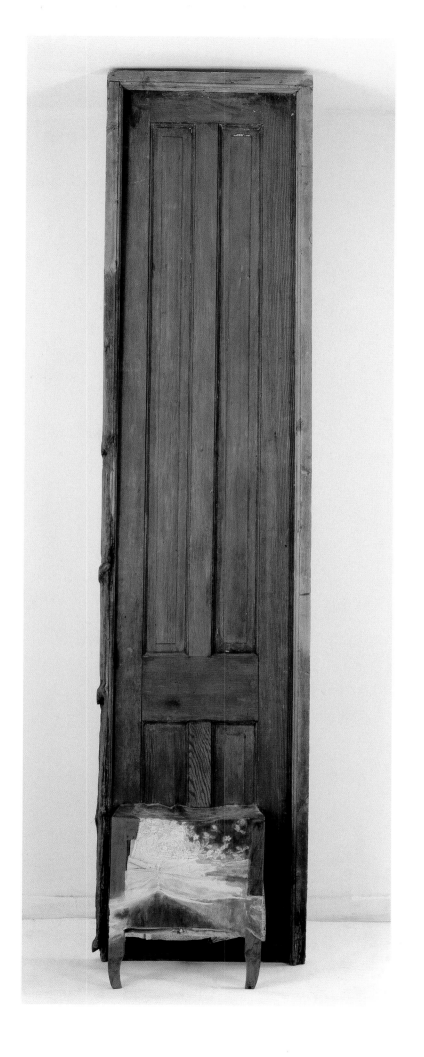

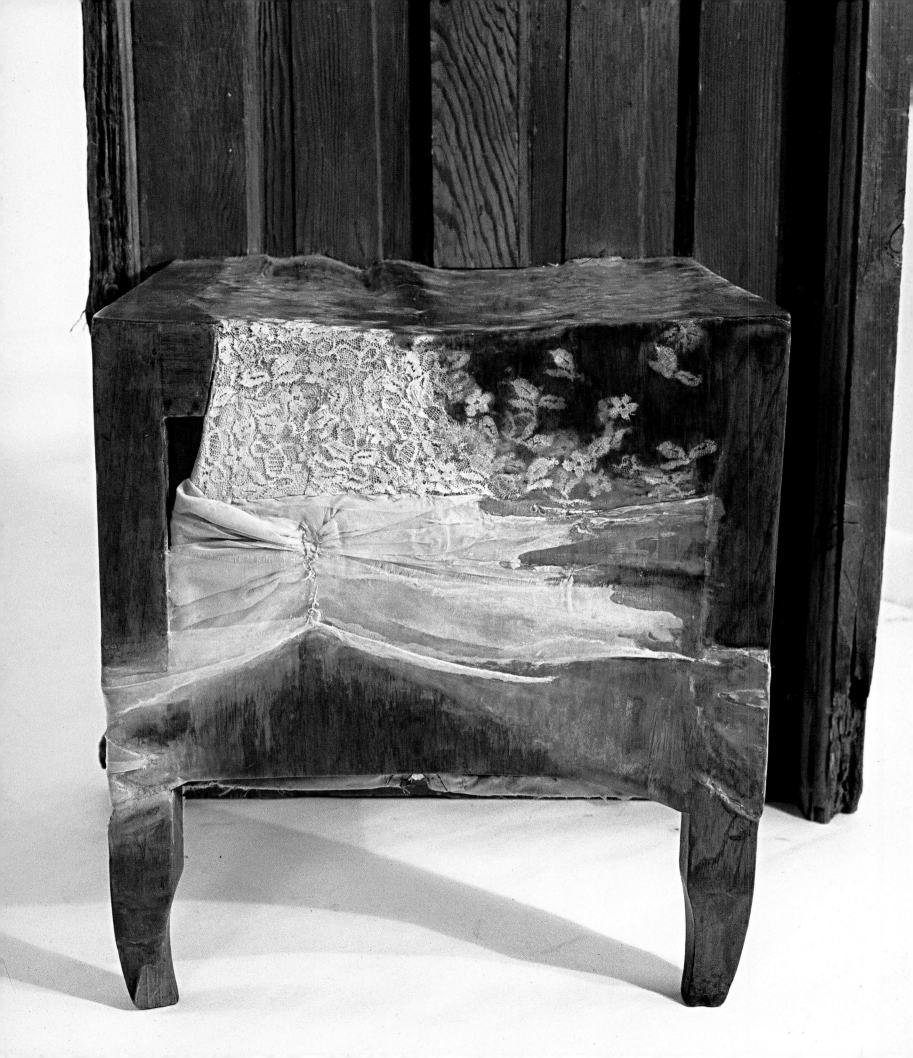

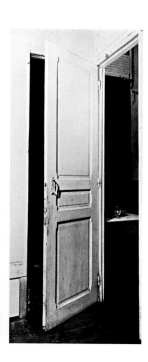

Salcedo **My answer to the last question was perhaps misleading because I was thinking of Surrealism in painting and sculpture, to which I had no links. However, at that time I was reading George Bataille, whom I consider to be the most interesting Surrealist thinker. So, there was indeed a connection through Bataille and it was a very important one when it came to conceptualizing a new work. I was only able to confront the horror because Bataille led me by the hand. When you come up against horror, reason seizes up – only the unconscious and affect remain. There's no way you can think. You can plan things a thousand times over, you can be well prepared, but when it comes to the crunch, everything vanishes and you are put to the test, on the fringes of the raw unconscious.**

Basualdo Structurally, your works appear to be articulated by what Freud described as the two organizing principles in dreams: condensation and displacement. I wonder if on a material level too there's a connection to the unconscious of the type you've just described. I'm referring specifically to the combination of materials in your sculptures and the way in which no material seems to be what it is, but appears to turn into, or point to, something else.

Salcedo **The way that an artwork brings materials together is incredibly powerful. Sculpture is its materiality. I work with materials that are already charged with significance, with a meaning they have acquired in the practice of everyday life. Used materials are profoundly human; they all bespeak the presence of a human being. Therefore metaphor becomes unnecessary. I work matter to the point where it becomes something else, where metamorphosis is reached.**

The handling of materials in each piece is the result of a specific act, related to the event I am working on. It is an act of everyday life that gives shape to the piece. In some cases it is a hopeless act of mourning.

The image is the result of what has happened to the material as a result of this action. I work with gestures *ad absurdum*, until they acquire an inhuman character. The processes go beyond me, beyond my very limited capacity, whether because one single person couldn't possibly have made the work (*Unland*, 1995–98), or because of the brutality and massiveness of the act (untitled furniture sculptures, 1995–98), or because it is inhuman to handle certain materials (*La Casa Viuda*).

Basualdo Your work reveals an intense and intimate dialogue between the use of the Duchampian readymade and a certain type of craft fabrication. I would say that craft, in the context of our semi-developed countries, appears exactly as that which industrial production represses or marginalizes. This is a further way in which your sculpture occupies a position fluctuating between the aesthetic and the political. How do you reconcile the appearance of elements belonging to industrial aesthetics with those relating more to craft?

Salcedo **It reflects the situation in which I live – it's a mixture, a juxtaposition of diverse epochs. Parts of Colombian society remain feudal, other sections are industrial; you can see advanced technology existing side by side with extreme forms of underdevelopment. Oppositions of this kind are part of my life. Reality cannot be viewed on a single level, it always occurs on multiple levels. It is diachronic in spite of the fact that everything happens at the same**

time. But reality is always disrupted, always severed. In other words, it is not simply a mixture but a cruel juxtaposition of things striving violently to manifest themselves simultaneously. This propels me to construct the artwork in a parallel way: these uncanny images are a result of the mixture of materials that come from opposite realities.

Basualdo The kind of hybridism you're describing is usually attributed to Postmodern art and philosophy. Yet in your description it appears rather as an alternative form of Modernism, as if it were an integral part of the way you postulate modernity.

Salcedo **I do see this aspect of the work in terms of an alternative, marginalized form of modernity. It engages with the way we construct reality on the basis of our own day to day experience: a half-hearted, wavering reality, which lacks the solid rational reality of industrialized societies. The handmade element of the work marks not merely an absence of industrial values, but also a wholehearted rejection of rationalism. Paradoxically, war is the**

below, Installation, studio,
Bogotá, 1992
l. to r., **Untitled**
1989–92
Cloth, concrete, steel
13 × 34 × 17 cm
No longer extant

Untitled
1989–92
Wood, concrete, steel
Dimensions unknown

Untitled
1989–92
Wood, concrete, steel
72.5 × 55 × 45.5 cm

opposite, **Untitled**
1992
Wood, concrete, steel
130 × 214 × 58 cm
Collection, Art Institute of Chicago

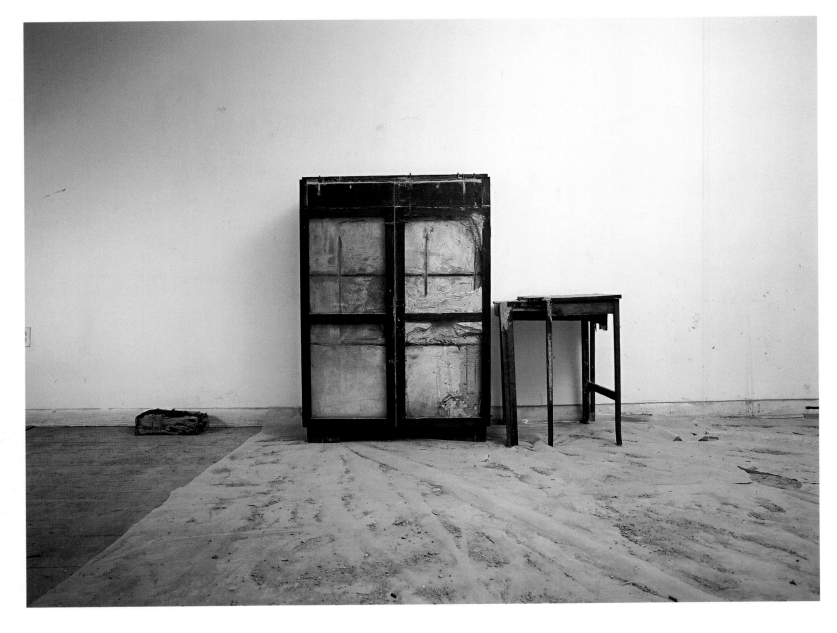

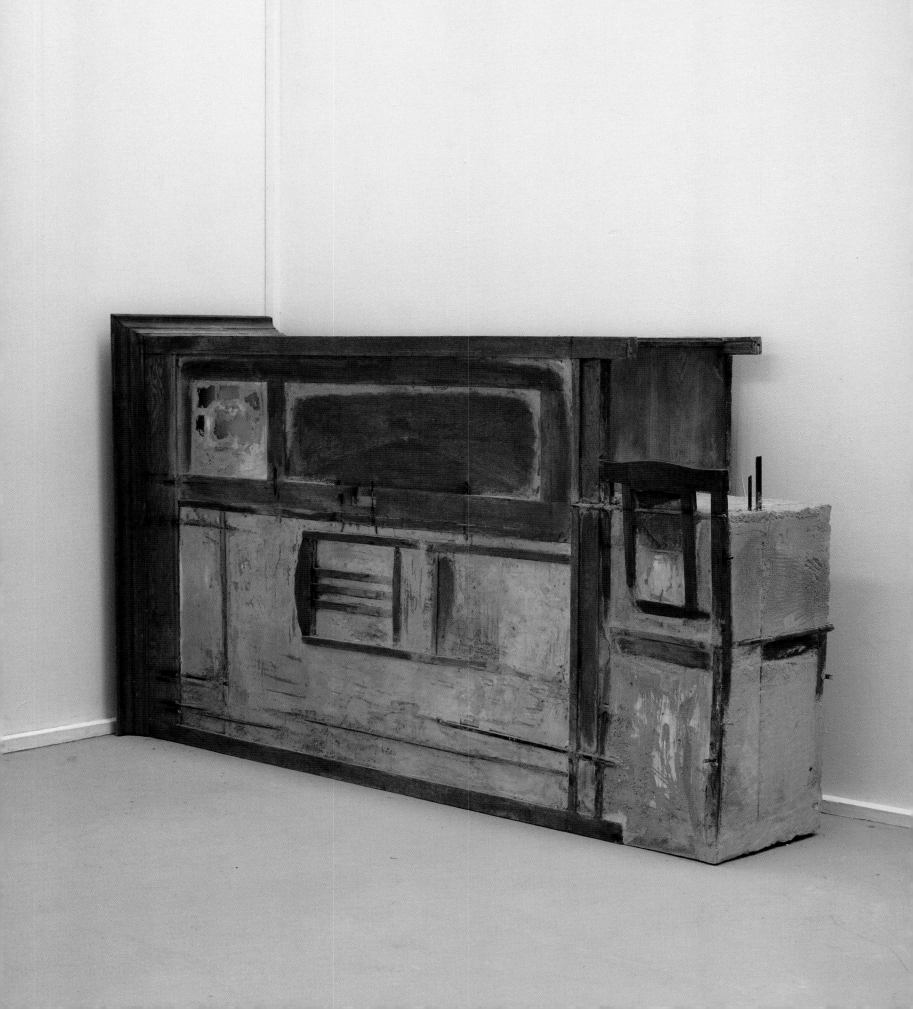

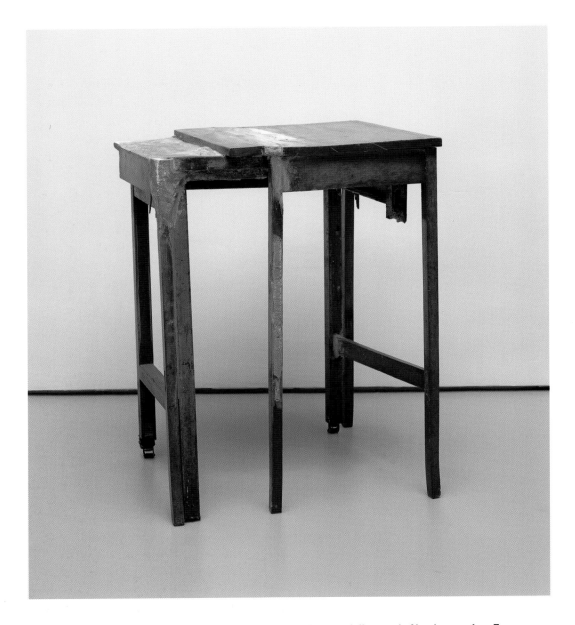

left, **Untitled**
1989–92
Wood, concrete, steel
72.5 × 55 × 45.5 cm

opposite, **Gordon Matta-Clark**
Splitting
1974
322 Humphrey Street, Englewood,
New Jersey

maximum expression both of industrialism and of its destruction. European thinkers who lived through the Second World War teach us how to think in the aftermath of Auschwitz. They provide us with a completely different angle on humanity and lead us to question the values that we're taught to regard as important. I'm interested in the notion of the artist as a thinker attuned to every change in society but at the same time producing art that is irreducible to psychological or sociological explanations.

Basualdo Matta-Clark's work operates on an archaeological level in relation to the architectural and urban status quo; your work evokes archaeology in terms of the layers of its various constituent parts. The individual elements that constitute your works never become fully integrated in a totality but remain autonomous; each part is separate from the other, retaining its individual character. Thus the way you piece a work together seems to respond to a desire to maintain the differences between these constituent parts. The sculptures cannot be apprehended as a self-contained unity; rather there is a sequence of superimposed stages, a montage in which the various elements assert their presence simultaneously. I wonder whether there isn't also a sense of

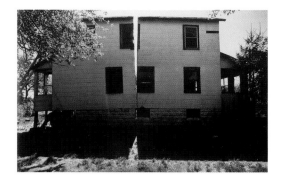

precariousness written into the materiality of these objects. How do you regard the idea of precariousness and fleetingness in relation to your work?

Salcedo **Precariousness is essential. As I said earlier, I work with what I can. In some cases, situations are so precarious that one is reduced to working with materials from the body itself – hair, bone – there is nothing else. Extreme precariousness produces a paradoxical image, one that is not defined; an image in which the nature of the work is never entirely present. It is indeterminate, so silence is all there is.**

When you are caught up in a conflict, in precarious conditions, you can't even remember things, never mind produce history. History summarizes, sanitizes and smooths out differences, so that everything appears to have been perfectly synchronized as a unified stance. This is not available to us. We not only have to deal with economic precariousness but with the precariousness of thought: an inability to articulate history and therefore to form a community.

Basualdo You've touched on something vital when you say that one is unable even to remember the traumatic incident; thus in effect one bears witness to nothing. This means that instead of monumentalizing a tragic event the artwork is merely a means of coming into contact with nothing. As I see it, that is what is inscribed in the materiality of the work.

Some critics interpret your work in terms of commemoration, as if it involved the recollection of a tragic event in the traditional sense of a monument. I think you operate on a far more complex level.

Salcedo **Yes, I think this came out clearly in *Unland*, where there is nothing, where nothing happens – absolutely nothing – and viewers desperately try to come to terms with the fact that vision gives them no answers. A surface reverberating no specific character allows the communion we discussed earlier to arise. Otherwise, there would be an imposition on the viewers of whatever occurred to me to tell them, and I never harbour such intentions, because I'm incapable of holding a clear grip on reality. As Maurice Blanchot has said, one cannot experience death.**

Basualdo In psychoanalytical terms, this 'communion' would perhaps be described as remembering myself as if I were someone else?

Salcedo **Yes.**

Basualdo The title *Unland* alludes to a work by the German Jewish poet Paul Celan (1920–70). Celan is a key figure not merely for the position he occupies in Western poetry of the post-war period but because of his stance in relation to the Holocaust. He translated the experience of absence, the horror of the Holocaust, precisely through the disintegration of language and its structures. Do you think that there are equivalences between the way Celan treated language and your approach to the material of your work?

Salcedo **I think that is exactly what we were saying earlier. You mentioned that the pieces are never wholly integrated, that they remain dismantled; that to some extent they occupy the same space and are part of the same**

object, but each one remains individual. Celan's poetry involves piecing together from ruptures and dissociations, rather than association and union. This is the way I approach sculpture. I concern myself with the disassembled and the diachronic.

Basualdo Celan's contemporary, the Frankfurt school philosopher Theodor Adorno, felt that it was no longer possible to write lyric poetry after Auschwitz. There is an affirmative attitude in Celan's decision not to remain silent but to convert silence into some other form of expression. I think that attempt is a key aspect of your work. In the context of countries like Colombia one also recalls the argument between Brazilian filmmaker Glauber Rocha and French director Jean-Luc Godard in the late 1960s. For Rocha, social and political critique in Godard's films had reached a point of utter sterility. Rocha maintained that Godard failed to understand the sheer need for cinema in Brazil, for a constructive and affirmative critical practice, even if its conditions may sound at times paradoxical. Does Rocha's experience resonate in your work?

Salcedo **Yes, what motivates the sculpture is necessity. We are living in a highly complex reality which wipes everything out very quickly. There is vertigo in violence: if one violent element wipes out another, and so on, time gathers momentum and complete chaos ensues. The only way of attempting to check this speed, this chaos, is through the process of the artwork.**

Basualdo You have stressed that *Unland* operates on the basis of invisibility. It is a work in which connections are clear and the constituent pieces retain their individuality, but there are also some highly subtle transformations. These require one to stare fixedly at the work and to forfeit the visibility of its context, so that one's gaze fluctuates between a view of a detail and a view of the whole. That fluctuation might be reminiscent of blindness, an inability to comprehend an artwork visually in its entirety. Invisibility of this kind appears to be inscribed in your work and becomes increasingly more explicit. Do you feel that this counteracts the materiality of the work? Does your sculpture involve an opposition between presence and invisibility?

Salcedo **I'm not interested in the visual. I have constructed the work as invisibility, because I regard the non-visual as representing a lack of power. To see is to have power; it's a way of possessing. At least from where I stand, I cannot conceive of human beings as all-powerful and knowledgeable. We are just human beings, without memory.**

Basualdo Does this resistance to visuality in the artwork reveal an aversion to materiality itself, to the possibility of transforming the work into a monument in the classical sense?

Salcedo **Yes, it does, because what I'm addressing in the work is something which is actually in the process of vanishing. As I stated earlier, it is a half-present reality. You never manage to perceive it as something concrete; you never manage to grasp it. I'm most concerned about what goes beyond my understanding. I myself fail to apprehend it.**

Basualdo I'm interested in such allusions to excess: that which is beyond one's

above, **Glauber Rocha**
Terra em Transe (Earth in anguish)
1967
115 mins, black and white
Film still

opposite, Installation of untitled works, 1989–95, 'Carnegie International 1995', Carnegie Museum of Modern Art, Pittsburgh

reach, which one cannot hope to recall, and which overshadows the very presence of the artwork. Through excess, the work seems to convey the presence of otherness.

Salcedo **Of course. Everything that is beyond me, that I fail to grasp, that I cannot remedy or deal with, is the Other, or in the philosopher Emmanuel Levinas' description, 'the face of the neighbour'. In addition to what I have already described, there is a sense of delay: the Other needs me urgently, but I arrive late. I always work on the premise of that delay in arrival, which marks my work with a lack of hope. It is not a question of the impossibility or immensity of the task but of my being incapable of acting effectively. I am disabled. My work is too.**

Basualdo What do you feel has happened in the last few years, during which your work has earned international acclaim and made inroads into what we could describe as the circuit of capitalization? How do you think this affects your work, if at all, and what is your reaction to this process?

Salcedo **That's a complicated question; when works leave my studio they no longer have anything to do with me; they become completely alien. I acquire a distant view of my works once they have reached completion. Each work has to find its proper place in the world. They will never become real objects that someone could wholly possess, because of their intimate character, their material fragility, and in some cases because of the very nature of the**

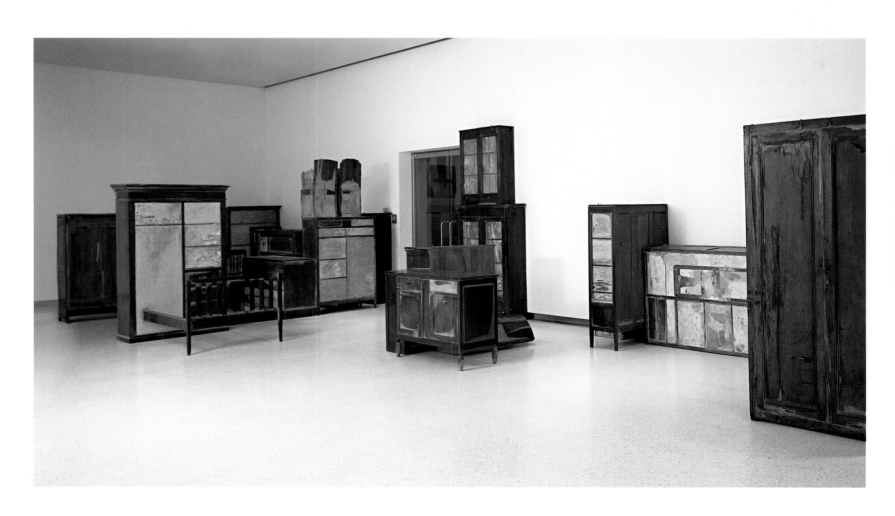

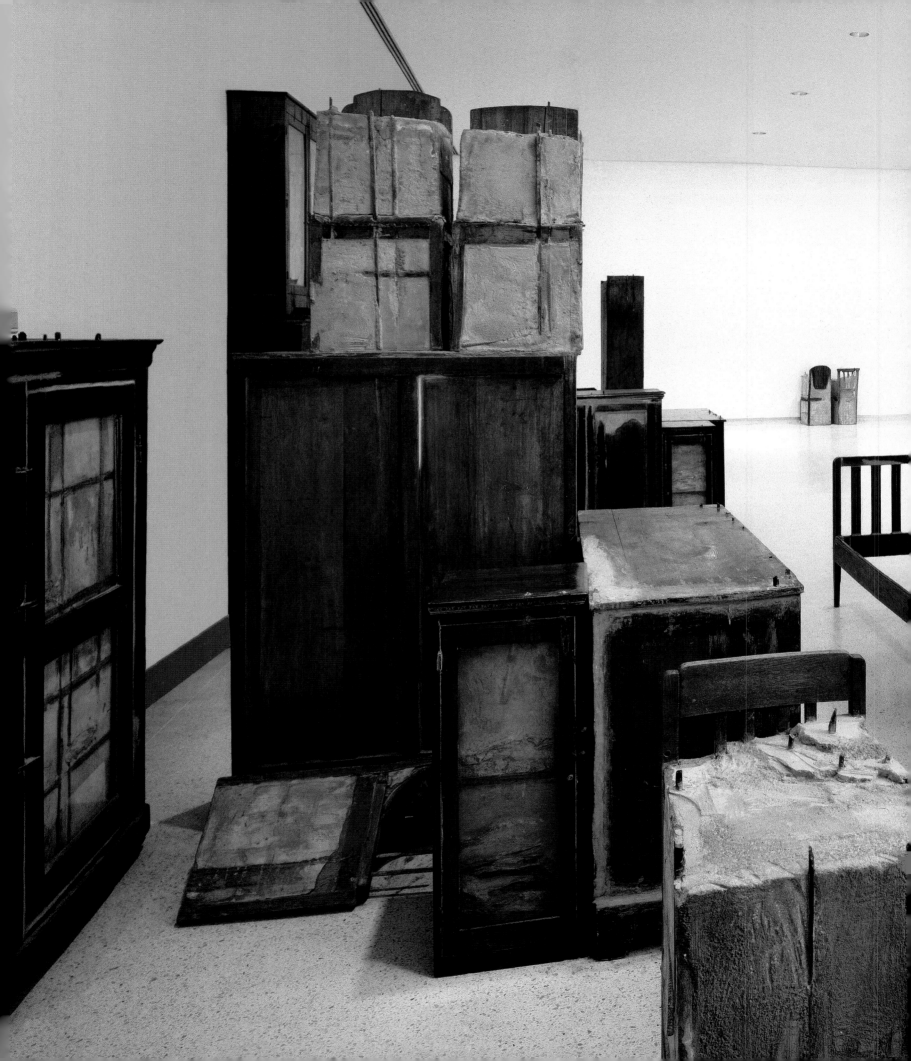

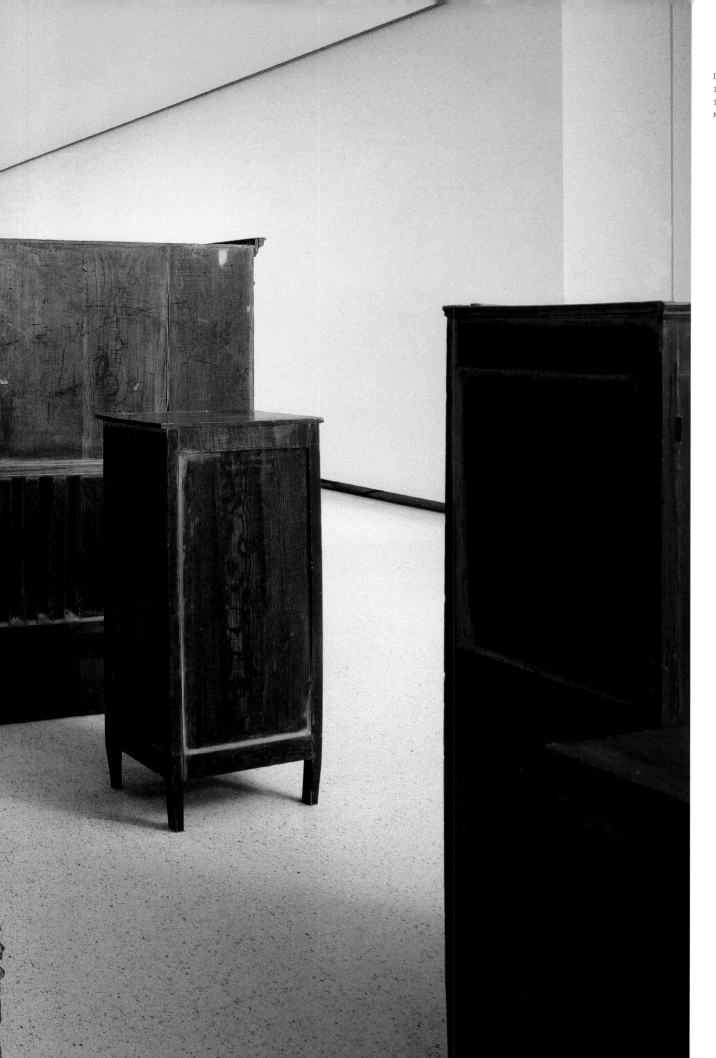

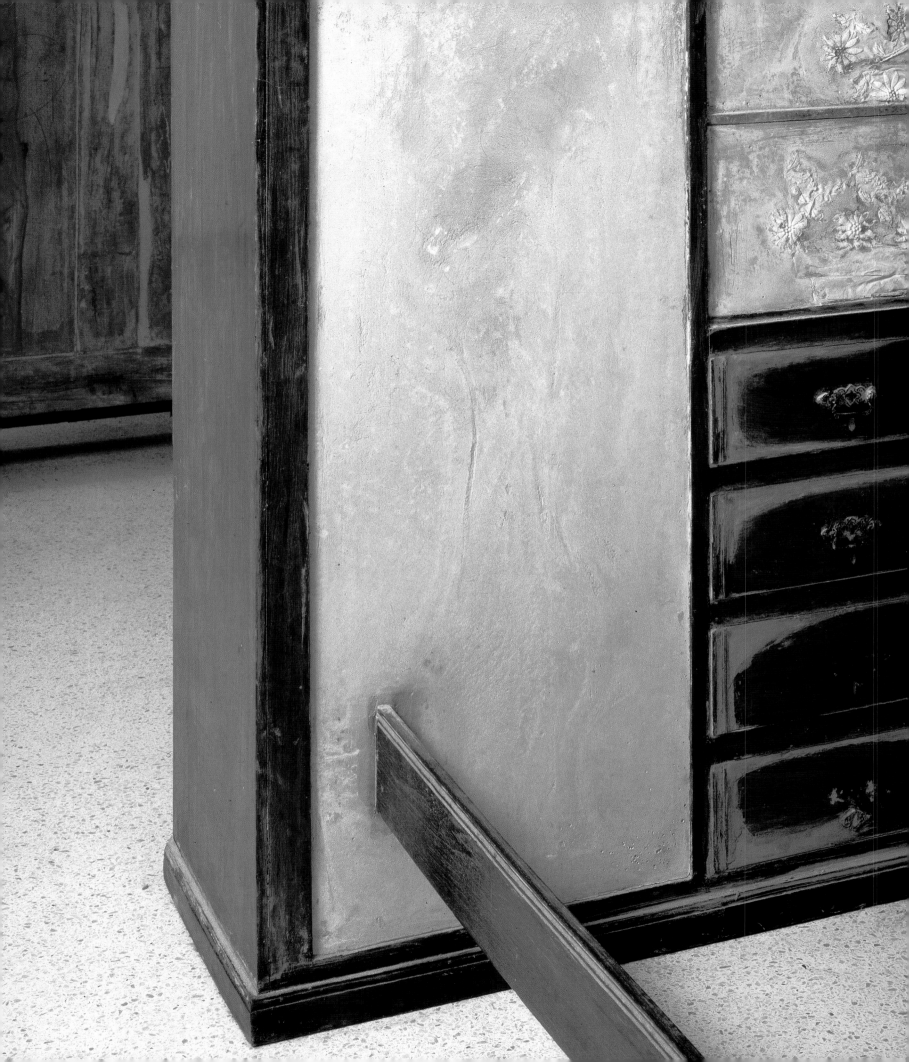

Untitled
1995
Wood, concrete, cloth, steel
196.5 × 124.5 × 193 cm
Installation, 'Carnegie
International 1995', Carnegie
Museum of Modern Art, Pittsburgh
opposite, Detail

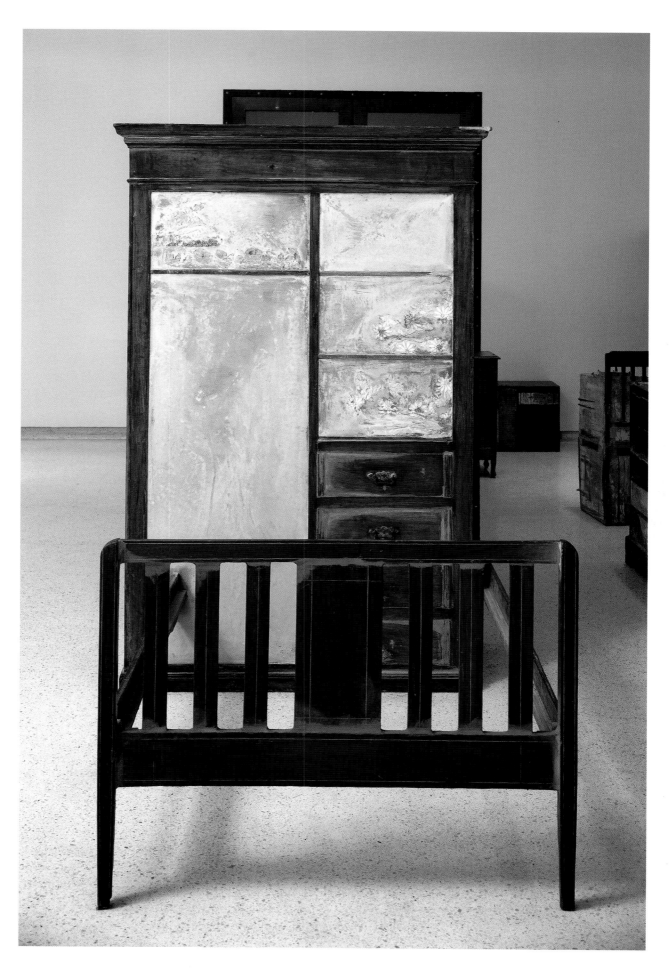

Interview

material. There's also the fact that they've become dissociated from the installation in which they were originally presented.

Basualdo It's interesting to note that the very presentation of the works constitutes a manifestation in itself. I wonder what happens when the show's over and the works are dispersed – when they become discrete 'works' in the traditional sense. That seems to go very much against the way you conceive the presentation of your work.

Salcedo **Yes, dismantling the structure of an installation is a painful process but there's nothing I can do – I'm not building temples where sculptures can remain intact forever. Time moves on, and that is a challenge because once the installations have been dismantled, as far as I'm concerned the initial work vanishes and a new one appears. But for me there is a void, which is enormous and lasts for many years. I'm not very prolific; there are intervals of up to three years between my works.**

Basualdo Should one accept the wear and tear of the materials as intrinsic to the work?

Salcedo **Yes, the work involves a process of deterioration. I've always liked using the word 'creatures' to describe the sculptures – I learned that from Paul Celan. As creatures we all deteriorate and go into decline. I'm not building bronze or marble monuments but producing works that refer to something extremely private, that challenge us constantly by virtue of their fragility. This fragility is an essential aspect of the sculptures. They can even be affected by someone coming too close to them; they show us how fragile another human being can be. I am talking of the fragility of a passing caress. We are even exercising an influence on the world by delicately touching the surface of an object, because the object changes. If we were capable of understanding this fragility implicit in life, we would be better human beings.**

Basualdo When I arrived in Bogotá, I mentioned to someone that I was visiting you, and I was told about your involvement in a recent public action in a street of the city. Can you describe how this came about?

Salcedo **In August 1999 the humourist Jaime Garzón, who had played an important role in giving Colombians some sense of identity, was killed. Most Colombians were in mourning; I was in mourning too. When things of this nature happen one is overwhelmed by a feeling of extreme impotence. This painful event led me to make a public appearance. It was difficult for me, because I've always considered it important to remain private. Privacy allows me to be an outsider in my own city in order to have the critical distance required to make my work. This action was a response to what most Colombians, including myself, were feeling. Such public action was direct; the fact that we felt so strongly had a real effect.**

A group of Colombian artists, in which I was included, decided to manifest their pain, in the most respectful way. We made a ritual act of mourning. A wall was chosen, where people had already expressed their pain and profound indignation by placing all kinds of messages on it. This wall was in front of the house where the assassinated humourist had lived.

5,000 roses placed on a wall in
memory of Jaime Garzón, Bogotá,
Colombia, August 1999
l. 150 m

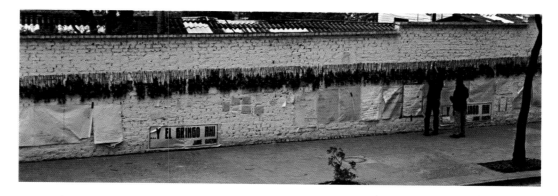

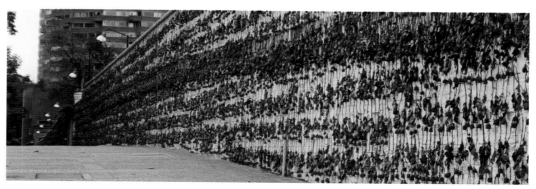

**We decided to place 5,000 roses along a 150 metre stretch of the wall. The
roses slowly withered and declined, becoming an ephemeral site of memory.
 The importance of this act of mourning lay beyond this particular action.
A month later another intellectual and professor at the national university
was killed on campus. The students spontaneously covered the walls of the
university with flowers.**

Basualdo It's remarkable how that action, which bordered on the anonymous,
prompted the production of other works. The way it operated in the social
sphere, and took on a sculptural dimension, seems closely related to the rest
of your work.

Salcedo **I didn't think of it that way. I never thought of it as an artwork.
When someone dies, one brings flowers. I was paying homage. It was never
an artwork, and much less a piece attributable to a particular artist. The idea
was to bring together a group of artists, viewing our own tragedy and
responding to such a terrible event. Well, unfortunately this action was
attributed to me; in that respect it half failed.**

Basualdo But it was a successful failure in the sense that it provided the
incentive for something similar.

Salcedo **Yes, it did provide the incentive, but to paraphrase Samuel Beckett,
'What does it matter who's talking?' If one knows who's doing the talking,
it rather detracts from the image. You are imposing an image, handing
something down. The idea was basically to provide a gesture in the
prevailing climate of grief that forced us to articulate our mourning.**

Basualdo Can your deliberate anonymity in Colombia be reconciled with your

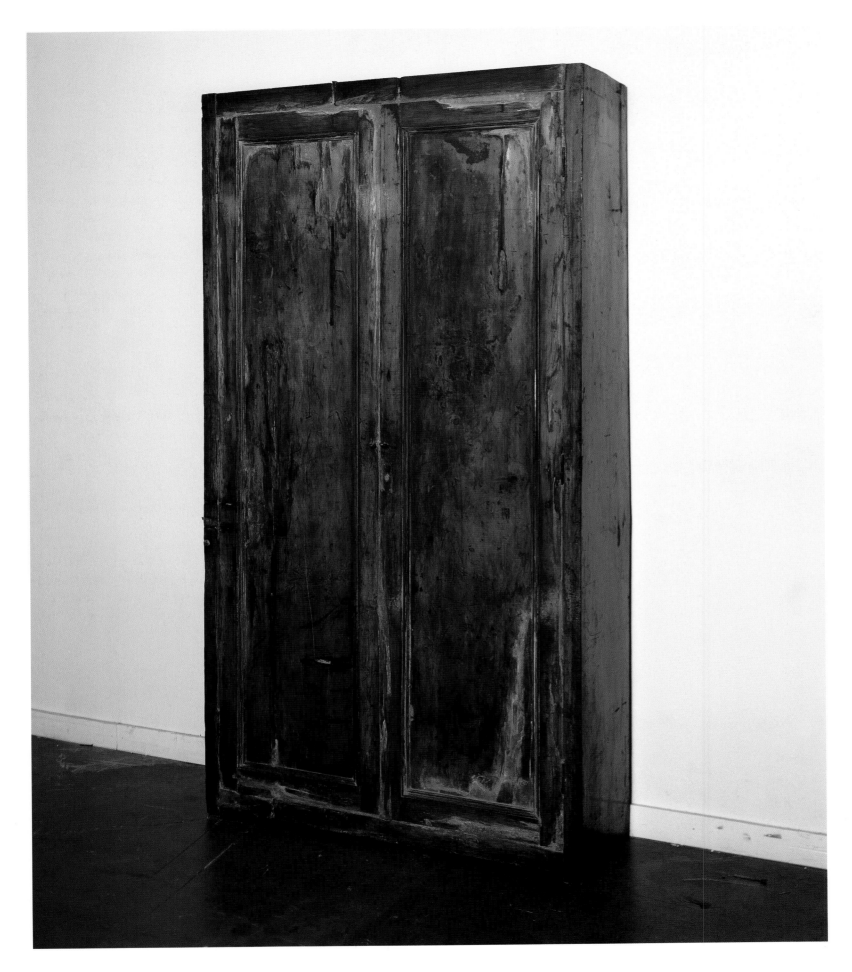

Untitled
1995
Wood, concrete, steel
217 × 114.5 × 39.5 cm
Collection, The Museum of
Contemporary Art, San Diego

following pages, right, **Untitled**
1998
Wood, concrete, glass, cloth,
metal
183.5 × 99.5 × 33 cm
left, Detail

acclaimed position in the international scene? Does this anonymity respond to
a strategy or to a premeditated intention?

Salcedo **It's absolutely deliberate. Being a foreigner or an outsider in a
parochial setting is absolutely essential. I would like to add that every setting
is parochial. It's a basic survival strategy. Otherwise, it would be very difficult
to have the privacy I need to work and research with mobility and complete
discretion. While anonymity gives me freedom, showing abroad gives me
hope, because in the midst of war, art can be made. It's not only horror that is
produced in this country; there is also sophistication in a complex reality like
the one we live in Colombia. My work can be exhibited abroad, because the
Colombian situation is a capsule of condensed experience that is valuable to
the rest of the world. Our horror is, in a way, a paradigmatic one. That is why
knowing that these works come from Colombia, and that a woman from
Colombia produced them, is important. Both are premeditated strategies,
and I think my artworks have a journey to make, and they will return when
the time is right. A civil war obviously doesn't provide the right timing.**

Basualdo Your response to this predicament is a highly active form of
anonymity.

Salcedo **Very active, because I'm producing artworks. I'm only active in the
field that interests me. Socially I'm not active but artistically I am.**

Basualdo I've noticed that, instead of the word 'marginalized', you prefer the
term 'displaced', which has many connotations, and that the displacement in
question affects all spheres: the aesthetic, the phenomenological, the political
and the social.

Salcedo **Displaced is the most precise word to describe the position of the
contemporary artist. Displacement allows us to see the other side of the coin:
indifference and war. It is obviously a position that generates tension and
conflict, but I believe that from the position of displacement art derives its
most powerful expression.**

Translated from Spanish by Dominic Currin

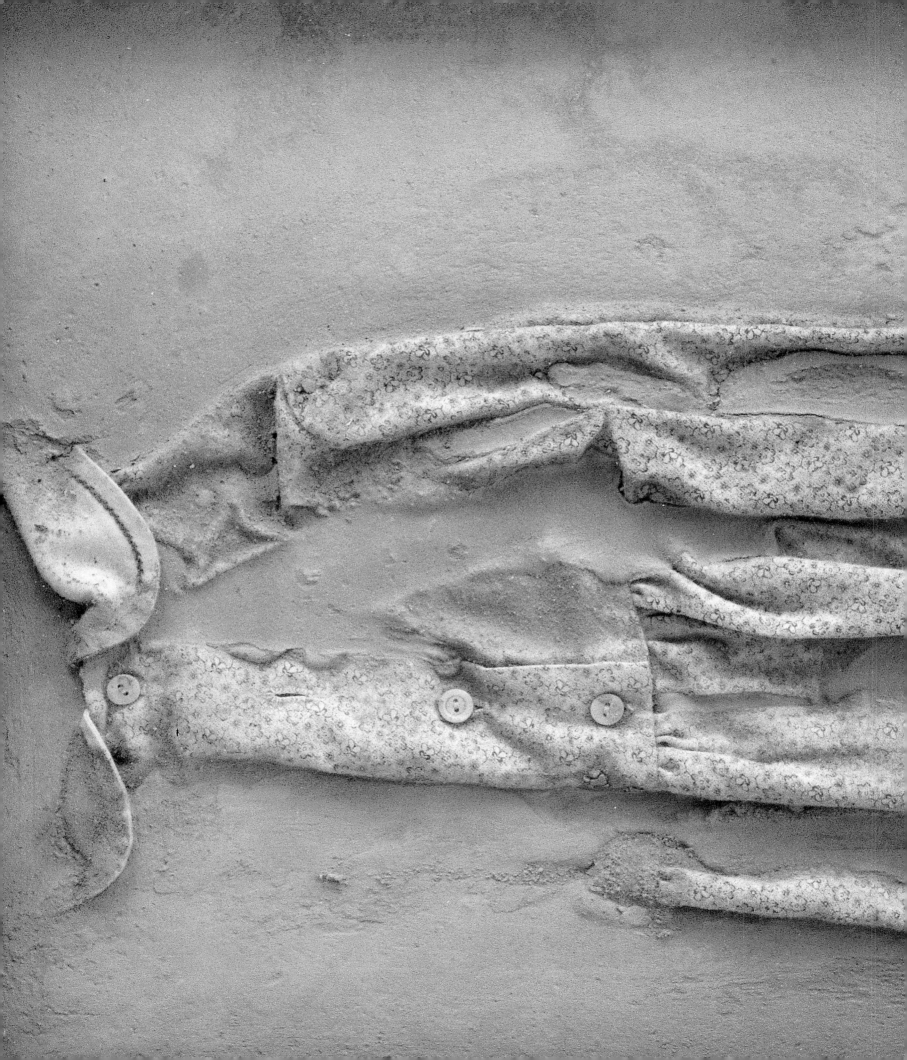

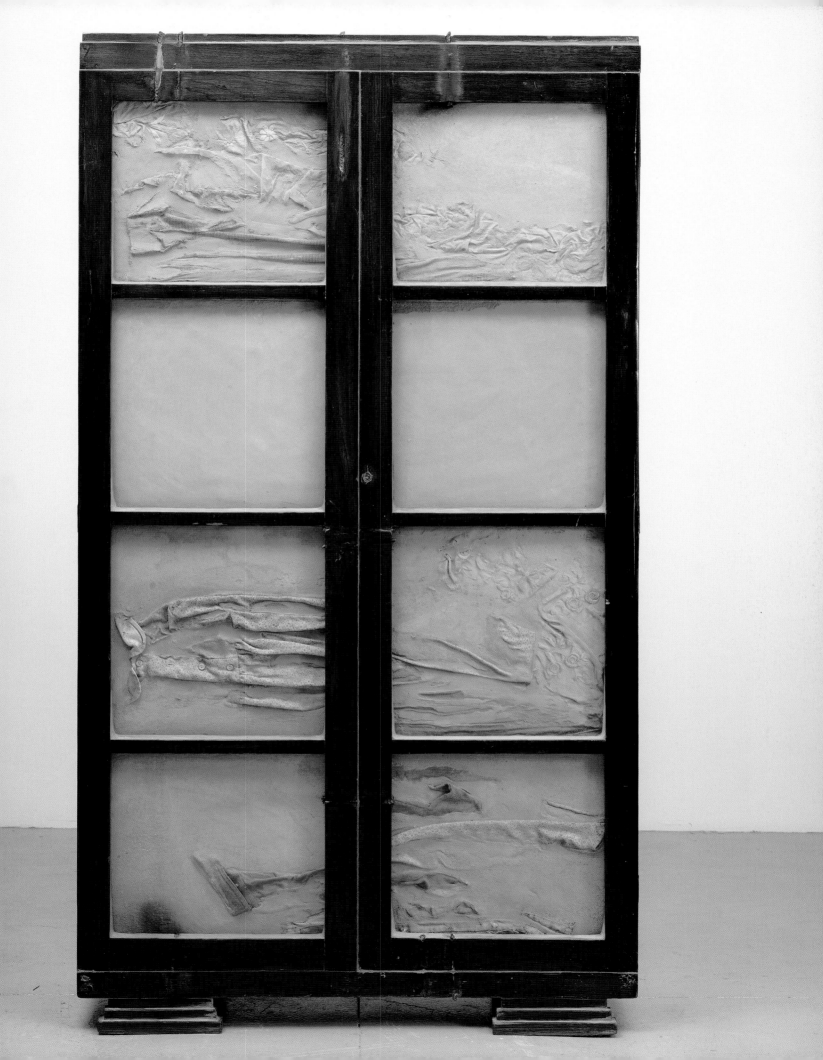

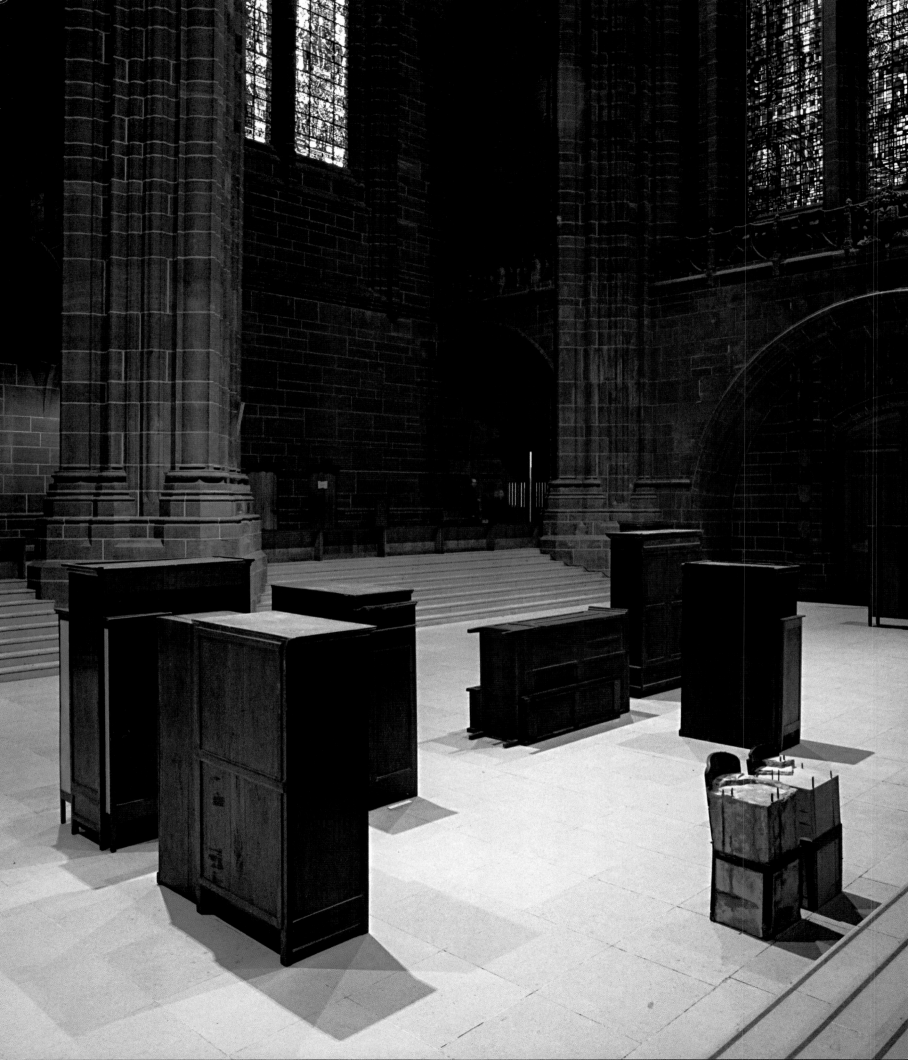

Contents

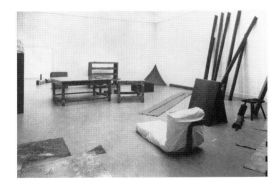

Vladimir Tatlin
Complex Corner Relief
1915
Iron, aluminium, zinc
73 × 152 × 76 cm

Marcel Duchamp
Studio, 33 West 67th Street, New
York, 1917

Joseph Beuys
Installation, 'Joseph Beuys',
Stedelijk Van Abbemuseum,
Eindhoven, 1968

'*I believe that the major possibilities of art are not in showing the spectacle of violence but instead in hiding it … It is the proximity, the latency of violence that interests me.*'[1]
– Doris Salcedo

Doris Salcedo's quietly spellbinding sculpture is born of the greatest urgency, but speaks in a language of obstacle and delay. It works by slowing and thickening experience, finding forms that are eloquent of both massive, inescapable acts of violence and of the nearly imperceptible damage they leave. To events that are extreme in their specificity, Salcedo responds with the most lyrical and universal of imagery. The dilemmas that she wrestles with involve accepting breathtaking responsibility while remaining steadfast in opposition to using evidence literally. '*I know that art doesn't act directly*', she says. '*I know that I cannot save anybody's life, but art can keep ideas alive, ideas that can influence directly our everyday lives, our daily experiences.*'[2] To maintain balance among these conflicting imperatives presents nearly insuperable difficulties. Even the victims she honours, Salcedo has admitted, don't recognize themselves in her work.[3] But her profound respect for them, and her unswerving honesty, guarantee her work's integrity; her psychological and visual acuity ensures its quietly shattering effect.

Born in Bogotá in 1958, Salcedo was interested in art from an early age and studied fine arts and art history at the University of Bogotá, where she received her BFA in 1980, concentrating on painting and, secondarily, theatre. Among her teachers was the Colombian painter Beatriz González, whom Salcedo remembers conducting rigorous seminars with readings that included Wölfflin, Berenson, Panofsky, Gombrich, Merleau-Ponty and Francastel. The utopian Russian Modernists – the Constructivists and Suprematists whose programme promised cultural reform through improved, visually purified design – interested Salcedo greatly, as did the visual austerities of Minimalism. But she was most engaged by the more insubordinate twentieth-century artists, whose spirit of social engagement was more anarchic: 'From very early on', she recalls, 'I paid special attention to Duchamp and Beuys.'[4] Feeling constrained by what she remembers as an uninteresting local art scene, with a paucity of important work, either historical or contemporary, Salcedo left Bogotá for graduate school, where she made sculpture for the first time, completing an MA in that discipline at New York University in 1984. The experience was something of a disappointment: '*Going to NYU was not so important for my work … Actually I found it quite poor at every level, technically and intellectually … I feel the education I had acquired before, in Colombia, that is education at the periphery, was much richer than the one I found at the centre.*'[5]

Her return to Colombia, following her graduation from NYU, coincided with a resurgence of violence there, beginning with the takeover of Bogotá's Palace of Justice by guerrilla forces, which ended horrifically. From the start, Salcedo's work as an artist and her concerns for survivors of the war were inseparable. But she has always represented violence and mourning indirectly.

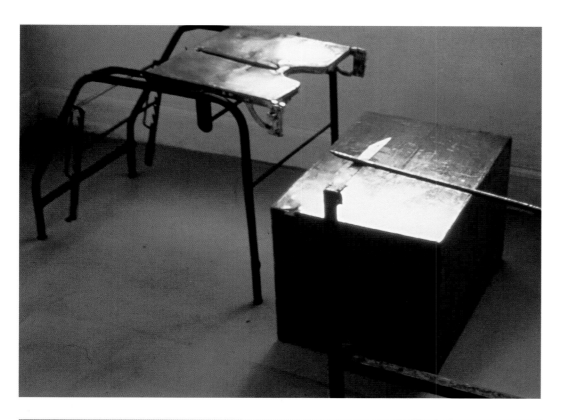

top, **Untitled** (detail)
1986–87
Steel, wood, plastic
2 units of 3 part work,
72 × 92.5 × 56.5 cm
95 × 85 × 90 cm

bottom, **Untitled**
1986
Animal fibre, steel
2 parts, 92 × 115 × 35 cm
90 × 118 × 50 cm

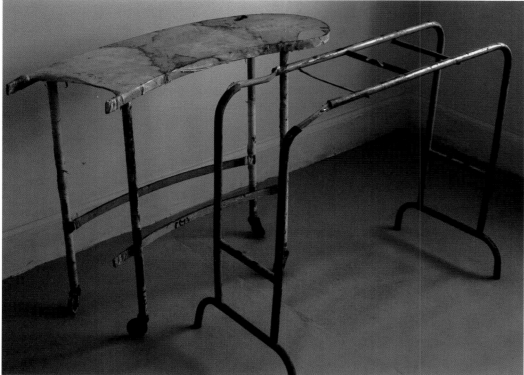

Untitled
1987
Metal, plastic, animal fibre
220 × 400 × 45 cm

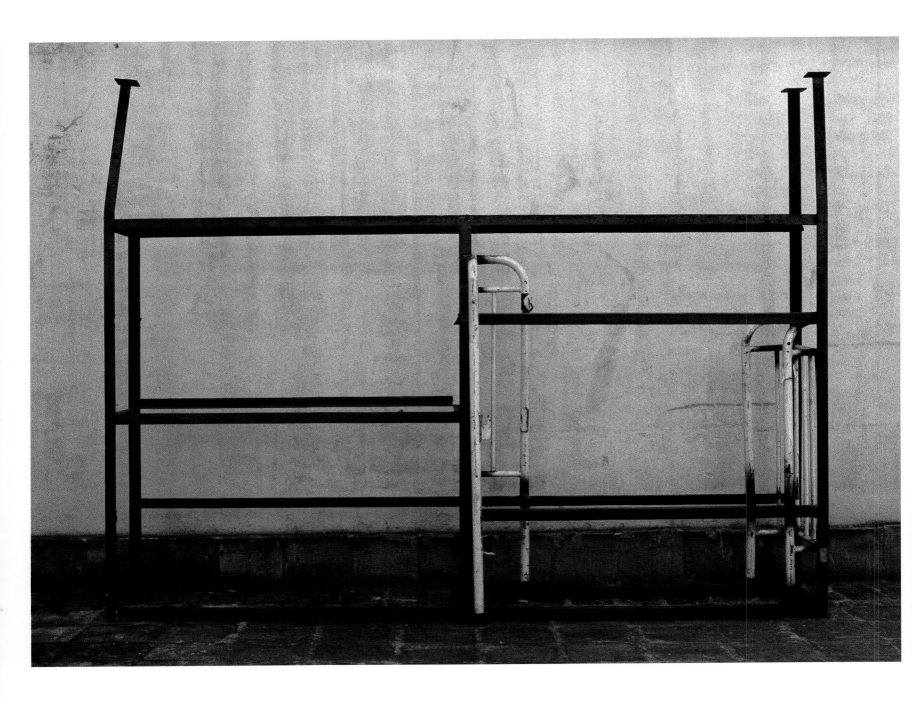

Bodies of victims are never shown, though viewers are made keenly aware of traces they have left on domestic furniture and, less frequently, discarded clothing. Similarly, the instruments of abuse are not given: there are no weapons of any kind in Salcedo's work and there is no direct representation of perpetrators. But the intimacy with which chairs and chests, shirts and shoes have been touched and worn, their long service and deep implication in the daily lives of ordinary people, heighten the impact of their shift into the realm of art.

Salcedo's enlistment of these utilitarian objects in the service of active memory is simultaneous with their functional death: the several kinds of physical quarantine to which they are submitted include being shielded behind translucent skin and immobilized by concrete. Salcedo's attentive care and painstaking alteration only makes the absence of the objects' former users the more apparent. This vacancy stands not only for unseen acts of aggression but also for the kind of emotional departure that results from subjection to physical terror. Salcedo represents, that is, a psychic process in which experience of violence is sequestered, transposed, written into a code not well recognized by ordinary language and therefore always threatened with the disappearance that is the central motif of her work.

Early Works

Salcedo's earliest sculptures of 1985–89 are among her most spare, yet they introduce themes, materials and processes that have appeared in all of her work to date. The discarded hospital beds, trolleys and baby cribs from which they are constructed are all objects in which protection, care and confinement play equal parts. As is true of later assemblages, the metal bed frames in these early untitled works are partly dismembered and recombined, with missing elements replaced – in a kind of doomed repair – by less durable material, including wax, fabric, animal fibre and plastic, variously liable to melt, fray or shatter. Furniture frames translated into a kind of mournful Minimalism, these sculptures invoke bodies shelved and forgotten, or worse. In an untitled sculpture of 1986–87, the skeleton of an institutional-looking bed, its frame painted in chipped white enamel, is compressed and skewered by a metal scaffold that could be a partially dismantled bunk bed. A battered metal crib used for a 1988 sculpture has had its bars removed and

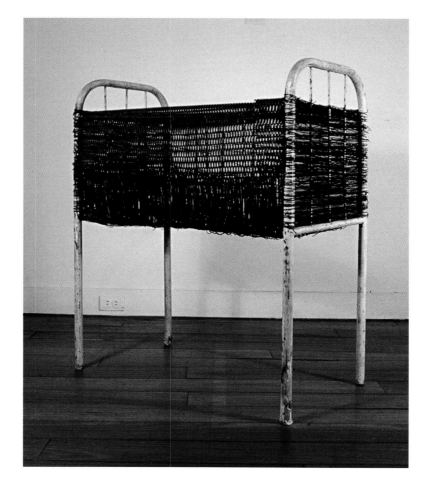

Untitled
1988
Iron, steel, wax, fabric
96 × 79 × 45 cm
Collection, Museum of Fine Arts, Boston

Untitled
1989–90
Steel, animal fibre, plaster
200 × 90 × 8 cm each

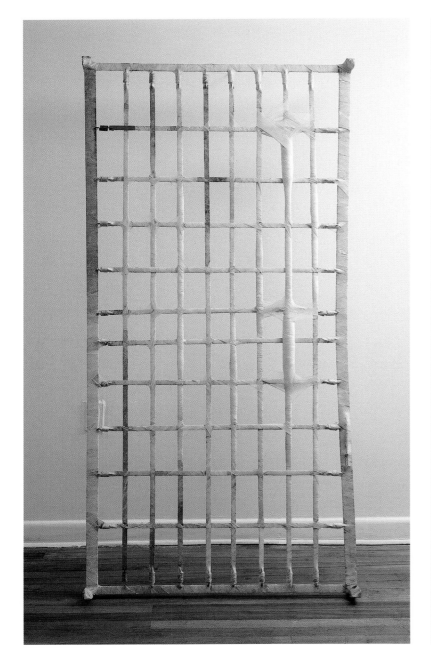 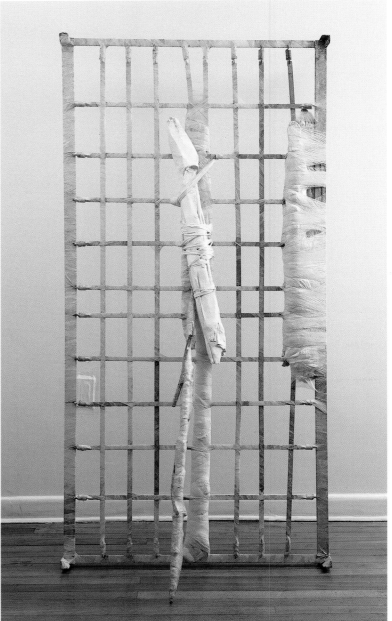

replaced with a steel mesh (plus fabric and wax) that connects head and foot boards, forming a ghostly cage that seems as inadequate to a baby's needs for comfort and support as it is impregnable.

Gridded steel bed frames, presented upright, are the basis for several untitled works of 1989–90. Some of the metal struts are thickened and extended with animal skins, forming a rough kind of bandaging. These have been installed in relation to another untitled series (1989–90) that consists of stacks of white shirts impaled on tall metal spikes. Ranging from a couple of dozen to fifty shirts high, the stacks are stiffened with a heavy coat of plaster and run through with pointed metal rods that extend well above them. Impelled, in part, by massacres in 1988 at the La Negra and La Honduras plantations, the very directness of these sculptures is a striking departure from Salcedo's other work. The shirts are more urgently evocative of human bodies than are the found materials in her preceding work. And unlike the *Atrabiliarios* (1991–96) and *La Casa Viuda*

(*Widowed House*, 1992–94) installations that would follow, there is no veil cast over the imagery here. It is subjected neither to physical displacement nor to slow emotional asphyxiation. The language of these sculptures is fiercely guarded, even to the extent that the placement of the bars carefully avoids positions where vital organs would be hurt. Folded, starched and pressed, stiff as any proverbial stuffed shirt, these stacks of clean, bright white shirts have a dignity and composure as substantial as its manifest waste; they are images of explicit refusal, of men cancelled by the metal stakes that unite them. Made to seem identical, interchangeable and two-dimensional, they are reduced, like receipts on an old-fashioned office spindle, to filed bits of information: accounts paid.

A totalitarian bureaucrat's dream of death, Salcedo's skewered shirts seem tailored by the kind of culture described in Hannah Arendt's 1969 essay *On Violence*. This is an analysis of that characteristic twentieth-century form of violence

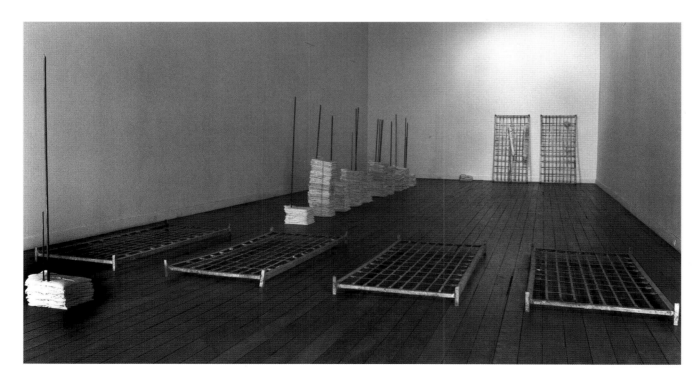

Installation, Galeria Garcés-Velásquez, Bogotá, 1990
background, right, **Untitled**
1989–90
Steel, animal fibre
200 × 90 × 8 cm each

left and overleaf, **Untitled**
1989–90
Cotton shirts, plaster, steel
Dimensions variable

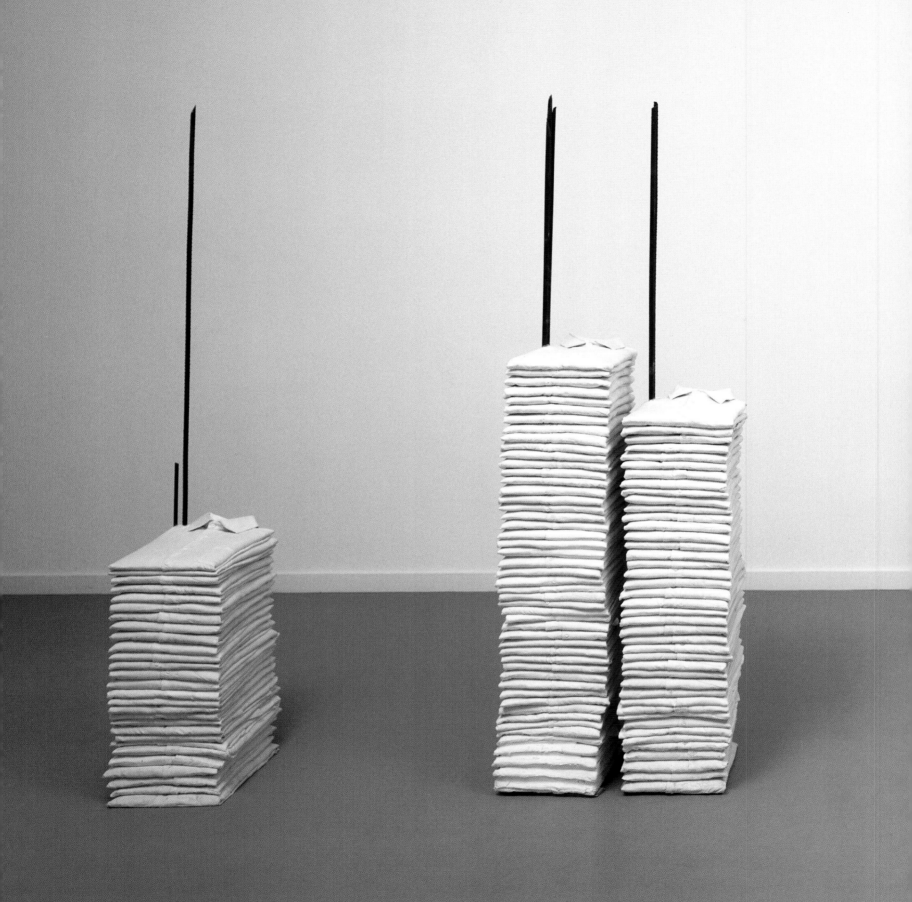

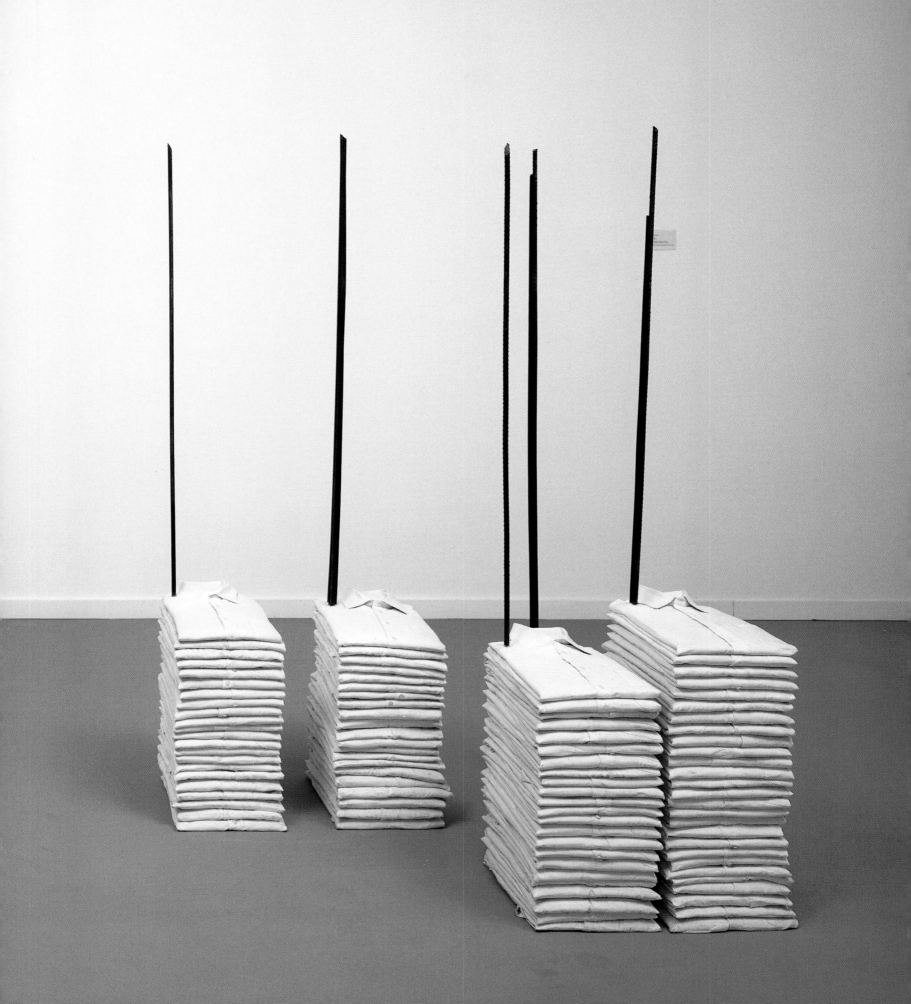

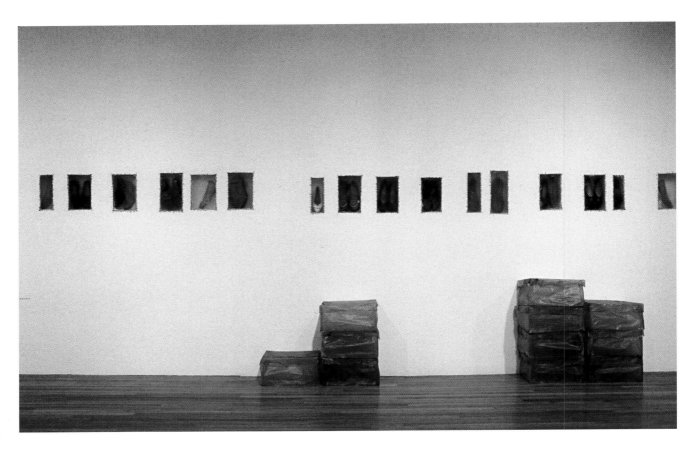

that has no avowed aim or origin, its perpetrators anonymous and victims nameless, its reign based on technology rather than real political power. While *'The extreme form of power is All against One'*, Arendt writes, *'the extreme form of violence is One against All. And this latter is never possible without instruments.'*[6] Violence, she says, is always only a means, whose ultimate end is the installation of a reign of terror. Tellingly for the present and particularly for the most volatile sites of current conflict, from Colombia to the Balkans to central Africa, Arendt continues, *'The effectiveness of terror depends almost entirely on the degree of social atomization.'*[7] And in a glance at bureaucracy that reprises her own earlier writing: ' ... *we identify tyranny as government that is not held to give account of itself, rule by Nobody is clearly the most tyrannical of all, since there is no one left who could even be asked to answer for what is being done.'*[8] Again, the applicability to contemporary conditions of political terror worldwide is unmistakable and the relevance to the anonymity

preserved in Salcedo's work is clear. Arendt concludes the essay with a word of caution about a tendency to treat violence as an organic problem, a universal, instinctual animal urge: *'It is no doubt possible to create conditions under which men are dehumanized'* – she mentions concentration camps, torture, famine – *'but this does not mean that they become animal-like; and under such conditions, not rage and violence, but their conspicuous absence is the clearest sign of dehumanization.'*[9] It is precisely this absence that is given such eloquent voice in Salcedo's work.

Atrabiliarios

By 1990, Salcedo had become closely involved with survivors of violence and with those who mourned its victims. Research and extensive field work took her throughout Colombia and led to her understanding that female *desparecidos* were often subjected to extended periods of capture before execution. Captivity, surrender, violation and death all figure, if only allusively, in *Atrabiliarios*; so too does Salcedo's first-hand encounter with the identification of corpses in mass graves by their shoes. In this series of installations (1991–96), used shoes, mostly female, are presented in wood-framed box-like niches, which are inserted into windows cut directly into walls. The niches' fronts are sealed with translucent animal fibre, stretched taut and stitched flush to the plaster with surgical thread.

At first the shoes were those of victims; those used later have no proven connection to acts of violence. Comparisons can be made, as art historian Charles Merewether has done in one of his several astute analyses of Salcedo's work, to the showing of discarded shoes at museums of the Holocaust, and also to other artists' use of such relics; Christian Boltanski, in particular, has used both found photographs and heaps of discarded clothing to evoke the enormity of loss caused by twentieth-century genocide.[10] Salcedo's use of worn shoes, though, is distinctive and involves a manifold process of transformation. The first stroke and the simplest is that by which they become relics or fetishes, standing in metonymic, part-to-whole relationship to a missing body. Merewether writes that the niches' contents in *Atrabiliarios* *'occupy a point somewhere between a relic and a fetish … As a relic they stand in for the remains of the deceased; as a fetish they become a substitute object of both identification and disavowal.'*[11] Not only in contemporary sculpture but also in traditional cultural practice there is ample corroboration of the power that clothing and other personal effects have in connecting the living to the dead. In some cemeteries in Spanish-speaking countries, the dead are commemorated in glass-fronted boxes – in the well-known nineteenth-century 'New Cemetery' on the seaward side of Montjuic in Barcelona, these are dug into the side of the hill – containing mementos of the deceased, a rather close visual parallel to *Atrabiliarios*.

As it happens, it was not an association the artist had in mind. Such niches are rare in Colombia and considered rather strange. Actually, Salcedo was thinking of the impossibility of burying loved ones, of elaborating mourning. As is expressed with exquisite circumspection in

Christian Boltanski
Reserves: The Purim Holiday
(detail)
1989
Black and white photographs,
metal lamps, wire, used clothing
Dimensions variable

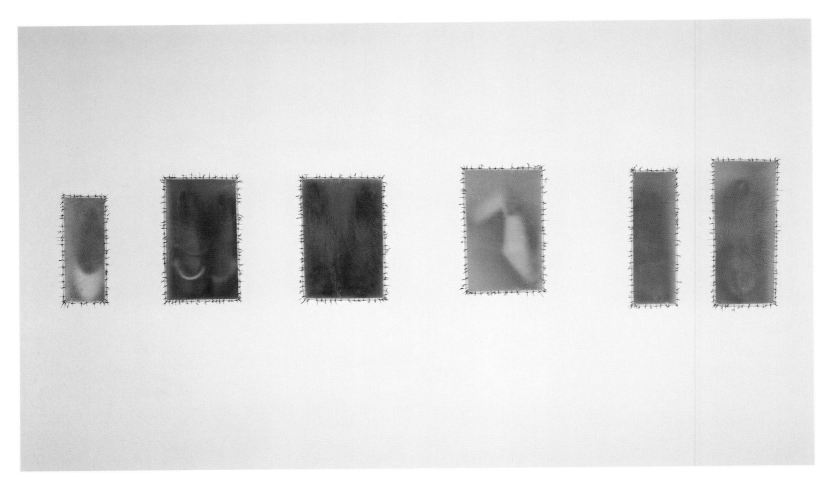

Atrabiliarios
1993
Wall niches, shoes, animal fibre,
surgical thread
Dimensions variable

the *Atrabiliarios*, violent death creates emotional abscesses for survivors that too often fail to heal and that remain the more painfully open when bodies of the dead cannot be recovered. The most important signifying function of *Atrabiliarios*, then, is the representation of an abysmal void, which Salcedo achieves at least as much by the mode of the shoes' presentation – behind windows that obscure, within walls that give way – as by the objects themselves. This presentation involves not simply a substitution of symbolic for functional status (shoes into relics, standing as fragments of lost bodies) but a more thoroughgoing change of perceived physical aspect. By being sealed off behind yellowed, finely wrinkled, glossy sheets of stretched and dried animal fibre, through which they are dimly visible as, for the most part, only

delicately tinted shadows, these intimate items become images rather than objects. They become pictorial – or, perhaps more precisely, photographic – rather than sculptural.

In so doing, they become linked to another language of disappearance. The association of photography and death is delicately elucidated by the French structuralist Roland Barthes in his study of photography, *Camera Lucida*. '*The photograph*', writes Barthes, '*represents that very subtle moment when … I am neither subject nor object but a subject who feels he is becoming an object; I then experience a micro-version of death (of parenthesis): I truly become a spectre*.'[12] A shift between animate, contingent being (subject) and image (object) is a constitutive, not simply ancillary, aspect of the photographic process.

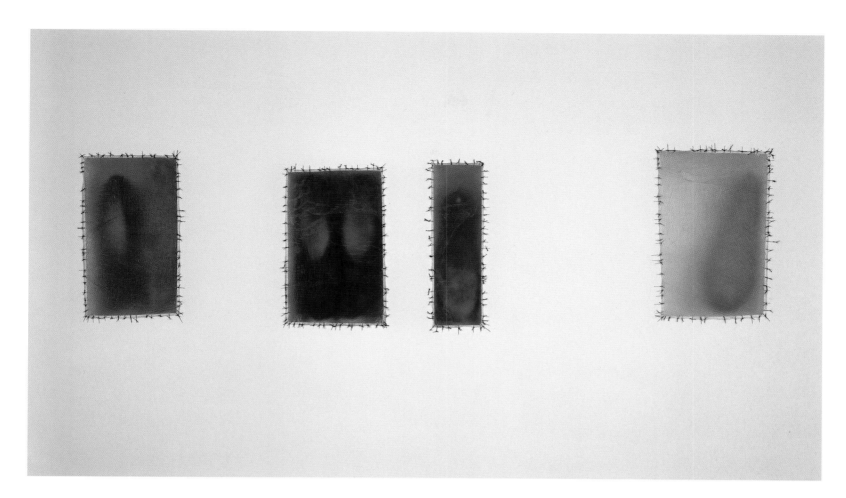

And it is registered on both sides of the lens. That is, the death of the subject is prefigured not only in every innocent snapshot, but even in the act of composing oneself for the camera. '*Photography is a kind of primitive theatre*', Barthes writes, '*a kind of Tableau Vivant, a figuration of the motionless and made-up face beneath which we see the dead.*'[13]

That photographs manifest a passage analogous to mortality itself – the passage from living body to memory fragment, in which the image sustains ('outlives') the existence of its subject – is what makes the photographic quality of *Atrabiliarios* so eerily affecting and apt. It can even be said that the process is to some extent reversible, photography serving to resurrect the living being who impinged upon the light striking the film that produced it – and in this way too the

photograph parallels an essential aspect of the *Atrabiliarios* installations' power, that part which represents, as does all of Salcedo's work, the possibility of healing and redemption along with the evidence of loss. '*What defines the originality of photography*', Susan Sontag has written, '*is that, at the very moment in the long, increasingly secular history of painting when secularism is entirely triumphant, it revives – in wholly secular terms – something like the primitive status of images.*' If Sontag is right that '*our irrepressible feeling that the photographic process is something magical has a genuine basis*',[14] it is surely a complicated magic, angry and also resurrectionary, that finds its voice in *Atrabiliarios*. The untranslatable title, now arcane in Spanish, derives from the Latin expression for melancholy associated with

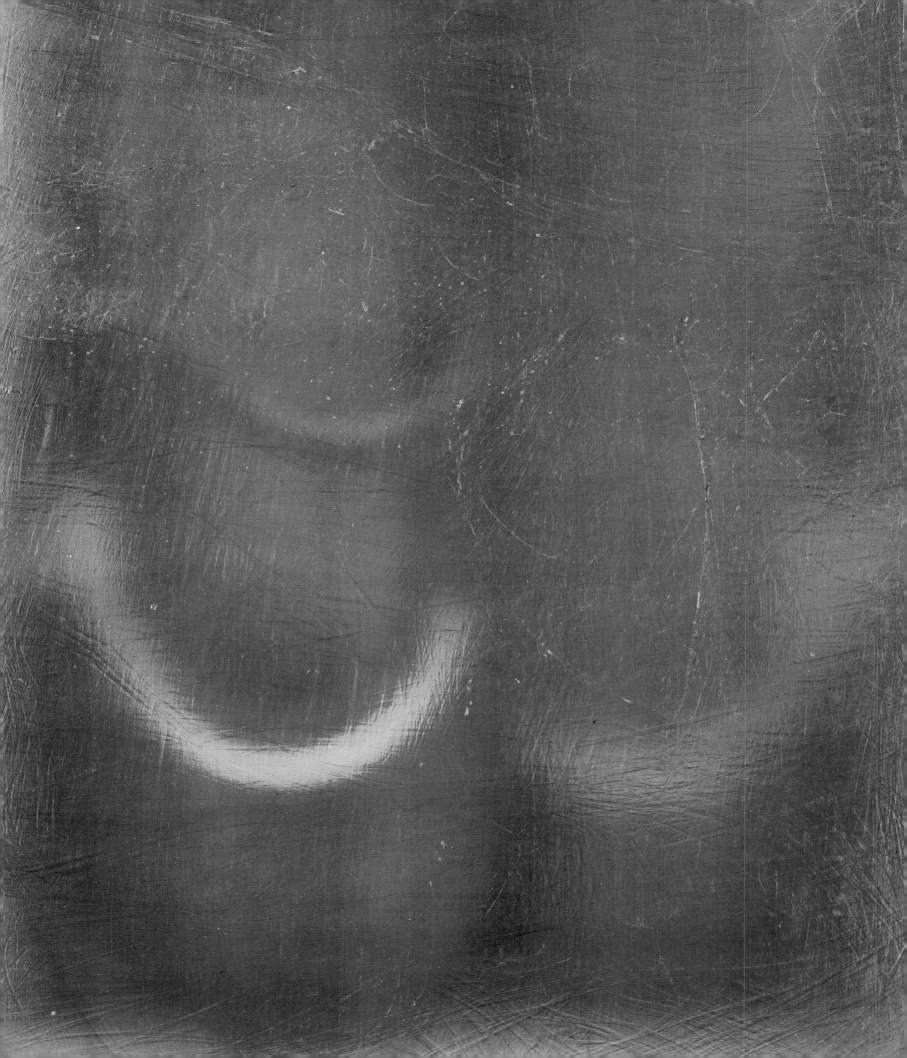

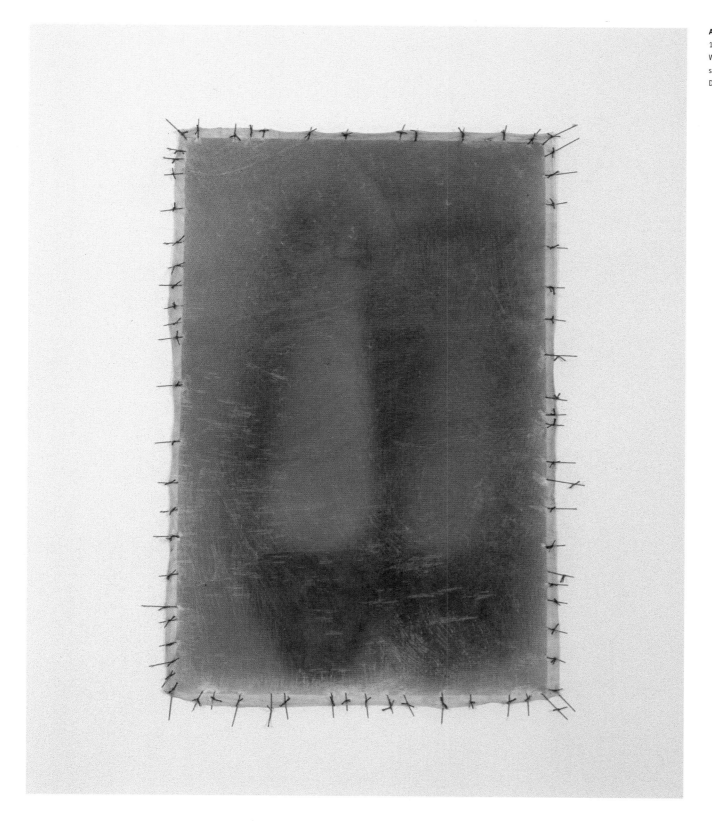

Atrabiliarios (details)
1993
Wall niches, shoes, animal fibre,
surgical thread
Dimensions variable

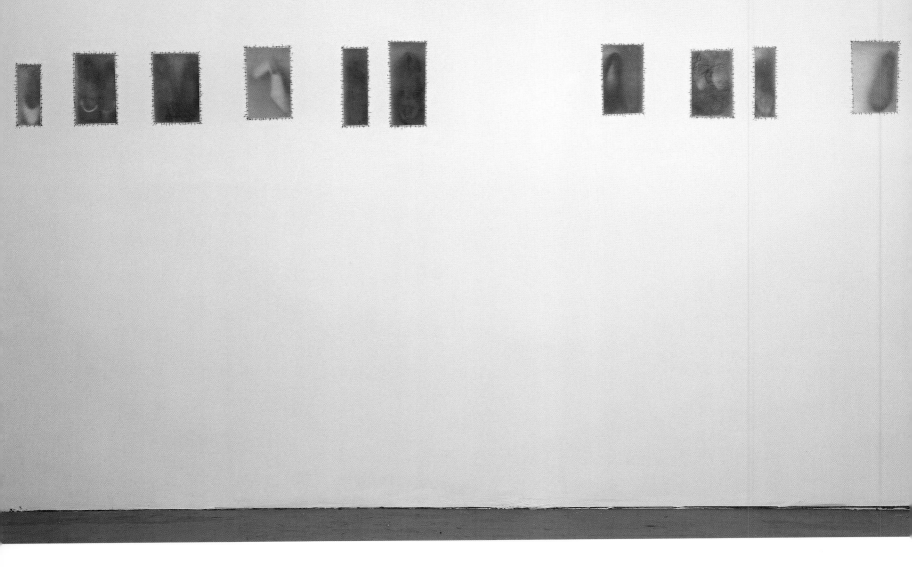

mourning, *atra bilis*, derived from *atratus* (clothed in black, in mourning) and *bilis* (bile or rage).

In addition to negotiating the opposing terms of image and object, the *Atrabiliarios* mediate a further polarity, between individuality and anonymity, the insular and the social. Here, as throughout her work, Salcedo expresses both the always exceptional nature of violence, experienced by one body at a time in catastrophic isolation, and also its (equally horrific) universality. Installed in linear sequences of niches, the several versions of *Atrabiliarios* assume something of the presence of group portraits, yellowed and faded photographs in which select characteristics are

strikingly evident and interpersonal relationships in some cases clearly suggested. All such details are minutely determined by Salcedo, who takes great care in the selection of shoes, their orientation within each niche and the size and position of the niches with respect to each other.

In one grouping, a pair of small dark pumps, leaning up, heel to toe, is separated by some distance from a similar pair in a slightly smaller niche. Close by, another narrower niche holds a single shoe, its sole forward, the tip of its spiked heel facing the viewer. A fifth niche also contains a single shoe, this time in a bigger box, which admits more light and clarity. Proceeding to the

right, a single, white pump is followed by a pair of big green shoes, boldly trimmed in white; in this company, they seem almost bawdy. The next niche contains a pair of red pumps, heels a bit apart and then a single, square-heeled, strap-back white shoe, poised rather ponderously on its toe. The last two in this sequence are harder to see, one a single narrow shoe, followed by its apparent mate, wrapped, as is true of a few other examples, in its own cocoon of animal skin, which further obscures its contours while refining its profile.

But carefully distinguished by psychological attributes as these accessories are, the dominant visual experience in *Atrabiliarios* is not of narrative coherence but of clouded vision. The yellowed skin with its web-like wrinkles makes the niches analogous not simply to photography but to photographs faded and creased with age, or to paintings whose heavy varnish has yellowed with time. Temporal distance is surely one effect of the semi-transparent windows in *Atrabiliarios*. But a stronger and perhaps more important connection is to the dimness associated with remembering trauma, which for its victims and witnesses is so often emotionally inaccessible. The blur which obscures the shoes (or, in later work, the concrete that swallows furniture), is a form not of expressive discretion but rather of brutal candour.

As described by the psychiatrist and writer Dori Laub, *'Massive trauma precludes its registration; the observing and recording mechanisms of the human mind are temporarily knocked out, they malfunction. The victim's narrative ... begin[s] with someone who testifies to an absence, to an event that has not yet come into existence, in spite of the*

overwhelming and compelling nature of the reality of its occurrence.'[15] In other words, the crisis in question doesn't take place within the continuum of normal experience: *'The traumatic event, although real, took place outside the parameters of "normal" reality, such as causality, sequence, place and time. The trauma is thus an event that has no beginning, no ending, no before, no during and no after. This absence of categories that define it lends it a quality of "otherness", a salience, a timelessness and a ubiquity that puts it outside the range of associatively linked experiences.'*[16] Philosopher Elaine Scarry describes this in even more graphic terms: *'Physical pain is not only itself resistant to language but also actively destroys language, deconstructing it into the pre-language of cries and groans.'*[17] In fact, the difficulty associated with remembering and articulating both psychological and physical terror comes to constitute an important aspect of the trauma. It is the impossibility of finding language, writes cultural theorist Cathy Caruth, that victims ultimately (lastingly) experience as constituting traumatic experience. *'What returns to haunt the victim ... is not only the reality of the violent event but also the reality of the way that its violence has not yet been fully known.'*[18] Finally, these nearly insurmountable obstacles to the recollection of a traumatic event can sometimes result in the hijacking, by trauma, of memory itself. Nadine Fresco has observed that it is *'As if one gave oneself the right to remember only with genocide as one's memory. As if the very faculty of remembering and forgetting derived from the genocide. As if the genocide alone had made you a being of memory and forgetting.'*[19]

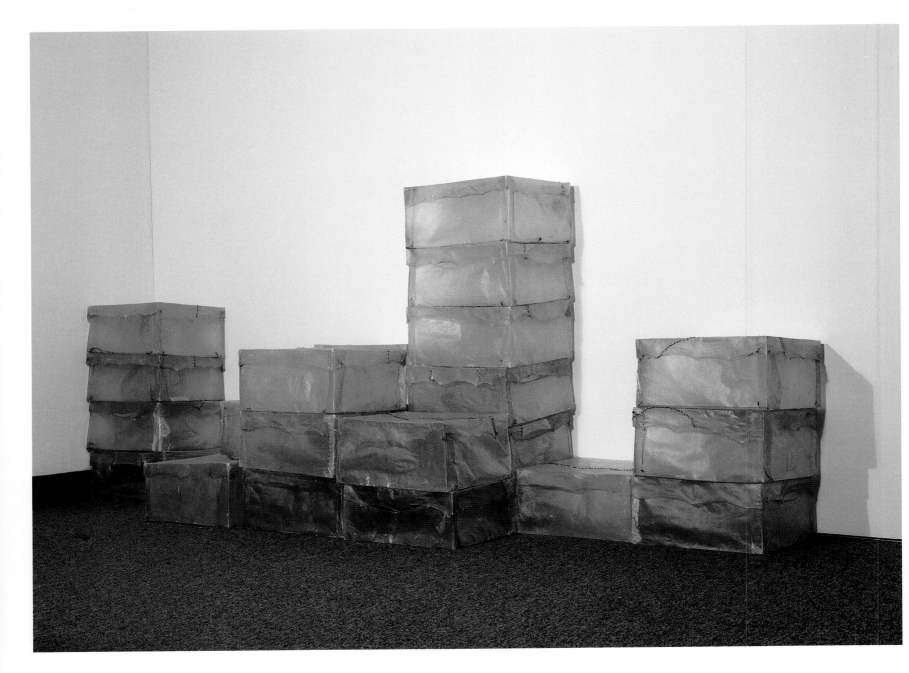

Atrabiliarios (detail)
1996
Wall niches, plywood, animal
fibre, surgical thread
Dimensions variable

In *Atrabiliarios* (and also, with varying parallel practices, in subsequent work) these monumental difficulties are expressed two ways: implicitly, in the hiddenness of the work's literal contents and also overtly, at the seam where image meets physical, quotidian context. The veiled niches may be elegant and mistily beautiful, but the sutures by which the translucent skins are attached to the wall are themselves obtuse, even crude. Tied by hand, one at a time, with black surgical thread, the stitches are carefully knotted but irregularly spaced. If imagined as repairs to the body, they are acutely uncomfortable. In other words, the pain expressed most directly in *Atrabiliarios* is not conveyed by the material contents of the memory (the shoes, the missing people they stand for) but by the attempt to join that experience to present, normal, unbroken time and place. This is the final aspect of the shoes' transformation, the effect of a nearly surreal conjunction of displaced object and daily experience.

By contrast, the boxes on the floor that are also part of some of the earlier *Atrabiliarios* installations place the whole problem at the viewer's feet, as an altogether literal impediment. Empty, ghostly versions of the wall works, shown in quantities equal to the number of niches, the boxes are made of the same material, stitched-together animal fibre stretched and dried into the shape of standard packing cartons. Their placement on the floor, in casual stacks, means they share the viewer's domain. Unindividuated, unprepossessing, their claim on our attention is only moderate. But their vacancy and their removable lids keep the subject open: while seeming to reside comfortably in the present, they speak in the future tense. They are at emotional vision's periphery, accidents waiting to happen, warily anticipated; pre-emptive, protective scars formed around wounds not yet inflicted.

La Casa Viuda

The screened memories of *Atrabiliarios* have a kind of counterpart in the installations of *La Casa Viuda*, realized between 1992 and 1995. The title invokes a lonely woman, bereavement, grief, but that is inexact, because Salcedo doesn't name the house of a widow (a residence for the single, surviving woman) but a physical structure that has itself lost a caretaker and mate, a loss by which it will henceforth be identified. The series is built around found doors, sometimes presented singly, sometimes in pairs and always compounded with dislocated parts of other heavily worn wooden furniture. Throughout, the impression they create is of passages blocked, of desires, attachments and habits frozen in place, of domestic arrangements shattered but also held together by the force of an explosion. 'La Casa Viuda *makes use of what [Robert] Smithson has called a non-place, that is a place of passage, where it is impossible to live*', Salcedo told an interviewer.[20] The connection is a little unexpected, because Salcedo works with precisely the kind of heavily associative objects Smithson forswore, but it illuminates an important link between the social conditions that shaped *La Casa Viuda* and the thoroughgoing alienation, devastation and uninhabitability evoked by Smithson's displaced fragments of the American industrial wasteland.

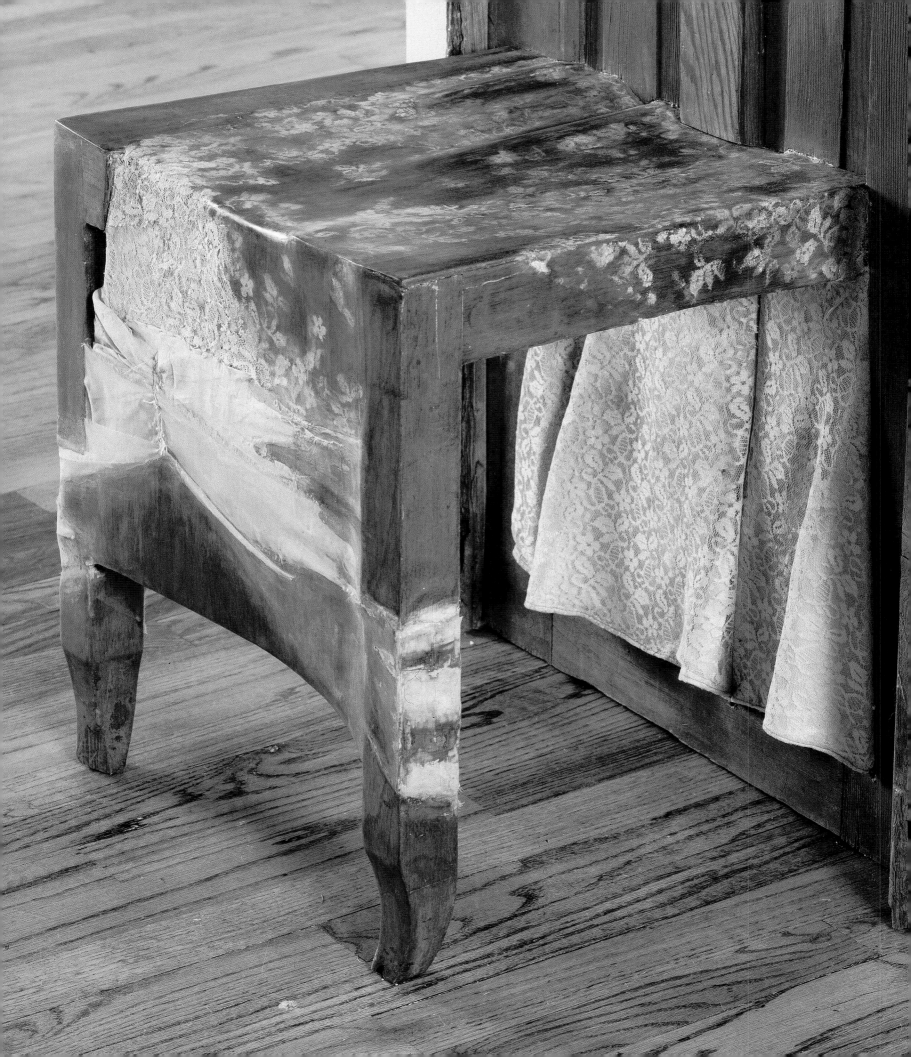

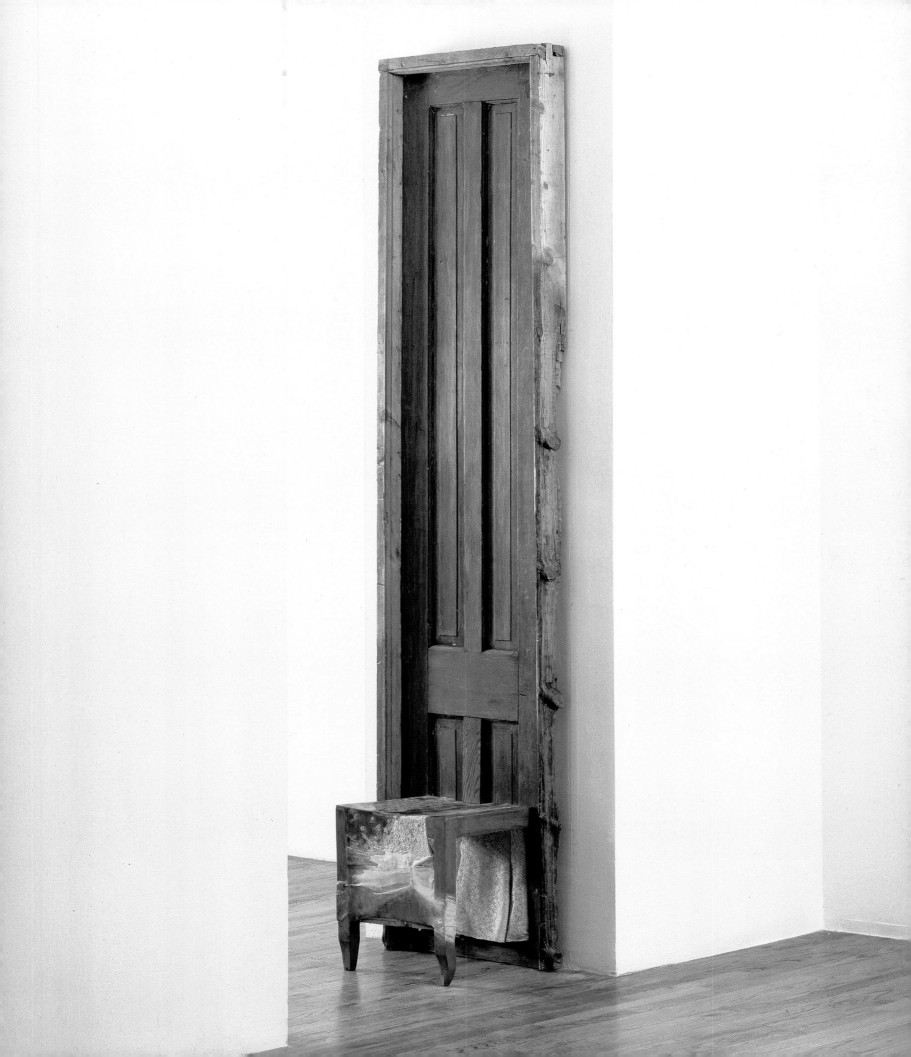

In the first version of *La Casa Viuda* (1992–94), a narrow, age-darkened door stands flush with the wall, framing a blind entryway. As a further impediment, the door is barricaded near the floor with the seat and front legs of a small wooden chair, which seems to have been pushed into the door at its knees, the chair's two front legs perched tensely on pointed feet. Across the chair's seat is laid a remnant of lacy, pale blue cloth, which hangs over its back edge to form a skirt near the door's base; it is also drawn tight around the chair's legs. The cloth that hangs under and behind the chair is relatively intact and given a pert flounce. But the bit that lies on its seat and wraps around its front legs, is worn to a state very near disintegration, the barest traces of its pattern visible as frail flowers, thin connecting tissue and thread. The fabric is acutely uncomfortable to look at, gauzy-thin but sticky, its sweet, pale prettiness mired inextricably in the meaty-looking red-stained wood.

La Casa Viuda II (1993–94) is at least as disturbing. Here, a mid-sized bureau has collided with a ghostly, whitewashed door. Along the top surface of the bureau, in the seam between two dark varnished boards, Salcedo has inserted tiny white buttons and, wedged in shallowly but painfully tight, like a splinter in flesh, a sliver of bleached bone. Running up the side of the bureau, just below its top, is a short length of metal zipper, partly open. Though small and covert, these details are clearly visible. But to describe them in terms that lead to explicit associations with the human body is slightly misleading: such links, though real, are so subtle as to seem fugitive, even

imaginary. Moreover, the most telling details seem to enter consciousness at least in part through touch (even when, as is generally the case, touching is prohibited), an uncanny effect – it's a little like seeing with closed eyes – that obtains in much of Salcedo's recent work. This rather remarkable perceptual transposition between the tactile and the visual has a counterpart in her ability to invert perceptions of animate and inanimate objects. In *La Casa Viuda* evocations of the human through garments, with their closeness and likeness to skin – indeed, references to bodies as direct as the use of bones themselves – are made to seem like inert, foreign elements in the living bodies of wooden furniture. The lace, the buttons and the bone mark sites where the skin of chairs and chests of drawers is rubbed raw; in effect these elements become, despite their obvious frailty, the instruments by which those wounds are inflicted.

In his essay 'Wound Culture: Trauma in the Pathological Public Sphere', Mark Seltzer discusses the degradation of contemporary culture caused by – and reflected in – its addicted appetite for spectacular violence. Terrifying acts of physical harm, he argues, are actually a kind of paradigm for the ultimate implosion of social relations, since they represent an extreme breach of personal boundaries. '*The opening of relation to others (the "sympathetic" social bond) is at the same time the traumatic collapse of boundaries between self and other (a yielding of identity to identification)*', he writes.[21] '*The understanding of trauma ... is inseparable from the breakdown between psychic and social registers – the breakdown between inner*

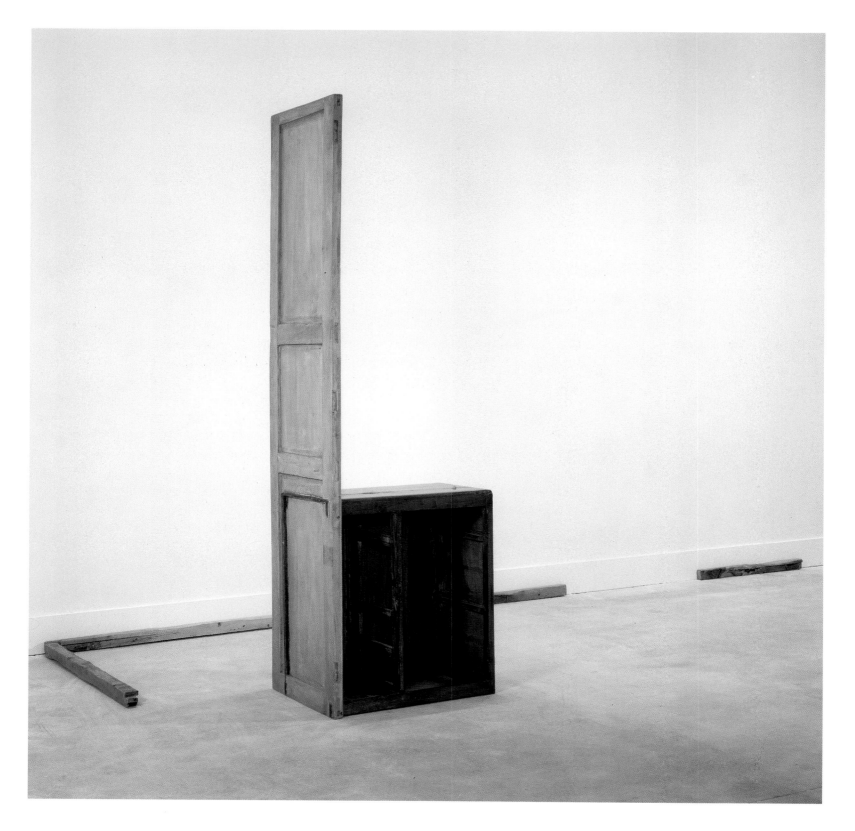

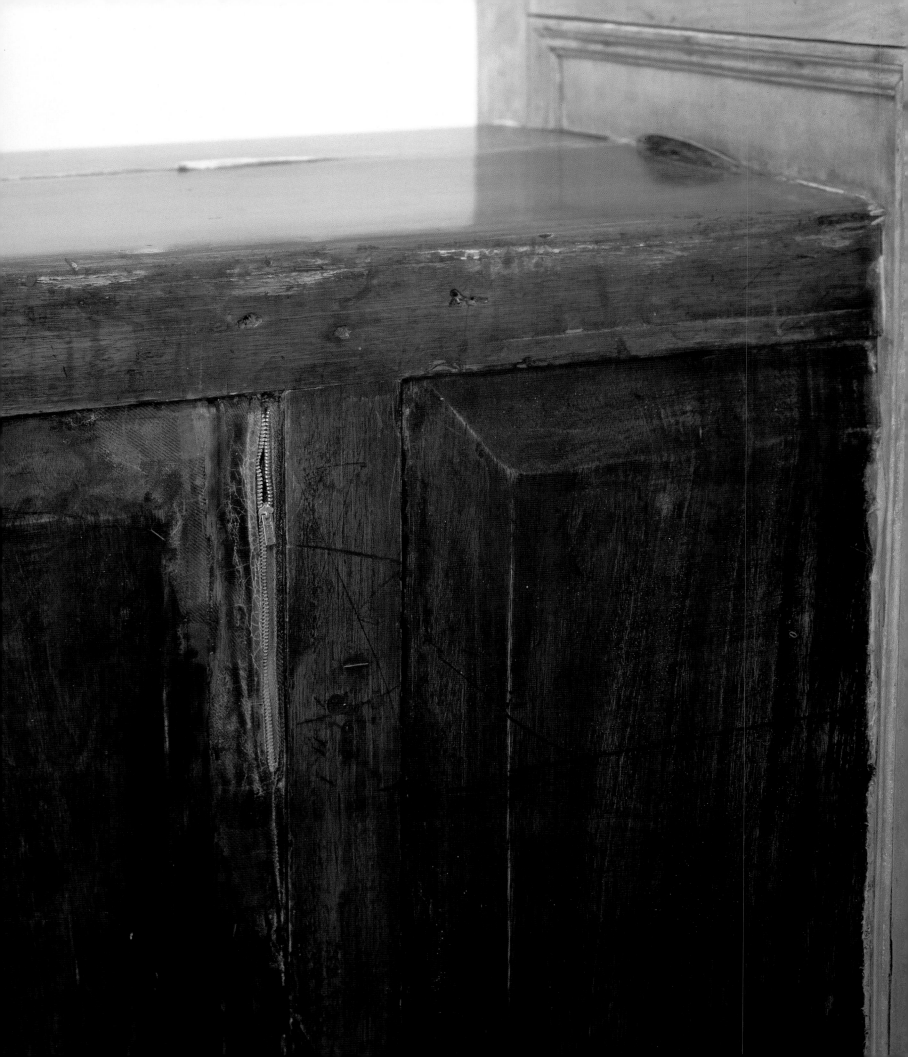

*and outer and "subject" and "world" – that defines
the pathological public sphere.'[22] In *La Casa Viuda
III* (1994), a wall is intersected by the headboard
of a wooden bed, the foot board of which appears
opposite it, across a narrow hallway. To view this
work is to stand, literally, in the place of the bed,
violating propriety in a way that makes witnesses
perilously akin to vicarious perpetrators, impli-
cated in 'wound culture' as Seltzer describes it.
Similarly, *La Casa Viuda IV* (1994) is constructed
from a narrow door, its cracked, stiffened shreds
of curtain stuck fast to a board replacing a missing
pane of glass. Paired ends of wooden bed rails are
attached on either side of the door, protruding
there like the arms of a walker for the disabled.
Here, the invitation is to project oneself through
the door – and the wall behind it – onto the bed
that would extend on its far side; barring one's
way, at eye level, is a long, slender bone inserted
horizontally into the wooden frame around the
door's missing glass pane.

Sharing Seltzer's awareness that contemporary
culture tends to compress the distance between
committing violence and subsidizing it, as a
member of the viewing public, Salcedo treads
carefully between inviting empathy and encourag-
ing projection. For every empty bed in *La Casa
Viuda*, there is a blocked passage, safeguarding
viewers against false identification. And for every
blocked passage, there is a diverted but still
potent emotional current. *La Casa Viuda VI* (1995),
a particularly elaborate construction, involves
three elements, each composed of a free-standing
door paired with one laid flat on the floor, like its
substantiated shadow. On one of these pairs is a

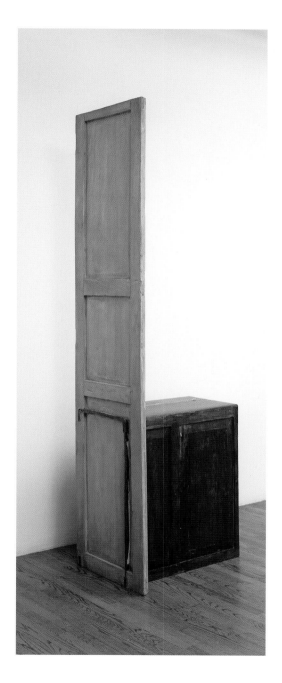

opposite, left and overleaf,
La Casa Viuda II (details)
1993–94
Wood, metal, fabric, bone
260 × 80 × 60.5 cm
Collection, Art Gallery of Ontario,
Toronto

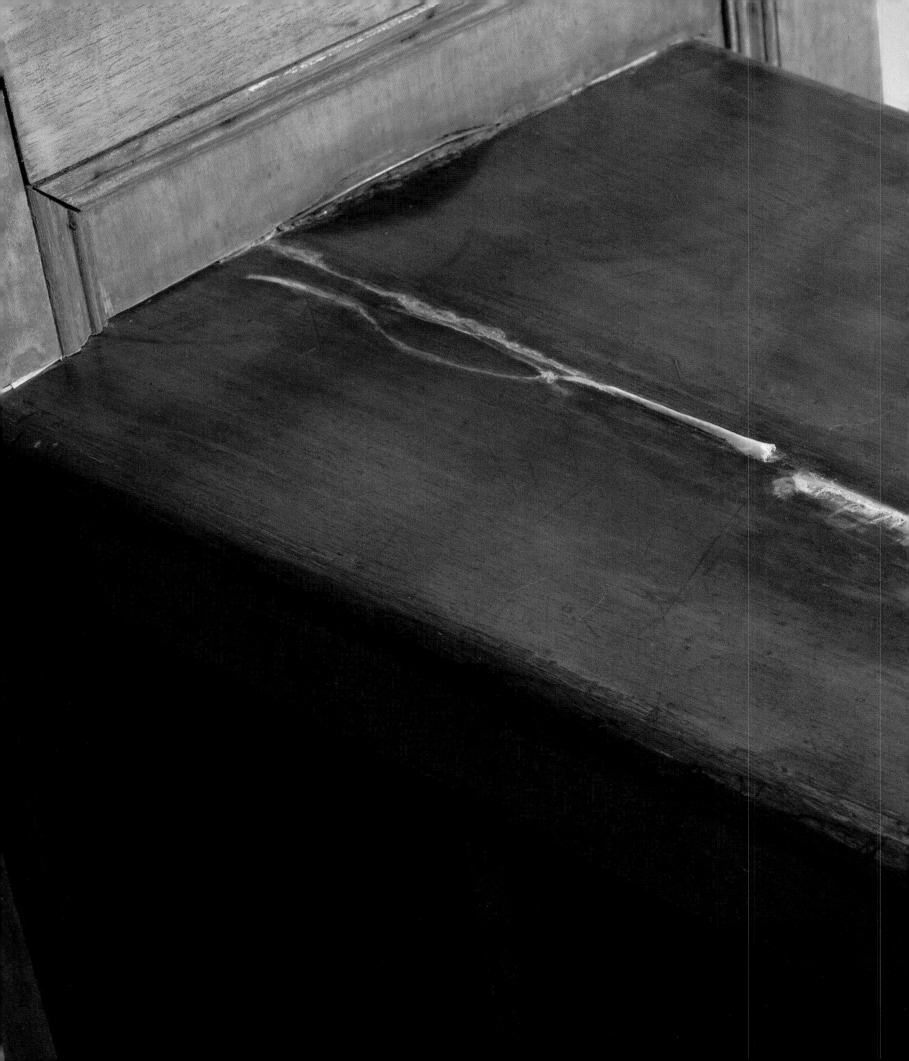

La Casa Viuda III
1994
Wood, fabric
2 parts, 258.5 × 86.5 × 6 cm;
83.5 × 86.5 × 5 cm

right, foreground, **La Casa Viuda
III**, *background*, **La Casa Viuda IV**,
Installation, 'Cocida y Crudo',
Museo Nacional Centro de Arte
Reina Sofía, Madrid, 1994

opposite, Installation,
'Displacements: Miroslaw Balka,
Doris Salcedo, Rachel Whiteread',
Art Gallery of Ontario, Toronto,
1998

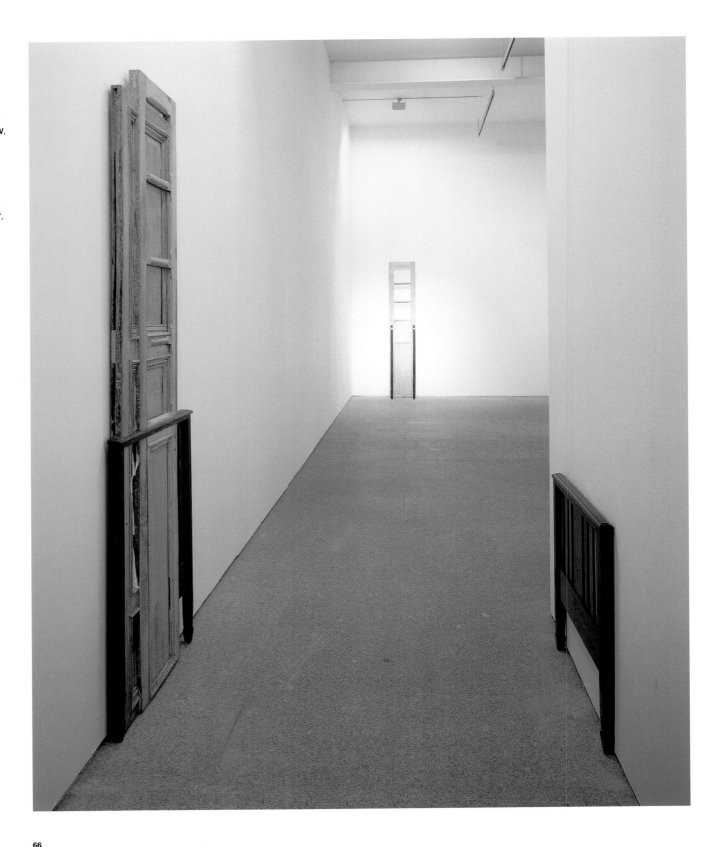

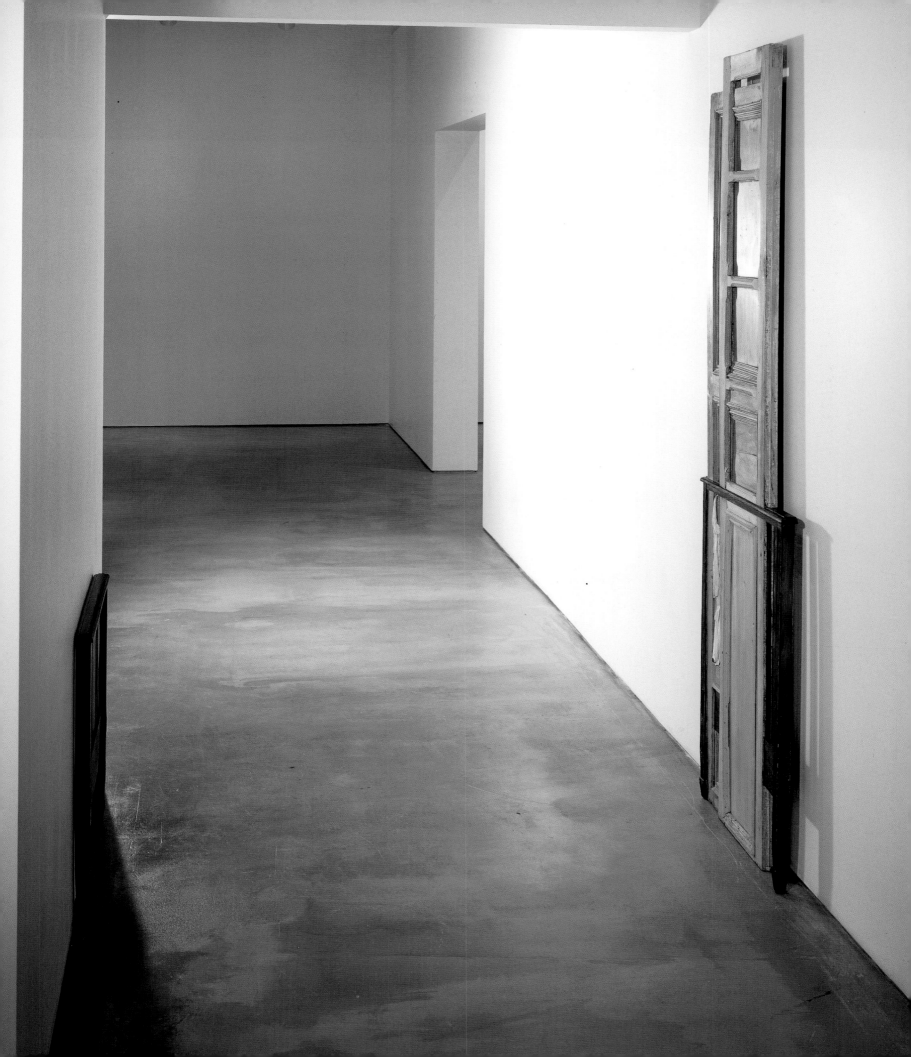

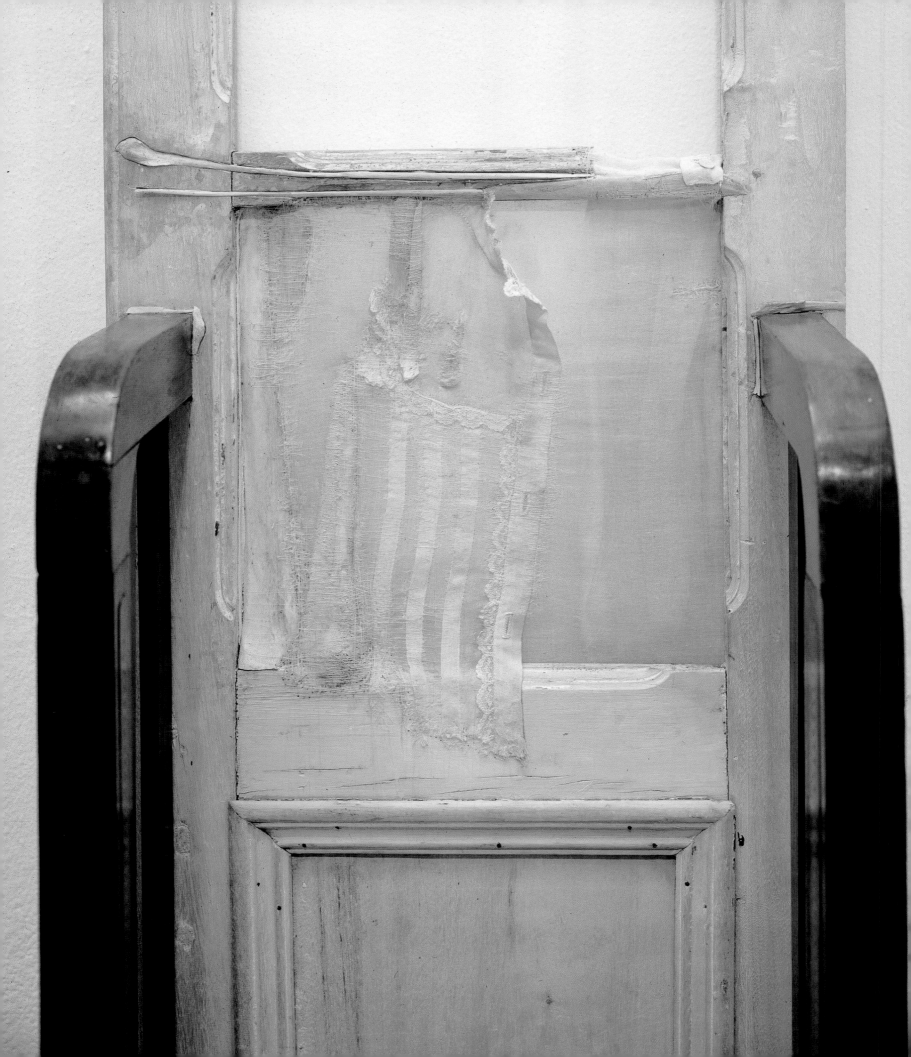

La Casa Viuda IV
1994
wood, fabric, bones
257.5 × 46.5 × 33 cm
opposite, Detail

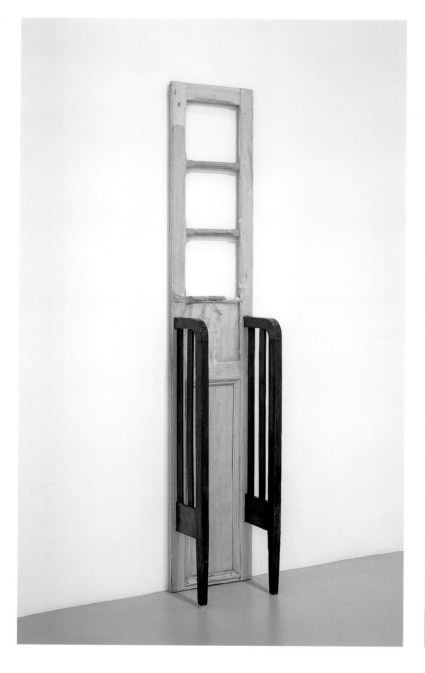

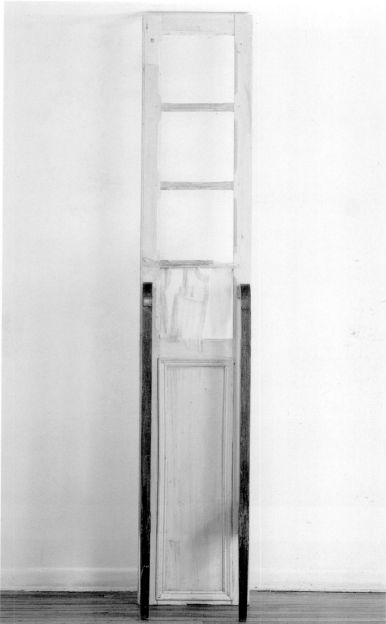

small metal seat, attached a little enigmatically to a curving length of metal pipe fitted with a metal handle. The seat, whose gracefully curving back legs are made of paired rib bones, is in fact meant to hold a child on a bicycle. Salcedo seldom makes reference to children, perhaps because the danger of sentimentality is so great. Here it is checked by the image of patent immobility. The function of the seat may not be immediately clear – indeed, even its scale is rendered ambiguous by the prevalence in *La Casa Viuda* of narrowed, blocked, shortened and otherwise attenuated furniture. But the fact of this small bicycle seat's utter paralysis, facing one closed door and rooted to another, stands for an injunction against any easy emotional reading, forcing affect, as in so much of Salcedo's work, the more potently underground. Though *La Casa Viuda*'s psychological and physical thoroughfares may be barred, its doors, Salcedo says, 'are not capable of closing anything'.[23] As with the shoes of *Atrabiliarios*, at once visible (if dimly) and unknown, or the whited-out shirts of the earlier

untitled work, the doors of *La Casa Viuda* stand for a visibility that is catastrophically stalled or blocked. The difference in this case is that the resolution it invites takes place wholly in the realm of the imagined, where memory can be reconfigured by hope.

Untitled Furniture

A closely related and ongoing body of work has involved domestic wooden furniture whose cavities – drawers, shelves, spaces for hanging clothes – have been filled with concrete that is smoothed with hand tools, leaving some prominent wooden features exposed and others submerged. Like a paradoxically lethal form of fortification or preservation, the crushing weight of the concrete would probably destroy these already battered wooden objects if they were not reinforced with threaded metal rods of the kind used in standard concrete construction; fragments of these rods protrude in places, as from ruins, or from an injured body indecorously (posthumously?)

opposite, **La Casa Viuda VI**
1995
Wood, metal, bone
3 parts, 190.5 × 99 × 47 cm
160 × 119.5 × 56 cm
159 × 96.5 × 47 cm
Installation, 'Distemper: Dissonant Themes in the Art of the 1990s', Hirshhorn Museum and Sculpture Garden, Smithsonian Institution, Washington, DC, 1996
Collection, The Israel Museum, Jerusalem
right, Detail

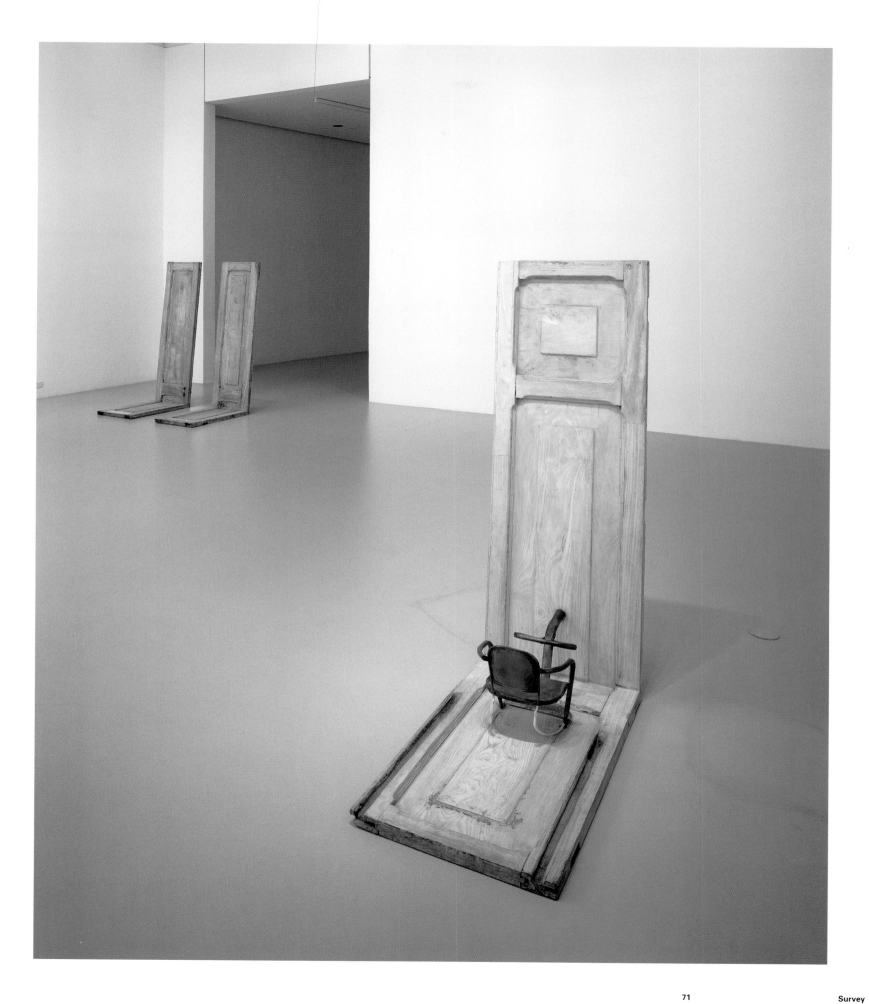

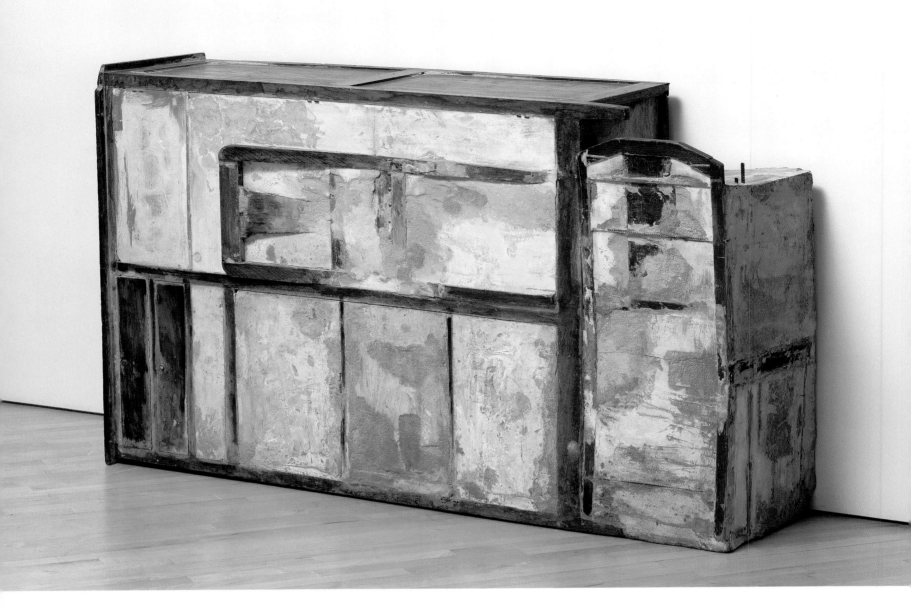

Untitled
1992
Wood, concrete, metal
114.5 × 187 × 51 cm
Collection, Carnegie Museum,
Pittsburgh

revealed to have prosthetic internal pins and metal plates. By contrast with the industrial associations of concrete and metal reinforcing bars, the wooden furniture seems to have a human quality – even more than in the installations of *La Casa Viuda*. The difference is the more striking as there are only scant remnants of clothing in these pieces. The strongest impression the work creates is of inescapable gravity: the dignity of the ponderous, massively self-effacing forms is precisely commensurate with the weight (physical,

emotional) they bear. Blinded, bound, even entombed, they are nonetheless monuments of steadfast and eloquent composure.

The range within the series is considerable, each individual work having a personality as distinct as those suggested by the shoes of *Atrabiliarios*. In one early example (1992), a chest and a chair are joined side by side, the seat of the chair weighted with a box-shaped load of concrete, metal rods protruding from its top. Isolated chairs appear both early (1992) and further into the

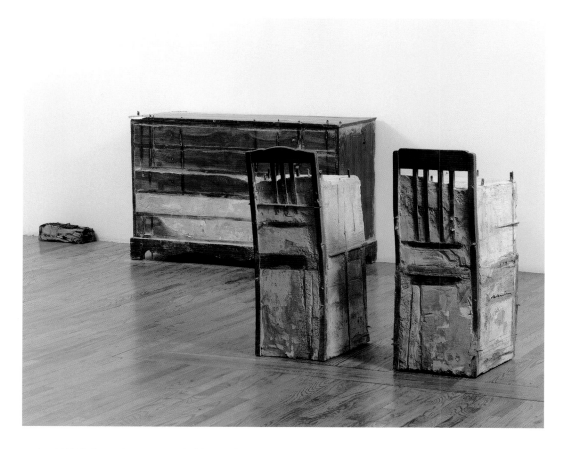

Installation, 'Matthew Benedict,
Willie Cole, Jim Hodges, Doris
Salcedo', Brooke Alexander, New
York, 1993
l. to r., **Untitled**
1989–92
Cloth, concrete, steel
13 × 34 × 17 cm
No longer extant

Untitled
1992
Wood, concrete, metal
89 × 138 × 53 cm

Untitled
1992
Wood, concrete, metal
95 × 41 × 41 cm

Untitled
1992
Wood, concrete, metal, cloth
97 × 43 × 43 cm

series (1998), in each case occupied by a volume of grey, inert concrete, the graceful, slender profiles of the chairs most legible from the sides or the back, as supple, swaying spines. More complex examples from the early and mid 1990s involve furniture compounded in ways that include (as in the metal sculptures of the late 1980s) dismemberment and interpenetration. A chest is turned on its side, the back of a chair emerging from its concrete-plastered front; alongside it is another, upright wooden chair, shown with its back to us and embedded in a block of concrete. A 1995 work is constructed of a concrete-smothered chest and, placed atop it, two small wooden chairs, their slightly bowed, sorely battered backs facing front, their seats piled with blocks of concrete and riddled with metal rods. Upended or pushed to the floor, stacked, stuffed, blocked and made to face the wall, these long-suffering furnishings have been deprived of function in the most merciless ways. Yet such manifold acts of repression have only stiffened their resolve and made them seem

Untitled
1995
Wood, concrete, steel, cloth,
leather
241.5 × 104 × 46 cm
Collection, The Museum of Modern
Art, New York
opposite, Detail

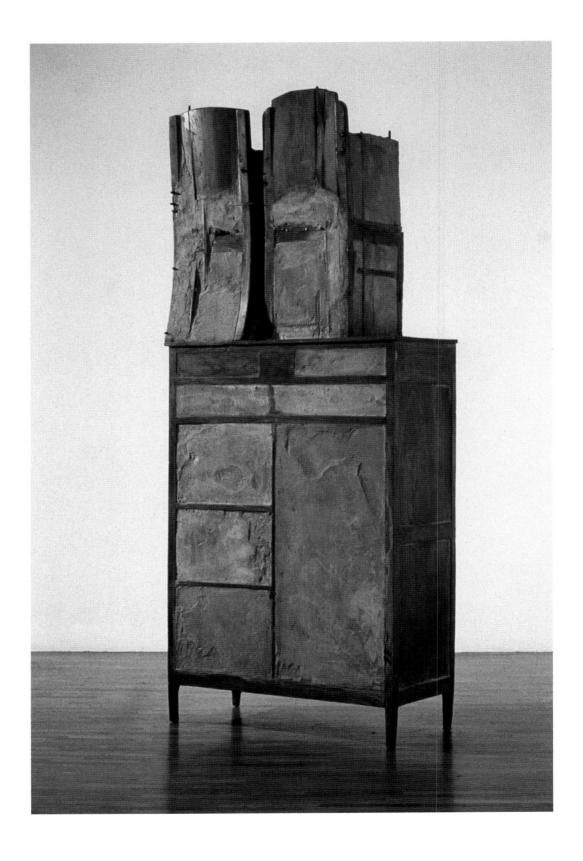

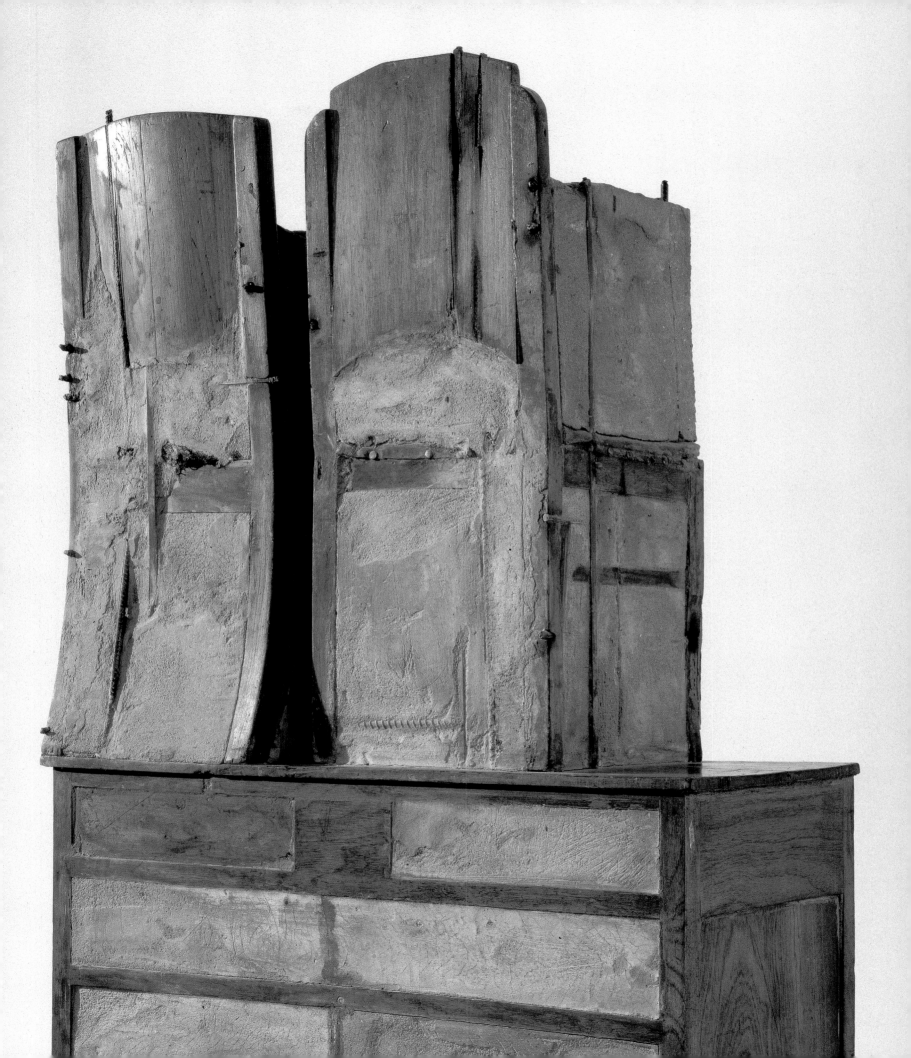

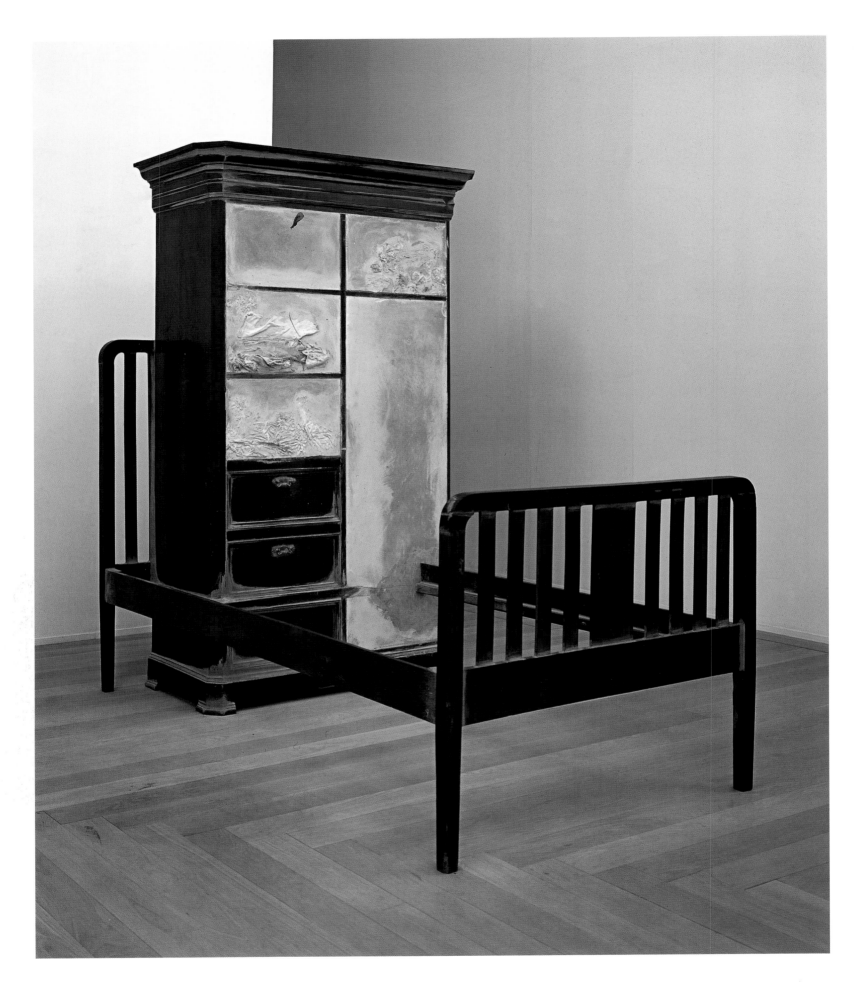

Untitled
1997
Wood, concrete, fabric
Approx. 198 × 122 × 188 cm
Collection, Moderna Museet,
Stockholm

the more obdurate, given them a fullness of purpose equal to the material burden they bear.

Also beginning from 1995 there have been a particularly imposing series of sculptures in which a massive armoire stands in front of the headboard of a skeletal bed and straddles its empty frame, forming a strong upright presence where the mattress – the bed's occupant – should be. A tableau of family life unusually open in expression and spatial disposition, it admits a breath of air but holds it in a silent, protracted inspiration. A slightly later work (1998) is less complicated structurally, though no less psychologically fraught: with uncharacteristic near-symmetry, Salcedo has filled the frames of a double-doored, glass-fronted chest with concrete, in which crumpled shirts are just discernible, pressed against the panes like bodies piling up behind windows that are stuck fast.

The sizable role furniture has played in recent art can be accounted for, in part, by its neatly bifurcated significance: it both stands for the absence of the body, by so clearly indicating a place where it might be (but isn't) and at the same time anthropomorphically represents that missing body, particularly in the case of chairs (with their backs, seats and feet) and beds (head and foot boards). This rudimentary range of signification is just a starting point for Salcedo, in whose *La Casa Viuda* and untitled furniture sculptures the two faces of this signifying pair ease into each other's features: the furniture seems most indicative of absence when it is most literally flesh-like, that is, when its figurative skin and bones are most exposed, vulnerable and frail.

Physical embodiment means susceptibility to self-betrayal, because the claims of the body, particularly the body under duress, are imperative and absolute: 'Pain is not "of" or "for" anything, it is itself alone', writes Elaine Scarry.[24] While imaginary absence from the injured body becomes a kind of refuge, the recovery of physical dignity is the goal of any organized thought still possible while pain holds sway. In Salcedo's untitled concrete furniture, the body is evoked as through a kind of multiple exposure of these competing claims, at once displaced (preserved, imaginatively) and grounded (made vulnerable), humanized (clothed and cared for; wounded) and objectified.

Though *La Casa Viuda* and the untitled furniture series can be considered together with respect to these issues, there are important distinctions between them. The first shows the furniture of daily life worn to near transparence by the lives it first shelters and then fails to shelter – the traces of that failure tattooed on its very skin. By contrast, the untitled furniture creates an imagery of equally doomed thickening, of spaces muffled with concrete until they are irremediably mute. This untitled work has a kinship to the casts that English sculptor Rachel Whiteread has made of the insides and underneaths of various domestic fixtures, from desks and chairs to substantial rooms and even, in one case, an entire London terraced house. Filling empty space with resin or plaster, Whiteread creates literal impressions, records of close attention that are also images of absolute immobility. Like Whiteread's, Salcedo's calcified furniture makes a literal tactile trace – an incontrovertible physical memory – into a figure of

Rachel Whiteread
Closet
1988
Plaster, wood, felt
160 × 88 × 37 cm

Piet Mondrian
Composition
1929
Oil on canvas
52 × 52 cm

Untitled
1997
Wood, concrete, fabric
185 × 157.5 × 59 cm
opposite, Detail

deathly deep forgetfulness, a well without echoes, ripples or reflections. The radical muteness of Salcedo's concrete furniture also has ties to recent work by Krzysztof Wodiczko, in which volunteer subjects wore sleek aluminium-cased video monitors strapped to their mouths, on which were projected their own narratives concerning the experience of immigration. Expressive devices that gagged their subjects as they spoke, Wodiczko's *Mouth Pieces* (1995) forced language and silence to occupy the same place, much as Salcedo's work does. That the narratives at issue are intimate and politicized in equal measure also links Wodiczkco's project to Salcedo's, as does his active and ongoing resistance to the use of civic space and public speech for conventional rhetoric. Traditional public monuments 'are the very failure

of memory', Salcedo said in a 1998 interview;[25] her alternatives include work that can be seen as a particularly subversive form of public burial, radically oppositional rituals in which bodies refuse interment, their incompletely covered fragments of sinew and flesh maintaining the most voluble of silences.

But in Salcedo's recent untitled concrete furniture there is a shift away from this kind of agonized physicality and towards an even more confounding immateriality. In the work from this series completed in the late 1990s, she has made several sculptures in which the smoothed concrete surfaces are broken by spectral facades of fraternal twins, ghostly parasitical siblings that protrude obliquely from the ashen skin of their hosts. In one example, a fragment of a chair's back emerges from a bureau, which an application of concrete between its wooden ribs has made as pure and simple in its geometry as a painting by Mondrian. In another, a blond oak chest emerges from the perfectly impassive, concrete-smothered face of a standing bureau. Two tall, slender cupboards step out in a stalled, side-by-side procession from one large armoire, the edge of an up-ended table is embedded like a fossil in the concrete face of another. As is always true of Salcedo's work, the attention to detail is such that, even on close inspection, surfaces and forms emerge very slowly. In one sculpture, a seemingly single armoire reluctantly discloses its mate, as if remembering it with difficulty; on a different scale, a short strip of wooden moulding gradually reveals itself to be composed of at least three similar patterns, the breaks between them almost indiscernible, like

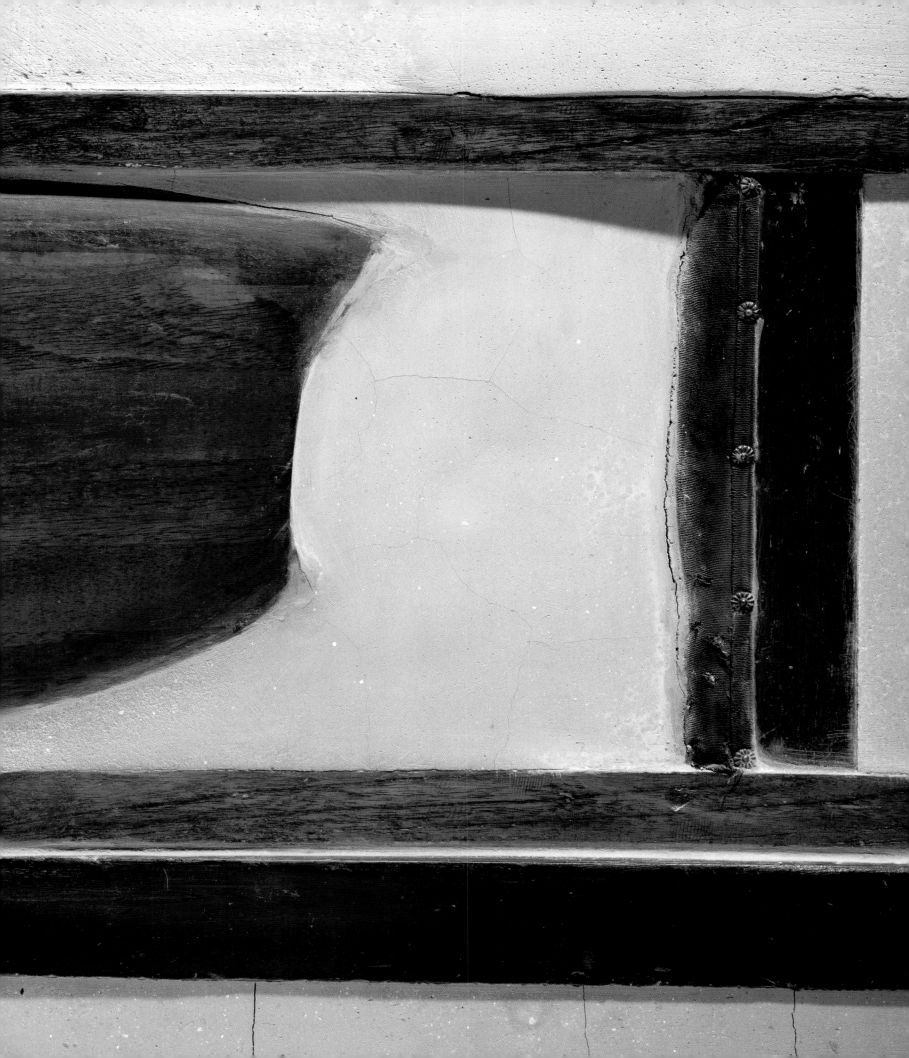

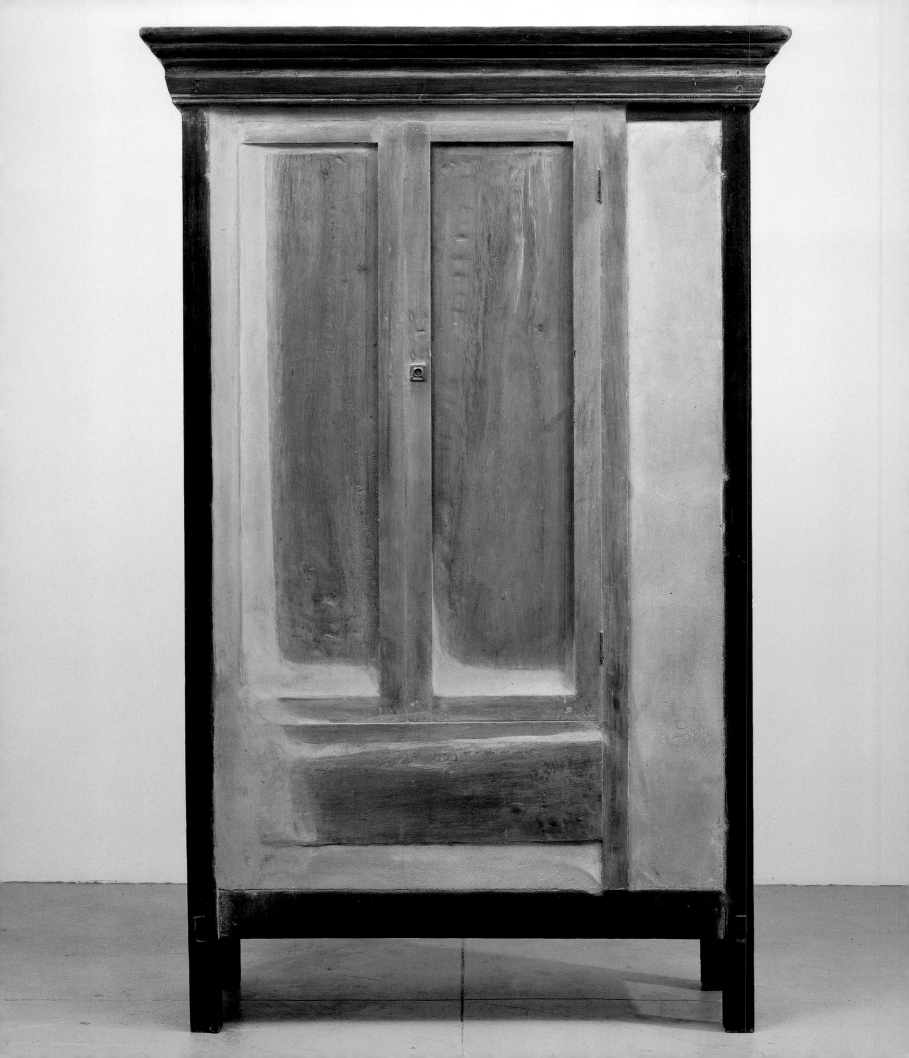

a melodic motif repeated in three fractionally different registers.

The results of heroically patient labour, such hesitantly divulged details require considerable exertion of focus and attention from the viewer as well. In *The Aesthetics of Disappearance*, theorist Paul Virilio states that advanced culture is characterized by a degree and prevalence of speed – he refers to the velocity of projected imagery (cinema), of transmitted information (digital communication) and of ever more accelerated travel itself – that has progressively eroded perceptual stability; Virilio argues, in fact, that contemporary culture not only allows for, but is ultimately defined by this new order of visibility. 'Speed treats vision like its basic element', Virilio writes.[26] Salcedo, too, is deeply and increasingly interested in the 'aesthetics of disappearance', in threshold conditions of perceptibility. And the violence that is implicit in Virilio's discussion of speed (elsewhere, he makes it explicit) strengthens the connection between his consideration of the urge towards invisibility and hers. But in her recent untitled furniture it is a kind of absolute zero of movement, an impossibly frozen moment of unending impact expressed as immutable stasis – an immobility to which the stiffened shirts, blocked doors and embalmed shoes of earlier work had pointed – that makes things tend to disappear into a state of altogether paradoxical dreaminess. Here a relevant body of public work can be found, perhaps, in Felix Gonzalez-Torres' untitled stacks of offset prints, offered to exhibition visitors at no charge. Images, often, of emptiness – blue skies, unbroken expanses of sand – they run eternity and

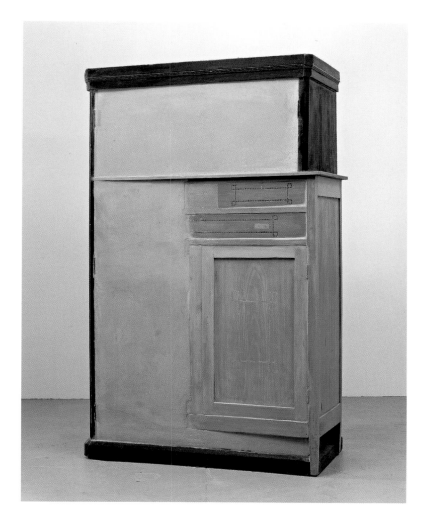

opposite, **Untitled**
1998
Wood, concrete, metal
200.5 × 124.5 × 51.5 cm

left, **Untitled**
1998
Wood, concrete, metal
210 × 129.5 × 100 cm
Collection, Albright-Knox Art
Gallery, Buffalo

mortality together, with ephemera given away freely, forever. The generosity of this work, as much as its transcendent serenity in the face of unending loss, seems close in spirit to that of Salcedo's sculptures which transform the most obdurate of materials into visions as blank and yielding as clear sky.

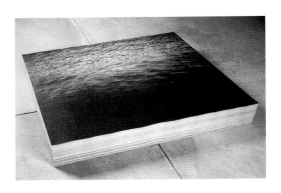

Felix Gonzalez-Torres
Untitled
1991
Offset litho on paper, endless
copies

Unland

The untitled furniture has often been installed in dense groupings that emphasize family connections among the individual works, for example in the Carnegie Museum, Pittsburgh, at the Carnegie International (1995) and in Liverpool Cathedral, at the Liverpool Biennial of Contemporary Art (1999). Suggesting well-worn residences and the lives they support, such installations powerfully evoke the unseen calamities that have turned these homes into warehouses or morgues. At the Museum of Modern Art in New York, on the other hand, an untitled furniture work was exhibited alone, one of the few recent works included in the museum's first, three-part ('People', 'Places', 'Things'), millennial re-installation of its collection. Moreover, Salcedo's work appeared not in the section designated 'Things', but 'Places'. It was a telling decision. Less a species of object than a marker of crossroads, the furniture speaks for both the political condition of a particular place and a universal intersection between human use and the forces that compel or impede it, a record palpable as scar tissue. But the decision to associate Salcedo's work with issues of place has further ramifications, which have been articulated even more clearly in her recent sculpture. Making physically massive, emotionally loaded objects – a chest, a door, a wooden work table – seem to disappear before one's eyes is a feat of displace-ment that parallels the cultural and, especially, emotional alienation with which the recent work, *Unland*, is concerned. The three sculptures that make up *Unland* relate to the writing of the exiled Jewish poet Paul Celan, who was a survivor of the Nazi Holocaust, and also to the unappeasable homelessness that has resulted when Colombians' birthplaces have been invaded by loss.

Unland: the orphan's tunic (1997) is made from the halves of two long, plain wooden work tables, of slightly different heights, grafted to each other at the centre. Towards one end, the surface is inflected by what seems at first the merest shadow but on close inspection is shown to be a methodi-cally applied net of black hair, sewn like a human transplant into hundreds of tiny follicles laborious-ly bored into the wooden skin. The narrow band of hair gives way, in turn, to a nearly translucent layer of minutely tattered silk, a cocoon (silk is, of course, also an animal product) that shades the transition between the uneven tabletops and slips like stockings over the table's legs. *Unland: irreversible witness* (1995–98) supports at one end a baby crib laid on its side and sunk, just barely, into the table top, its bars shrouded in silk and human hair. The surfaces of the conjoined tables are covered in layers of hair, silk thread and more hair, the last combed straight across its width. In *Unland: audible in the mouth* (1998), the tables are of equal height, the transition between hair and thread even more subtle. The three compon-ents of *Unland* are meant to be seen together, with uniform light and ample room, the dim and austere installation amplifying their considerable visual reserve. Each relates to a specific incident of violence in Colombia, but that information is not provided.[27] 'I do not illustrate testimonies', Salcedo said in response to a question about *Unland*.[28] Nor, she says, does she '*try to control the*

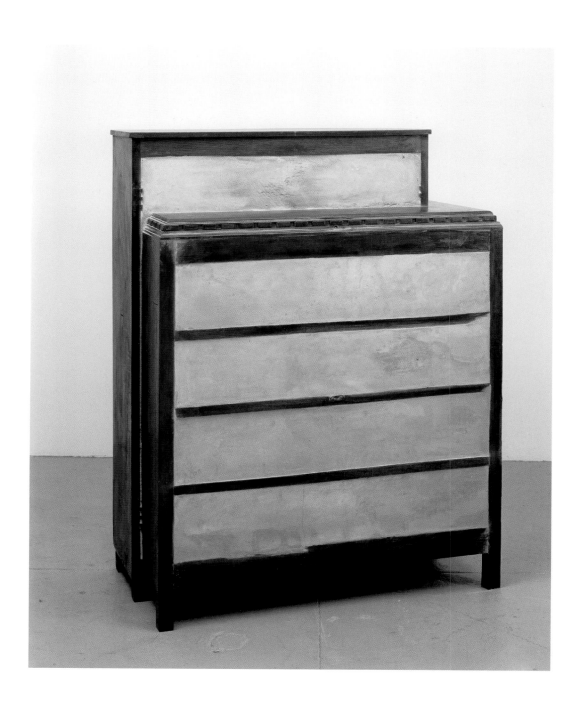

left, **Untitled**
1998
Wood, concrete, metal
$151 \times 116 \times 57$ cm

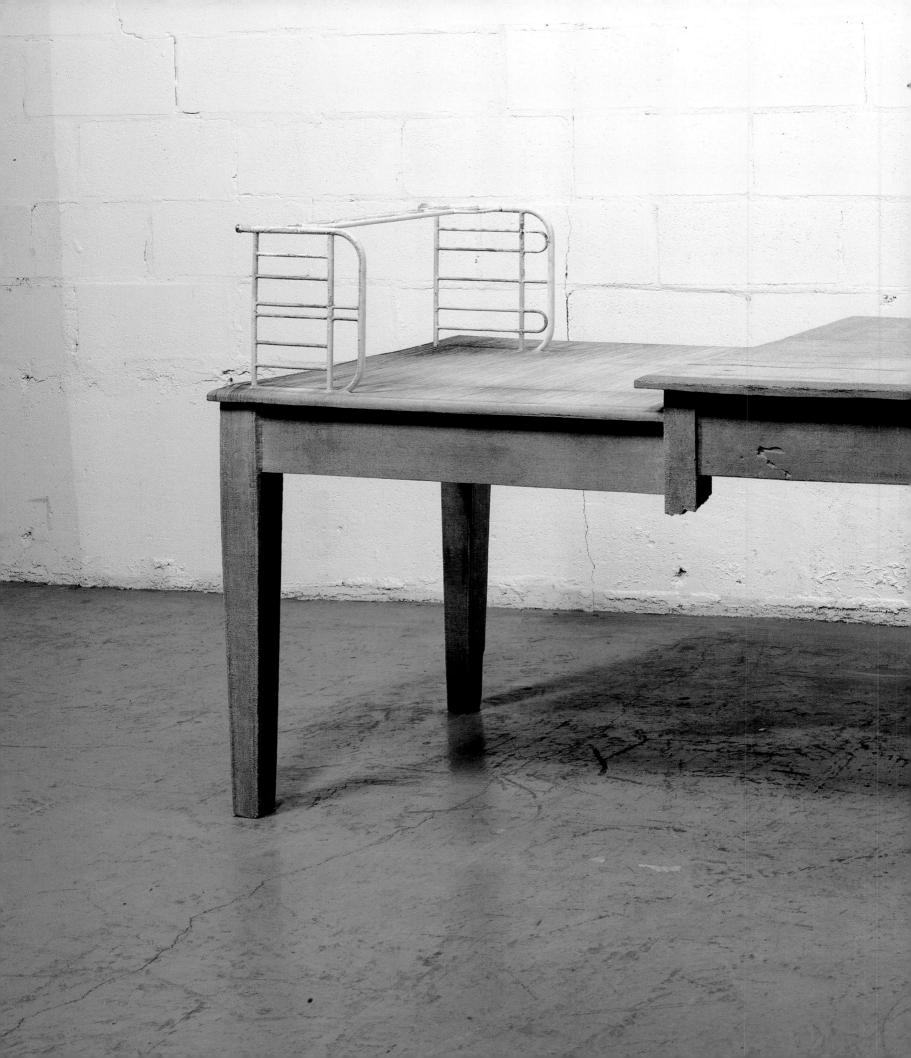

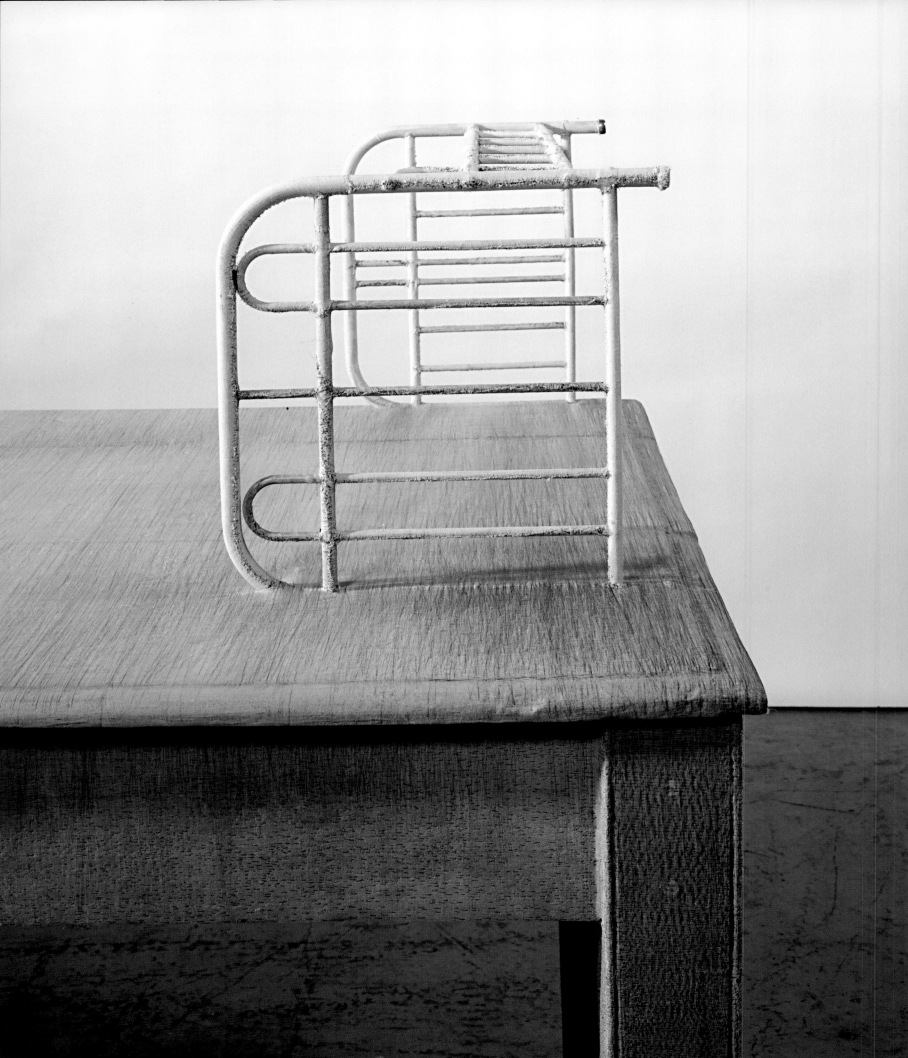

experience of the viewer. I simply reveal — expose – an image. I use this word expose (exponer) *because it implies vulnerability.'*[29] The hair shirts worn by the tables in *Unland* are penitential, slightly harrowing, but also protective, at once frail and vulnerable (exposed) and, like a film frame that has become a photo, finished (exposed).

The *Unland* works are also situated at perception's threshold and at a passage from the language of solid, inert material to another, less reliable species of visible form. In a reprieve of the effect of *Atrabiliarios* and also of some of the later concrete furniture sculptures, they are objects that seem to be in a state of transformation from solid to image. But the images towards which they incline are still less substantial this time, less substantial even than shadows, which are known by the surfaces they strike, while *Unland*'s horizontal planes are shifty, interrupted at levels both obvious (the step from one table to the next) and nearly microscopic. More dematerialized even than photographs, they are closer to holographs, but nearly lightless; visions hovering, again, between sight and touch. In this body of sculptures (as in much previous work), Salcedo shows common purpose with the American installation artist Ann Hamilton, who has made walls weep and sweat and caused floors to ooze honey, or spin, or grow hair. Describing her interest in cross-wired, inter-sensory perception, Hamilton has recommended 'letting the work work on you up through your body instead of from your eyes down',[30] as Salcedo's so often does. And Hamilton, too, has often made tables perform in installations as both working surface and human

surrogate, finding in them a form that – to cite an essay by philosopher Philip Fisher much admired by Hamilton – is 'uniquely adjusted to the radius of the human will'.[31]

For Salcedo, though, the interest is the greater where the efficacy of human will is least certain. Vulnerability and nakedness, skin that is flayed and cribs upended are metaphors she shares with Celan, who is quoted with uncharacteristic directness in the subtitle of one of the *Unland* sculptures:

'Night rode him, he had come to his senses,
the orphan's tunic was his flag …
it is as though …

the so-ridden had nothing on
but his
first
birth-marked, se-
cret-speckled
skin.'[32]

The first, secret, birth-marked skin that is the orphan's tunic and his semaphore, signal of an understanding he has come to only in darkness, is remarkably evocative of *Unland: the orphan's tunic* and also of *Unland: irreversible witness*, with its spectral infant, spilled onto a dark, yielding surface. As a survivor of the Holocaust who lost most of his family in the Second World War, Celan wrote poetry in which language was waged against itself, wound so tight it fractured into isolated words and then pieces of words; Celan's is a poetry that despairs of meaning. The negative prefix

Ann Hamilton
Whitecloth (detail)
1999
Mixed media installation;
electrical and mechanical
components, wood, silk, glass,
metal, video, water, drawing,
photography, found objects
Dimensions variable

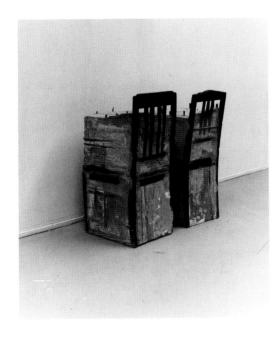

Untitled
1992
Wood, concrete, metal
95 × 41 × 41 cm

Untitled
1992
Wood, concrete, metal, cloth
97 × 43 × 43 cm

('un') recurs in his work, written in a tongue (German) that was for him, in exile (in Paris), the speech of the enemy and which couldn't be used without anger, suspicion or the evocation of loss. All have close parallels to Salcedo's use of visual language, in a general sense and, more than once, in particular choices of imagery. For another example, there is the early Celan poem, 'Shroud', which begins:

'*That which you wove out of light thread*
I wear in honour of stone.
When in the dark I awaken
the screams, it blows on them, lightly.'[33]

For Celan, as for the victims of violence addressed in Salcedo's work, the screams are always there. They may slumber, but sometimes, in the dark, they are aroused. To do so isn't hard – they are sensible to the slightest touch, to breath blown on them lightly, to the caress of thread that stands for stone. In Celan as in Salcedo there is recurring reference to darkness and other constraints against sight. In a later poem, Celan writes:

'*Go blind now, today:*
eternity also is full of eyes –
in them
drowns what helped images down
the way they came, in them
fades what took you out of language
lifted you out with a gesture
which you allowed to happen like
the dance of the words made of
autumn and silk and nothingness.'[34]

Like the shoes of *Atrabiliarios*, the lace-curtained doorways of *La Casa Viuda* and the sturdy wooden faces of the untitled furniture entombed in concrete, the tables of *Unland* incline toward disappearance. Their exquisitely refined detail requires the very closest of scrutiny, but for viewers who persevere, the image it delivers most vividly is of sight's failure. In fact, within Salcedo's realm of reconfigured perceptual experience, it is precisely restrictions on vision that make other, crucial kinds of seeing – of insight – possible. In José Saramago's novel *Blindness*, all the inhabitants of an unnamed city have lost their vision except one, who '*serenely wished that she, too, could turn blind, penetrate the visible skin of things and pass to their inner side, to their dazzling and irremediable blindness.*'[35] That inner, blind side of objects is where Salcedo's work takes place. The experience of extreme danger extinguishes the difference between what can be verified by touch and what has existed only in the mind, as nightmare. And afterwards, when nightmares recur, the dreamer loses a last defence, which is the certainty – unthinkingly assumed by those untouched by violence – of waking. In the face of that terror, in the place between willed but unavailing blindness and devastating sight, Salcedo's work stands as a remarkable act of sympathy and witness.

1 Doris Salcedo, interview with Santiago Villaveces-Izquierdo, 'Art and Media-tion', *Cultural Producers in Perilous States: Editing Events, Documenting Change*, ed. George E. Marcus, University of Chicago Press, 1997, p. 238

2 Ibid., p. 233

3 Ibid., p. 243

4 Ibid.

5 Doris Salcedo, letter to the author, 16 November 1999

6 Hannah Arendt, *On Violence*, Harcourt Brace Jovanovich, New York, 1969, p. 42

7 Ibid., p. 55

8 Ibid., pp. 38-39

9 Ibid., p. 63

10 Charles Merewether, 'To Bear Witness', *Doris Salcedo*, New Museum of Contemporary Art, New York/SITE Santa Fe, New Mexico, 1998, p. 18, footnote 12

11 Charles Merewether, 'Naming Violence in the Work of Doris Salcedo', *Third Text*, No. 24, London, Autumn, 1993, p. 42

12 Roland Barthes, *Camera Lucida: Reflections on Photography*, trans. Richard Howard, Hill and Wang, New York, 1981, p. 14

13 Ibid., p. 32

14 Susan Sontag, *On Photography*, Farrar, Straus and Giroux, New York, 1978, p. 155

15 Dori Laub, 'Bearing Witness, or the Vicissitudes of Listening', *Testimony: Crises of Witnessing in Literature, Psychoanalysis and History*, ed. Shoshana Felman, Dori Laub, Routledge, New York, 1992, p. 57

16 Ibid., p. 69

17 Elaine Scarry, *The Body in Pain: The Making and Unmaking of the World*, Oxford University Press, New York/London, 1985, p. 172

18 Cathy Caruth, *Unclaimed Experience: Trauma, Narrative and History*, Johns Hopkins University Press, Baltimore, 1996, p. 6

19 Quoted in Dori Laub, op. cit., p. 65

20 Doris Salcedo, 'Conversation with Doris Salcedo', Natalia Gutiérrez, *Art Nexus*, No. 19, Bogotá, January-March, 1996, p. 49

21 Mark Seltzer, 'Wound Culture: Trauma in the Pathological Public Sphere', *October*, No. 80, MIT Press, Cambridge, Massachussets, Spring, 1997, p. 9

22 Ibid., p. 11

23 Doris Salcedo, interview on videotape, 'Displacements', Art Gallery of Ontario, Toronto, 1998

24 Elaine Scarry, op. cit., p. 162

25 Doris Salcedo, 'Displacements', op. cit.

26 Paul Virilio, *The Aesthetics of Disappearance*, trans. Philip Beitchman, Semiotext(e), New York, 1991, p. 60

27 Charles Merewether, 'An Interview with Doris Salcedo', *Unland: Doris Salcedo: New Work* (exhibition brochure), San Francisco Museum of Modern Art, 1999, n.p.

28 Ibid.

29 Ibid.

30 Ann Hamilton, interview with Joan Simon, 'The Third Lyons Biennale of Contemporary Art. Ann Hamilton: Temporal Crossroads', *Art Press*, No. 208, Paris, December, 1995, p. 24

31 Philip Fisher, *Making and Effacing Art: Modern American Art in a Culture of Museums*, Harvard University Press, Cambridge, Massachusetts, 1991, p. 150

32 *Poems of Paul Celan*, trans. Michael Hamburger, Persea Books, New York, 1995, p. 295

33 Ibid., p. 71

34 Ibid., p. 247

35 José Saramago, *Blindness*, trans. Giovanni Pontiero, Harcourt Brace & Company, San Diego/New York, 1997, p. 58

Contents

A strange lostness was

palpably present, almost

you would

have lived.

– Paul Celan

The work is one of three in a series of sculptures entitled *Unland* (1995–98), and first exhibited far from their place of origin, at the New Museum of Contemporary Art, New York, in 1998. If the land is the site of life and culture, of community and nation, then 'unland' would be its radical negation. As a poetic neologism it implicitly retracts the promises contained in its linguistic kin, Utopia, the no-place of an imagined, alternative future. Thus, far from embodying the imagination of another and better world, unland is the obverse of Utopia. It is a land where even 'normal' life – with all its contradictions, pains and promises, happiness and miseries – has become unlivable. As an artist working in a country that is being torn apart by a self-perpetuating cycle of violence and lawlessness, Salcedo leaves no doubt as to the identity of this unland which serves as her melancholy inspiration. It is her homeland, Colombia.

If such a reading of the work's title suggests an explicit and straightforward political art practice, nothing could be further from the truth. Salcedo's sculpture captures the viewer's imagination in its unexpected, haunting visual and material presence in a way that does not easily relate to its mysterious title and subtitle, *the orphan's tunic*. The haunting effect is not there at first sight as the viewer approaches what from a distance looks like a simple, unremarkable table with some uneven surfaces. It comes belatedly, *nachträglich*, as Freud would say. It deepens as the viewer engages with the work. The muted, but expressive power of this sculpture grows slowly; it depends on duration, on sustained contemplation, on visual, linguistic and political associations woven together into a dense texture of understanding. And it raises the question of sculpture as material object in novel ways that sidestep the much debated issues of abstraction versus figuration, objecthood versus theatricalization, action or installation.

If classical sculpture captures the salient moment or crystallizes an idea or ideal form from the flow of time, then Salcedo's memory sculpture unlocks itself only within the

flow of time because temporality itself is inscribed into the work. It dramatizes its materials, yet holds onto an emphatic notion of work, object, sculpture, rather than dissolving work into performance. It embodies an expanded temporality, and as object it performs the process of memory. *the orphan's tunic* is *objet trouvé*, kitchen table, used and abused, material residue and witness. The object that appears simple and unassuming at first sight begins to come alive upon closer inspection. Its complexity has as much to do with what is there before the spectator's eyes as with that which is absent. That which is *heimlich* and familiar, the everyday piece of furniture, becomes *unheimlich*, uncanny; but the homely is both preserved and denied in the *unheimlich*, just as 'land' is in the Celan-inspired title *Unland*. For one realizes that what looked like one table with different level surfaces is actually made up of two tables of different length, width and height, violently jammed into each other: the smaller, somewhat wider and higher table shining in a whitish, luminous grey, the longer table dark brown with blackened marks of heavy usage. Both tables are mutilated. Where they clash and are mounted into each other, the inner two sets of legs are broken off.

As the spectator's gaze scans the surface, the whitish shine reveals itself to be a silk covering, the tunic, very thin natural silk that covers the surface and runs down the side boards and covers the two remaining legs. The silk is so thin that the eye is drawn to the cracks visible underneath, gaps between the five wooden boards that make up the table's rather rough surface, and other smaller cracks and gouges attributable to the table's former usage. The silk frays over the gap between the middle boards, suggesting perhaps that the table still expands, and it folds into some of the smaller cracks as if it were growing into them, attaching itself like a protective skin to the unevenness of the wood. Examining the surface of this table is like looking at the palm of a hand with its lines and folds. The effect is closeness, intimacy and at the same time a sense of fragility and vulnerability that contrasts with the sturdiness of the wooden table. Suddenly the table appears to be no more than a trace, a mute trace. But a trace that has now been so heavily worked over by the artist that it has acquired a powerful language. It speaks a language that is aesthetically complex without being aestheticizing, and subtly political without resorting to a direct message.

Salcedo's work on the homeliness of the kitchen table which has become the uncanny, is not that tied to individual psychology, nor are we merely dealing with a negative

aesthetic in an Adornean or avant-gardist sense of distortion or defamiliarization. At stake is rather the conscious artistic translation of a national pathology of violence into a sculpture that articulates pain and defiance by bearing witness. The work is not simply there as object in the present, even though it is very much of the present. It leads the viewer back to some other time and space that is absent, yet subtly inscribed into the work: Celan's 'strange lostness' that is 'palpably present'. Doris Salcedo's art is the art of the witness; the artist as secondary witness to be precise, the witness to lives and life stories forever scarred by the experience of violence that keeps destroying family, community, nation and ultimately the human spirit itself.

For some years now Salcedo has travelled the land, searching out and listening to the stories of people who have directly witnessed and survived gratuitous violence, who have lost parents and siblings, spouses, friends and neighbours to guerrillas, drug gangs and military death squads. In the case of *the orphan's tunic*, as Salcedo tells it, it was the story of a girl from an orphanage, a six-year-old, who had witnessed her mother's killing. Ever since that traumatic experience she had worn the same dress day after day, a dress her mother had made for her shortly before being killed: the dress as a marker of memory and sign of trauma. The story forces us to take *the orphan's tunic* literally as index of a death, a life, a trauma, something that did happen in the real world. A permanent marker of identity.

This metaphoric dimension is then put through another loop that adds to its texture. The choice of the word 'tunic', by way of an implicit *Engführung*, points to another Celan poem, a poem from *Lichtzwang*, a poem without title – orphaned, as it were.

> *Night rode him, he had come to his senses,*
> *the orphan's tunic was his flag,*
>
> *no more going astray,*
> *it rode him straight –*
>
> *It is, it is as though oranges hung in the privet,*
> *as though the so-ridden had nothing on*
> *but his*

previous pages, **Unland**
the orphan's tunic
1997
Wood, cloth, hair
80 × 245 × 98 cm
Collection, Fundaçio 'la Caixa',
Barcelona
opposite and following page,
Details

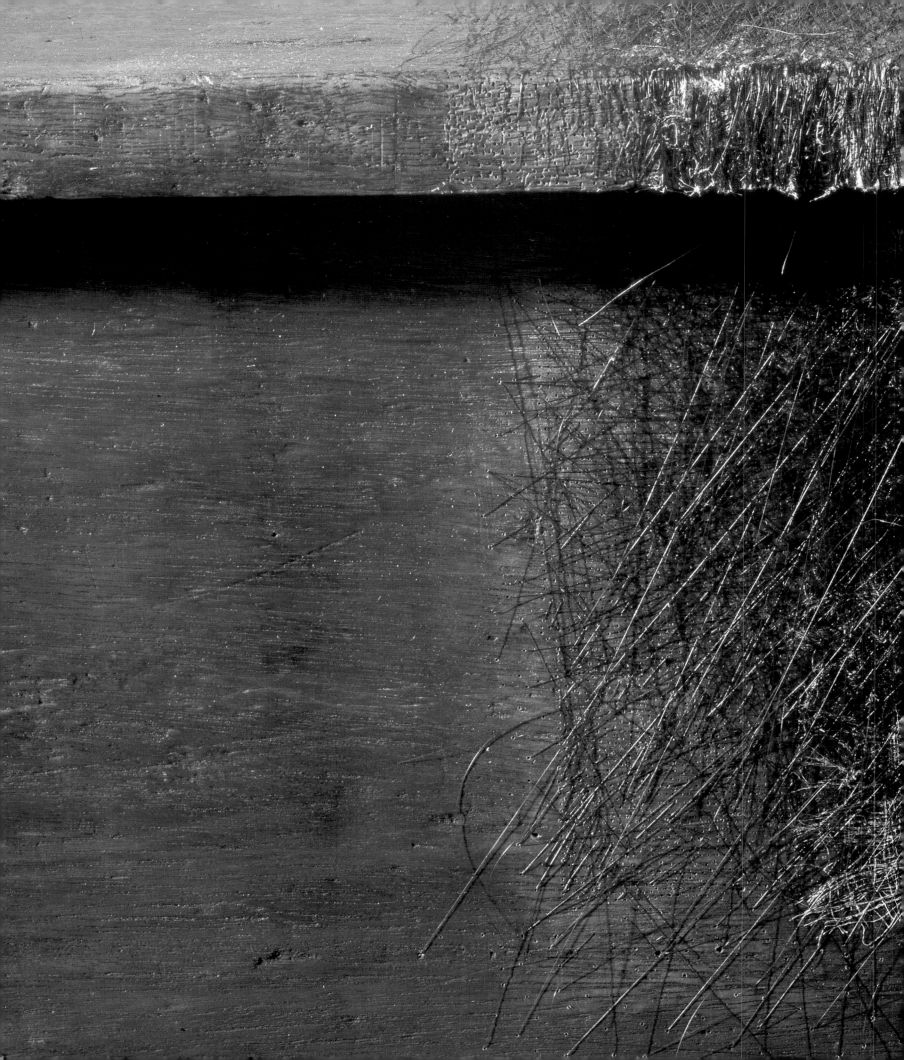

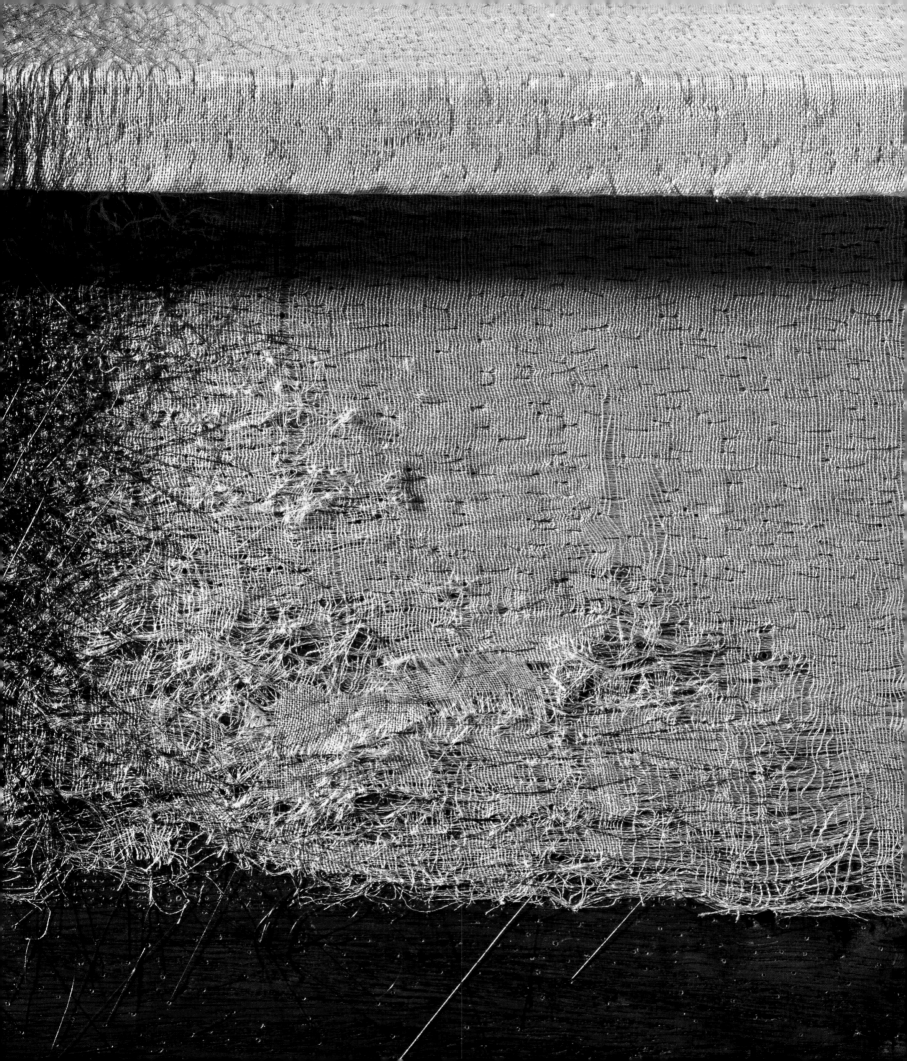

first

birth-marked, se-

cret-speckled

skin.

The poem, fraying into Salcedo's work by way of the sculpture's subtitle, provides the linkage between tunic and skin, or between dress and body, a linkage that proves to be central for the aesthetic and material transposition of event, idea and concept into the finished work. Documentary investigation, poetry and materials blend into the sculpture that lives off its temporal dimension as much as it relies on its spatial presence.

This double temporal and spatial effect is heightened when, looking even closer, one notices the thousands of minuscule holes, many of them a quarter to an eighth of an inch apart, with human hair threaded through them, going down into the wood, resurfacing and going in again. If the silk is marked from below by the unevenness and natural splits in the wood surface, it is marked from above by hundreds of hairs which look like small pencil marks, but actually hold the silk tunic close to the table. Now it is like looking at the back of a hand and noticing the short fine hair growing out of the skin.

If the tunic is like a skin – the 'first/birth-marked, se-/cret-speckled/skin' – then the table gains a metaphoric presence as body, no longer of an individual orphan but an orphaned community, deprived of normal life. Exhibited as memory sculpture far from its homeland in an international art world, this work appears itself orphaned and homeless in the spaces it now occupies.

How are we to understand this combination of human hair and wood? Both are material residues from formerly living organisms, now arrested in their growth. Clearly the work plays on the contrast: the hair as fragile, thin, vulnerable, with reminiscences of the famous piles of hair that we know from Holocaust photography, hair thus suggesting not life but death. The wood of the table, on the other hand, is solid, sturdy, a guarantor of stability. But just as the hair has been cut, the tables have been mutilated. Not the least of the various mutilations are the thousands of holes drilled through the surface with a 1/64 drill-bit before the hair could be stitched through. The very idea of the painstaking labour involved gives one pause. What an utterly absurd activity, stitching hair, and lots of it, through a

wooden surface. But is it only absurd? Or is it perhaps also an act of mending? If the table stands for community, family, life in its temporal extension, then the stitching of hair, inorganic trace of a human body, of the victim of violence, through the table's surface, is like the threading of pain and its memories through the surface of history.

But perhaps the most stunning part of the sculpture is the thick band of hair that looks as if woven across the table just at the threshold between the silk tunic and the bare surface of the brown table. Here the tunic appears as being stitched down and held down by the hair, secured in place. Hair, skin, texture, body, all come densely together in this part of the sculpture. It is close to where the two tables are jammed into each other, close to where the four middle legs have been broken off, the threshold that makes the table structure look vulnerable. Here it might cave in if pressure were to be applied from above. And precisely this tenuous threshold seems fortified by the band of hair, densely woven from one side of the table across to the other and down. It marks the end of the tunic on one side, the end of the barren brown surface on the other; it becomes thick texture. Hair appears here as providing strength while the table seems to be vulnerable, an imaginative reversal of the basic nature of the materials. However absurd this project of stitching hair through wood is, it also has an air of defiance: it defies the implacability of the wood, but it also defies the absurdity and gratuitousness of violence in Colombia.

Like all of Salcedo's work, *the orphan's tunic* is about memory, memory at the edge of an abyss. It is about memory in the literal sense, both the content of specific memories of violent acts, and memory as process and as structure as the work enters into dialogue with the viewer. And it is about memory in a spatial sense, approximating it, never quite getting to it, compelling the viewer to innervate something that remains elusive, absent – the violent death of the mother that left the child orphaned, the orphan present only in that residual tunic, which now seems more like a shroud covering part of the table. Forever absent are the communal or family events that took place around this table, the chairs, the people, the food and drink served here. If the people, especially the indigenous people, belong to the land, as Salcedo suggested in one of her rare interviews, then *Unland* marks the absence of the people from the communal site. But it is a forced absence, absence achieved through death and displacement.

If *Unland: the orphan's tunic* is adequately seen as a memory sculpture, inevitably

the question will arise: what of hope, what of redemption? And what kind of a politics of memory, if any, does Salcedo's artistic practice imply? Clearly, the work defies a politics of redemption, and it suggests defiance in an even broader sense: defiance first of any direct representation of a self-perpetuating violence it would be too legitimizing to call political; defiance also of an increasingly spectacularized culture of memory and its obsession with public sites of commemoration, monuments and memorials. Salcedo knows how public monuments and memorials are bound to serve as ciphers of forgetting through aestheticization or direct political comment. Her work does not trust mechanisms of public memory, while at the same time it desperately desires to nurture such memory. This is the minimal hope the work suggests. Sculptural form, rather than monument or memorial, addresses the individual spectator, inscribes its complex message and leaves the spectator moved by the memory of a powerful image. But the reality of *la violencia*, we know, continues unabated. There is no end in sight for the cycle of violence in Colombia, which feeds upon itself, like the mythical Kronos who devoured his own children.

Finally, there is Salcedo's defiance – or should one say overcoming – of the always present danger of aestheticization, due primarily to her use of simple everyday objects and materials. And yet, even if our gaze is not arrested in aesthetic pleasure, *Unland: the orphan's tunic* haunts us in its compelling beauty. As in other successful artistic works articulating historical trauma in unique media and materials, Salcedo's sculpture moves the spectator to the edge of an abyss only thinly veiled by the beauty of the piece itself. The veil, however, is indispensable in order for us to come face to face with the trauma and to become witnesses of a history we must not ignore.

Unland
the orphan's tunic (detail)
1997
Wood, cloth, hair
80 × 245 × 98 cm
Collection, Fundaçio 'la Caixa',
Barcelona

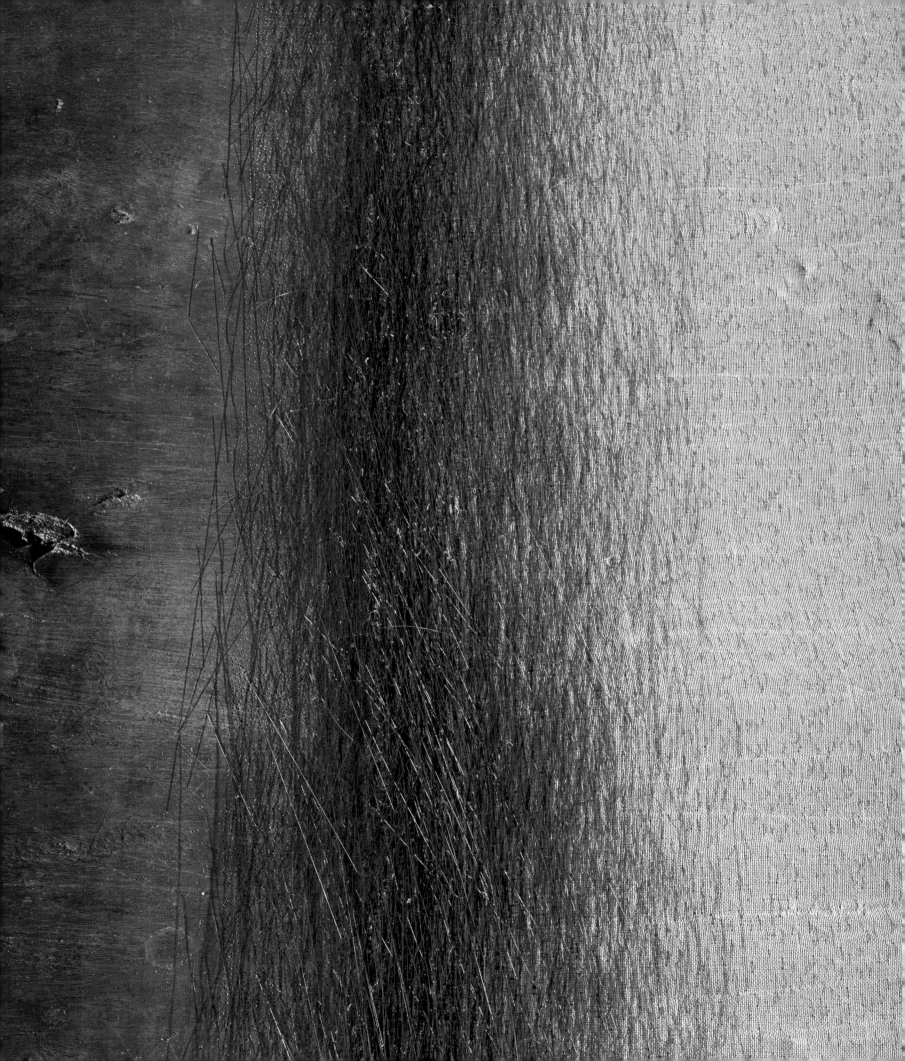

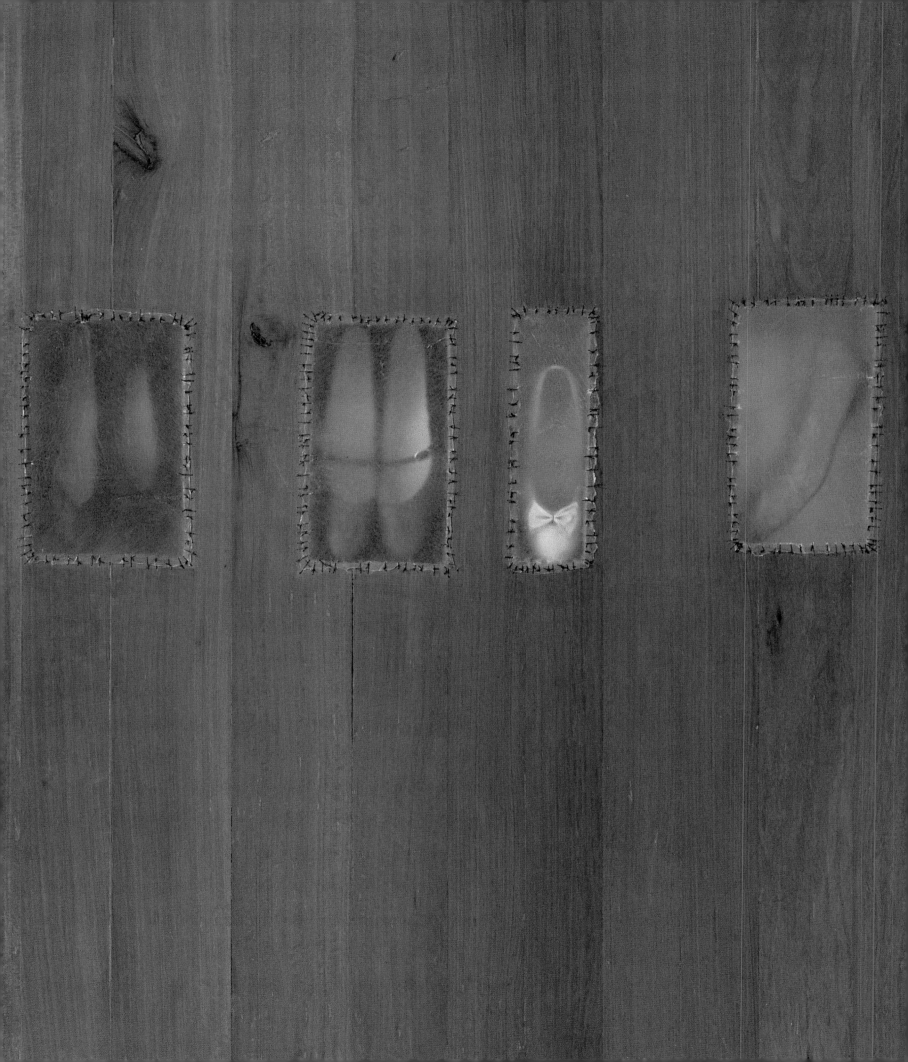

Contents

The morning's plumb lead, gilded,
affixes itself to your co-
vowing, co-
prospecting, co-
writing
heel.

Atrabiliarios
1993
Nazareno wood, 6 shoes, animal
fibre, surgical thread
200 × 100 × 8 cm

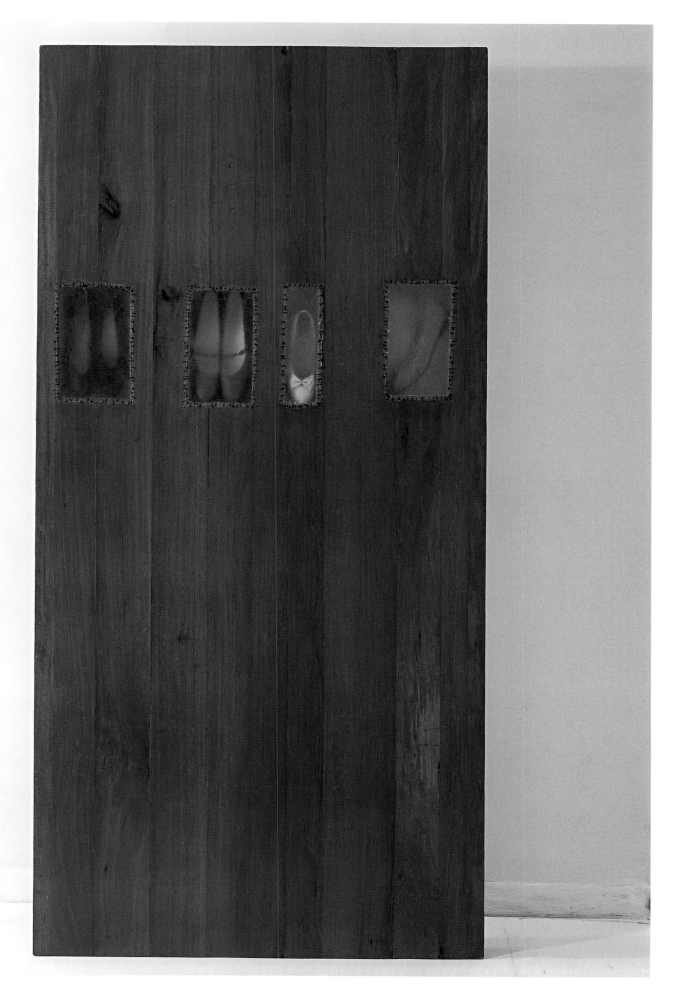

A star
listens to a light,
an hour casts out
an hour,

heart-heavy,
azure rolls
along over you,

your bloody
saliva
gives joy
to a grain of dust that's possessed,

a mother stump
leads a new-born face
through a pain,

its god
mowing muster the picture front
on the ridges
of the highest
cradle.

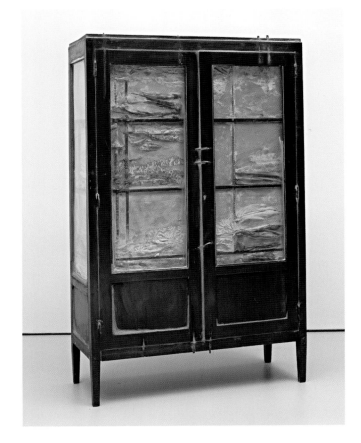

Untitled
1995
Wood, concrete, cloth, glass, steel
162 × 99.5 × 37 cm
opposite, Detail

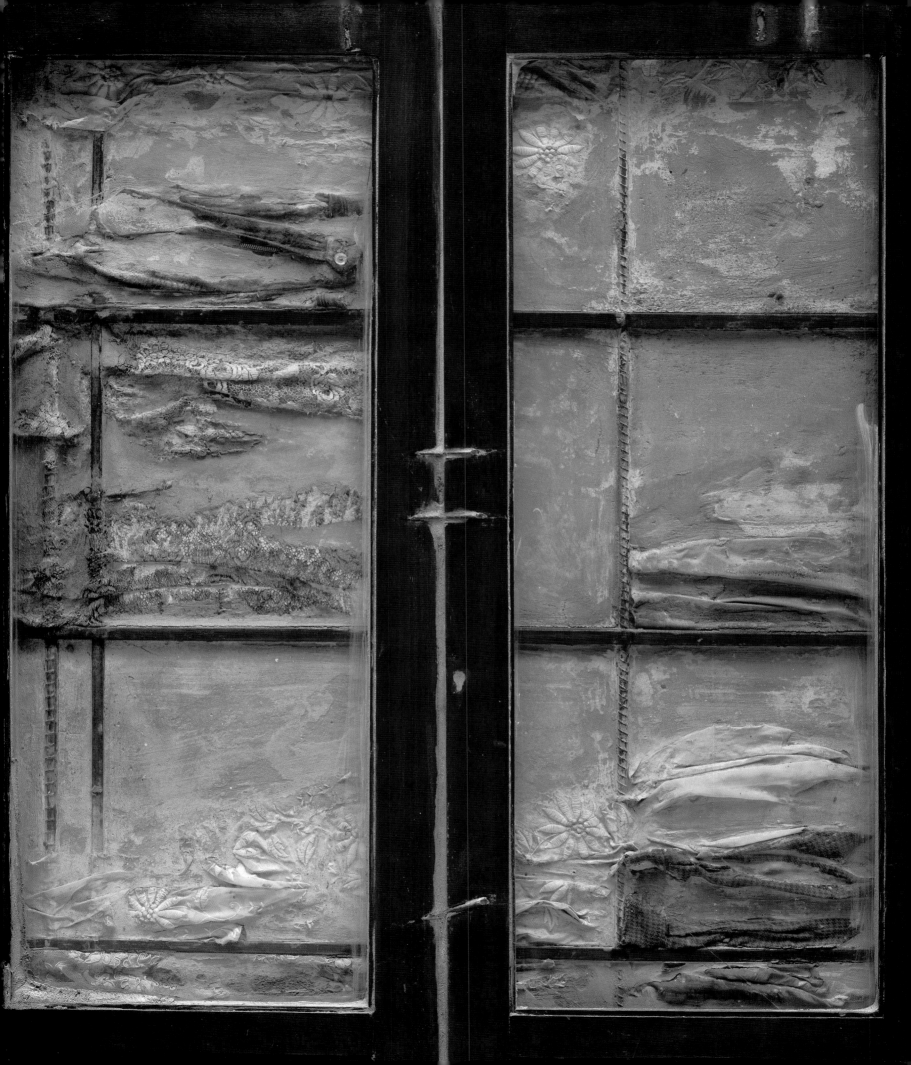

below, **Untitled**
1995
Wood, concrete, steel
94 × 115 × 49 cm

opposite, **Untitled**
1995
Wood, concrete, steel, glass, cloth
279.5 × 119.5 × 37 cm

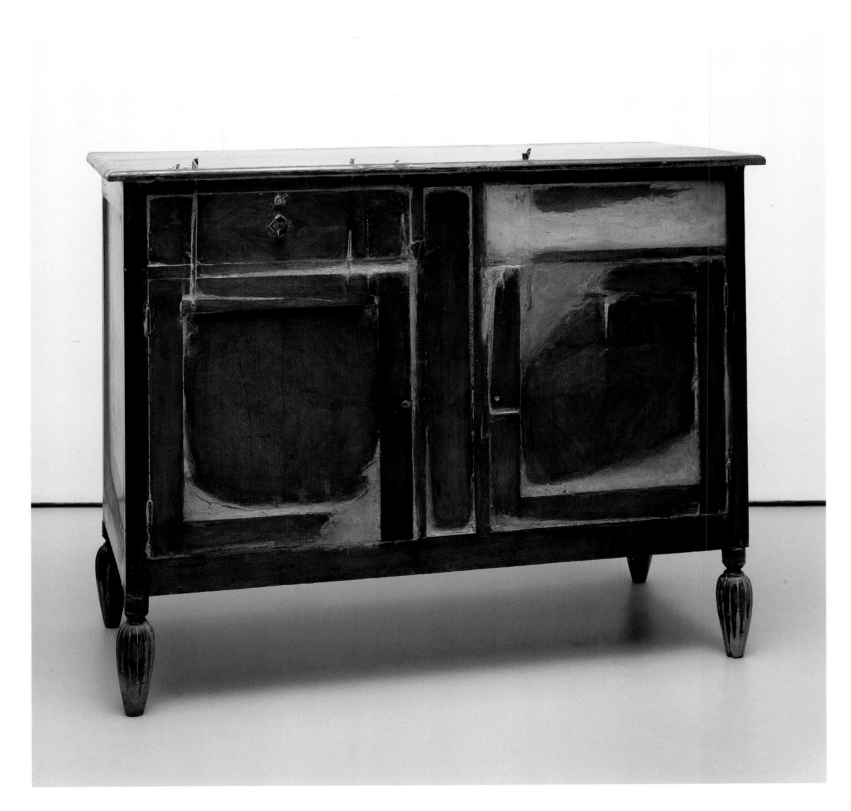

To stand in the shadow
of the scar up in the air.

To stand-for-no-one-and-nothing.
Unrecognized,
for you
alone.

With all there is room for in that,
even without
language.

Pledged to the persecuted, by
a late, un-
tacit, luminous
bond.

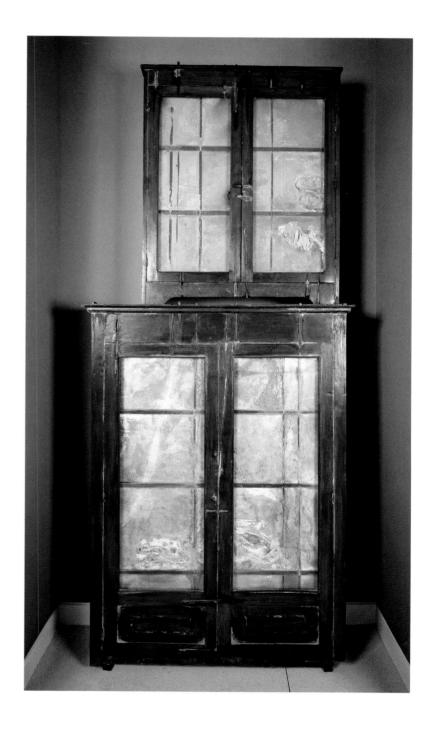

Untitled
1995
Concrete, wood, steel, leather
96 × 44 × 49 cm

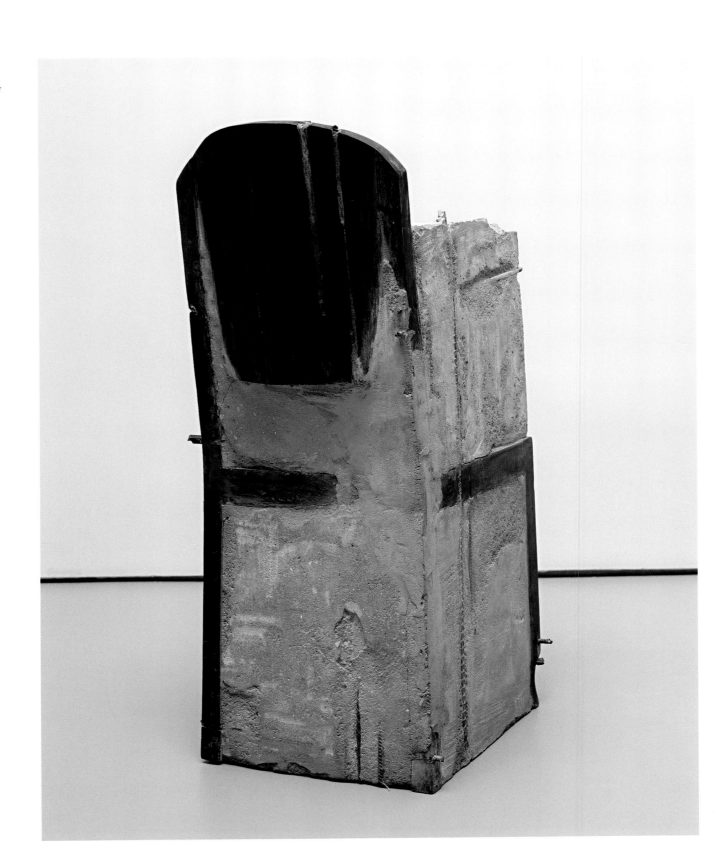

Little night: when you
take me inside, take me
up there,
three pain-inches above the
floor:

all those shroud coats of sand,
all those can't helps,
all that still
laughs
with the tongue –

Translated from German by Michael Hamburger

The Meridian (extract), 1960 **Paul Celan**

From a speech on the occasion of receiving the Georg Büchner Prize, Darmstadt, 22 October 1960

Art, you will remember, is [for Büchner] a puppet-like, iambic, five-footed thing, without offspring; this last characteristic has its mythological validation in Pygmalion and his statue. In this form, it is the subject of a conversation in *Danton's Death* which takes place in a room ... a conversation which we feel could go on forever if there were no snags. There are snags.

Art comes up again. It comes up in another work of Büchner's, *Woyzeck* ... Here, in very different times, art comes presented as a carnival barker and has no longer ... anything to do with 'glowing', 'roaring', 'radiant' creation, but is put next to the 'creature as God made it' and the 'nothing' this creature is 'wearing'. This time, art comes in the shape of a monkey. But it is art all right. We recognize it by its 'coat and trousers'.

Art comes to us in yet a third play of Büchner's, *Leonce and Lena*. Time and lighting are unrecognizable: we are 'fleeing towards paradise'; and 'all clocks and calendars' are soon to be 'broken' or, rather, 'forbidden'. But just before that moment, 'two persons of the two sexes' are introduced: 'two world-famous automatons have arrived'. And a man who claims to be 'the third and perhaps strangest of the two' invites us, 'with a rattling voice', to admire what we see: 'Nothing but art and mechanics, nothing but cardboard and springs.'

Art, with all its attributes and future additions, is also a *problem* and, as we can see, one that is variable, tough, long lived, let us say, eternal. A problem which allows a mortal, Camille, and a man whom we can only understand through his death, Danton, to join word to word to word. It is easy to talk about art. But when there is talk of art, there is often someone who does not really listen. More precisely: someone who hears, listens, looks ... and then does not know what it was about. But who hears the speaker, 'sees him speaking', who perceives language as a physical shape and also ... breath, that is, direction and destiny.

[...] I am speaking of [the character] Lucille. The snags that halt the conversation in *Danton's Death* are brutal. They take us to the Place de la Revolution: 'the carts drive up and stop.' They are all there, Danton, Camille, and the rest. They do not lack words, even here, artful, resonant words, and they get them out. Words ... about going to their death together; Fabre would even like to die 'twice'; everybody rises to the occasion. Only a few voices, 'some', unnamed, 'voices', find they 'have heard it before; it is boring.'

And here where it all comes to an end, in those long last moments when Camille – no, not *the* Camille, a fellow prisoner – when this other Camille dies a theatrical, I am tempted to say iambic death which we only two scenes later come to feel as his own, through another person's words, not his, yet kin – here where it all comes to its end, where all around Camille pathos and sententiousness confirm the triumph of 'puppet' and 'string', here Lucile, who is blind against art, for whom language is tangible and like a person, is suddenly there with her 'Long live the King!'

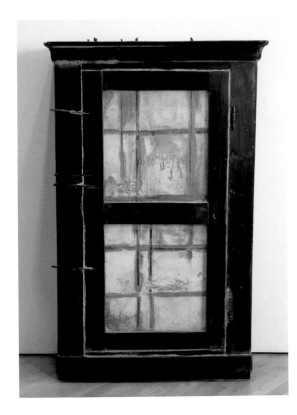

Untitled
1992
Concrete, wood, metal, glass
153 × 93 × 40.5 cm

After all those words on the platform (the guillotine) – what a word! It is a word against the grain, the word which cuts the 'string', which does not bow to the 'bystanders and old war-horses of history'. It is an act of freedom. It is a step. True, it sounds … at first like allegiance to the 'ancient régime'. But it is not. Allow me … to insist: this is not homage to any monarchy, to any yesterday worth preserving. It is homage to the majesty of the absurd which bespeaks the presence of human beings. This has no definitive name, but I believe that this is … poetry.

'Oh, art!' You see I am stuck on this word of Camille's. I know we can read it in different ways, we can give it a variety of accents: the acute of the present, the grave accent of history (literary history included), the circumflex (marking length) of eternity. I give it – I have no other choice – an acute accent. Art – 'oh, art!' – beside being changeable, has the gift of ubiquity. We find it again in Lenz, but, let me stress this, as in *Danton's Death*, only as an episode. 'Over dinner, Lenz recovered his spirits: they talked literature, he was in his element … ' 'The feeling that there is life in a work was … the only criterion in matters of art … ' I have picked only two sentences. My bad conscience about the grave accent bids me draw your attention to their impor-tance in literary history. We must read this passage together with the conversation in *Danton's Death*. Here, Büchner's aesthetics finds expression. It leads us from the Lenz fragment to Reinhold Lenz, author of *Notes on the Theatre*, and, back beyond the historical Lenz, to Mercier's seminal '*Elargissez l'art*.' This passage opens vistas: it anticipates Naturalism and Gerhart Hauptmann. Here we must look for the social and political roots of Büchner's work, and here we will find them.

It has, if only for a moment, calmed my conscience that I did not fail to mention all this. But it also shows, and thereby disturbs my conscience again, that I cannot get away from something which seems connected with art. I am looking for it here, in Lenz – now you are forewarned. Lenz, that is, Büchner, has ('oh, art') only contemptuous words for 'idealism' and its 'wooden puppets'. He contrasts it with what is natural for the creature and follows up with his unforgettable lines about the 'life of the least of beings', the 'tremors and hints', the 'subtle, hardly noticeable play of expressions on his face'. And he illustrates this view of art with a scene he has witnessed:

'As I was walking in the valley yesterday, I saw two girls sitting on a rock. One was putting up her hair, and the other helped. The golden hair hanging down, and a pale, serious face, so very young, and the black dress, and the other girl so careful and attentive. Even the finest, most intimate paintings of the old German masters can hardly give you an idea of the scene. Sometimes one would like to be a Medusa's head to turn such a group to stone and gather the people around it.'

Please note: 'One would like to be a Medusa's head' to … seize the natural as the natural by means of art! *One would like to*, by the way, not: *I would*. This means going beyond what is human, stepping into a realm which is turned towards the human, but uncanny – the realm where the monkey, the automatons and with them … oh, art, too, seem to be at home. This is not the historical Lenz speaking, but Büchner's. Here we hear Büchner's own voice: here, as in his other works, art has its uncanny side.

I have placed my acute accent. I cannot hide from you any more than from myself that, if I took my question about art and poetry, a question among others, if I took it of my own – though perhaps not free – will to Büchner, it was in order to find his way of asking it. But you see: we cannot ignore the 'rattling' voice Valerio gets whenever art is mentioned. This uncanny, Büchner's voice leads me to suppose, takes us far, very far back. And it must be in the air – the air we have to breathe – that I so stubbornly insist on it today.

Now I must ask, does Büchner, the poet of the creature, not call art into question, and from this direction? A challenge to which all poetry must return if it wants to question further? In other words … may we, like many of our contemporaries, take art for granted, as absolutely given? Should we, to put it concretely, think Mallarmé, for instance, through to the end?

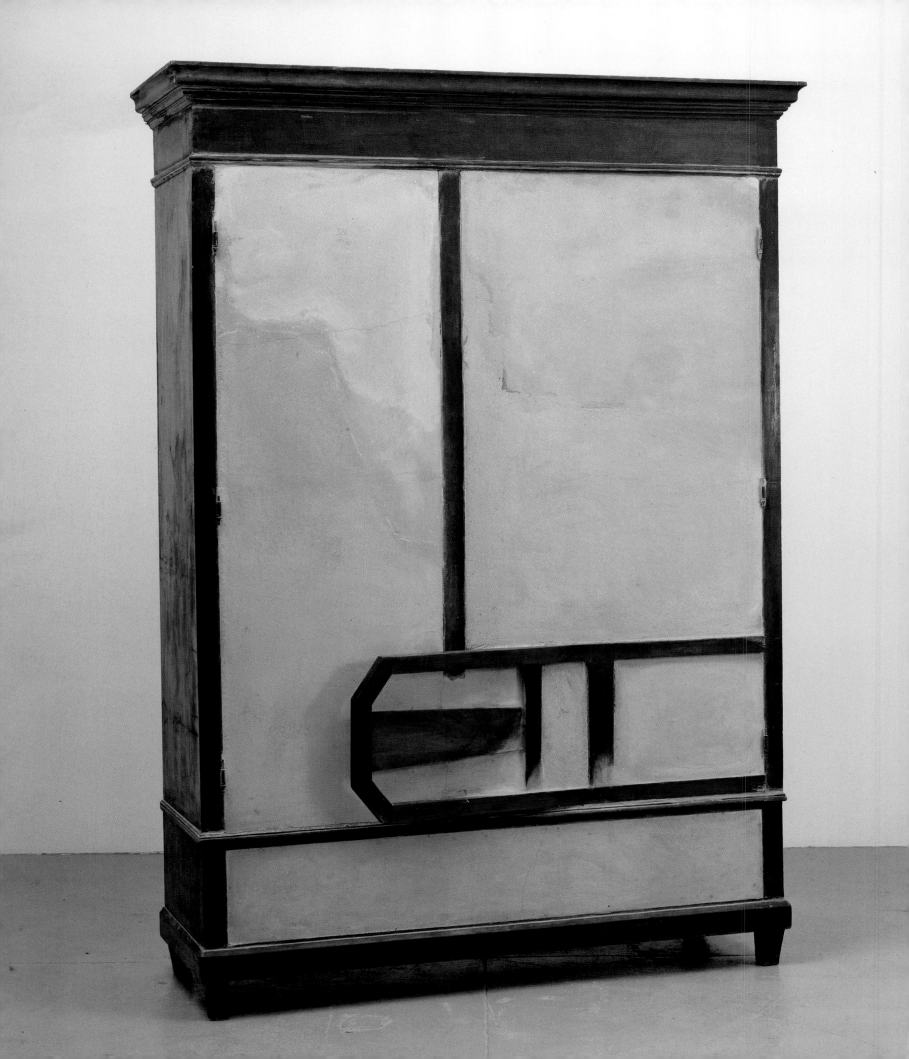

opposite, **Untitled**
1998
Wood, concrete, metal
151 × 115.5 × 57 cm
Collection, Tate Gallery, London

right, **Untitled**
1998
Wood, concrete, metal
181 × 124 × 63 cm

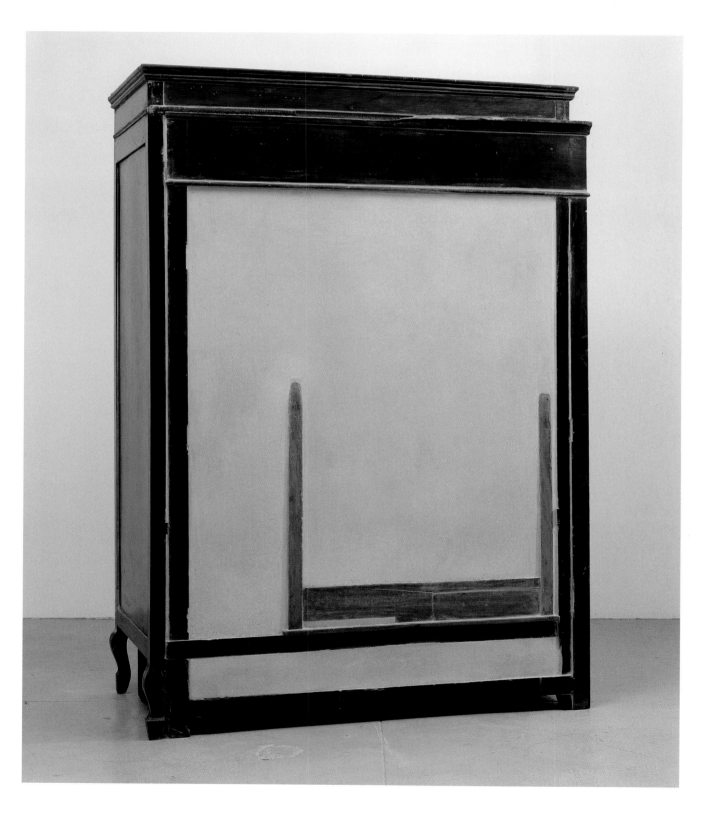

I have jumped ahead, reached beyond my topic, though not far enough, I know. Let me return to Büchner's Lenz, to the (episodic) conversation 'over dinner' during which Lenz 'recovered his spirits'. Lenz talked for a long time, 'now smiling, now serious'. And when the conversation was over, Büchner says of him, of the man who thinks about questions of art, but also of Lenz, the artist: 'He had forgotten all about himself.' I think of Lucile when I read this. I read: He, he himself. The man whose eyes and mind are occupied with art – I am still with Lenz – forgets about himself. Art makes for distance from the I. Art requires that we travel a certain space in a certain direction, on a certain road. And poetry? Poetry which, of course, must go the way of art? Here this would actually mean the road to Medusa's head and the automaton!

I am looking for a way out, I am only pushing the question farther in the same direction which is, I think, also the direction of the Lenz fragment. Perhaps – I am only speculating – poetry, like art, moves with the oblivious self into the uncanny and strange to free itself. Though where? In which place? How? As what? This would mean art is the distance poetry must cover, no less and no more. I know there are other, shorter routes, but poetry, too, can be ahead. *La poésie, elle aussi, brûle nos étapes.*

I will now leave the man who has forgotten about himself, who thinks about art, the artist. I believe that I have met poetry in the figure of Lucile, and Lucile perceives language as shape, direction, breath. I am looking for the same thing here, in Büchner's work. I am looking for Lenz himself, as a person, I am looking for his shape: for the sake of the place of poetry, for the sake of liberation, for the sake of the step. Büchner's Lenz has remained a fragment. Shall we look at the historical Lenz in order to find out what direction this life had? 'His existence was a necessary burden for him. Thus he lived on … ' Here the tale breaks off. But poetry, like Lucile, tries to see the figure in his direction. Poetry rushes ahead. We know how he lives on, on towards what?

'Death was not slow to deliver him', we read in a work on Jakob Michael Reinhold Lenz published in Leipzig, in 1909, from the pen of a Moscow professor, M.N. Rosanow, 'In the night from the 23rd to the 24th of May, 1792, Lenz was found dead in a street in Moscow. A nobleman paid for his funeral. His grave has remained unknown'. Thus he had lived on. He: the real Lenz, Büchner's figure, the person whom we encountered on the first page of the story, the Lenz who 'on the 20th of January was walking through the mountains', he – not the artist thinking about art – he as an 'I'. Can we perhaps now locate the strangeness, the place where the person was able to set himself free as an – estranged – I? Can we locate this place, this step? '… only, it sometimes bothered him that he could not walk on his head'. This is Lenz. This is, I believe, his step, his 'Long live the king'. A man who walks on his head … sees the sky below as an abyss.

It is very common today to complain of the 'obscurity' of poetry … This obscurity, if it is not congenital, has been bestowed on poetry by strangeness and distance (perhaps of its own making) and for the sake of an encounter. But there may be, in one and the same direction, two kinds of strangeness next to each other. Lenz – that is, Büchner – has gone a step farther than Lucile. His 'Long live the king' is no longer a word. It is a terrifying silence. It takes his – and our – breath and words away. Poetry is perhaps this: an *Atemwende*, a turning of our breath. Who knows, perhaps poetry goes its way – the way of art – for the sake of just such a turn? And since the strange, the abyss and Medusa's head, the abyss and the automaton, all seem to lie in the same direction – it is perhaps this turn, this *Atemwende*, which can sort out *the strange* from the strange? It is perhaps here, in this one brief moment, that Medusa's head shrivels and the automatons run down? Perhaps, along with the I, estranged and freed here, in this manner, some other thing is also set free? Perhaps after this, the poem can be itself … can in this now art-less, art-free manner go other ways, including the ways of art, time and again? Perhaps we can say that every poem is marked by its own '20th of January'? Perhaps the newness of poems written today is that they try most plainly to be mindful of this kind of date? But do we not all write from and toward some such date? What else could we claim as our origin?

Untitled
1998
Wood, concrete, metal
188 × 112 × 54.5 cm

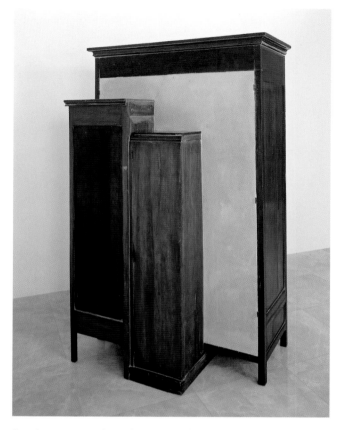

It is true that the poem today shows (and this has only indirectly to do with the difficulties of vocabulary, the faster flow of syntax or a more awakened sense of ellipsis, none of which we should underrate) a strong tendency towards silence. The poem holds its ground, if you will permit me yet another extreme formulation, the poem holds its ground on its own margin. In order to endure, it constantly calls and pulls itself back from an 'already-no-more' into a 'still-here'. This 'still-here' can only mean speaking. Not language as such, but responding and – not just verbally – 'corresponding' to something. In other words: language actualized, set free under the sign of a radical individuation which, however, remains as aware of the limits drawn by language as of the possibilities it opens.

This 'still-here' of the poem can only be found in the work of poets who do not forget that they speak from an angle of reflection which is their own existence, their own physical nature. This shows the poem yet more clearly as one person's language becomes shape and, essentially, a presence in the present. The poem is lonely. It is lonely and *en route*. Its author stays with it. Does this very fact not place the poem already here, at its inception, in the encounter, in the mystery of encounter? The poem intends another, needs this other needs an opposite. It does towards it, bespeaks it. For the poem, everything and everybody is a figure of this other toward which it is heading. The attention which the poem pays to all that it encounters, its more acute sense of detail, outline, structure, colour, but also of the 'tremors and hints' – all this is not, I think, achieved by an eye competing (or concurring) with ever more precise instruments, but rather by a kind of concentration mindful of all our dates.

But the poem speaks. It is mindful of its dates, but it speaks. True, it speaks only on its own, its very own behalf. But I think – and this will hardly surprise you – that the poem has always hoped, for this very reason, to speak also on behalf of the strange – no, I can no longer use this word here – on behalf of the other, who knows, perhaps of an altogether other.

This 'who knows' which I have reached is all I can add here, today, to the old hopes. Perhaps, I am led to speculate, an encounter is conceivable between this 'altogether other' – I am using a familiar auxiliary – and a not so very distant, a quite close 'other' – conceivable, perhaps, again and again. The poem takes such thoughts for its home and hope – a word for living creatures. Nobody can tell how long the pause for breath – hope and thought – will last. 'Speed', which has always been 'outside', has gained yet more speed. The poem knows this, but heads straight for the 'otherness' which it considers it can reach and be free, which is perhaps vacant and at the same time turned like Lucile, let us say, turned toward it, toward the poem.

'Attention' – if you allow me a quote from Malebranche via Walter Benjamin's essay on Kafka – 'is the natural prayer of the soul'. The poem becomes – under what conditions – the poem of a person who still perceives, still turns towards phenomena, addressing and questioning them. The poem becomes conversation – often desperate conversation. Only the space of this conversation can establish what is addressed, can gather it into a 'you' around the naming and speaking I. But this 'you', come about by dint of being named and addressed, brings its otherness into the present. Even in the here and now of the poem – and the poem has only this one, unique, momentary present – even in this immediacy and nearness, the otherness gives voice to what is most its own: its time.

Whenever we speak with things in this way we also dwell on the question of their where-from and where-to, an 'open' question 'without resolution', a question which points towards open, empty, free spaces – we have ventured far out. The poem also searches for this place. The poem, with its images and tropes? What am I actually talking about when I speak from this position, in this direction, with these words about the poem, no, about the poem? I am talking about a poem which does not exist! The absolute poem – no, it certainly does not, cannot exist.

But in every real poem, even the least ambitious, there is this ineluctable question, this exorbitant claim. Then what are images? What has been, what can be perceived, again and again, and only here, only now. Hence the poem is the place where all tropes and metaphors want to be led *ad absurdum*. And topological research? Certainly. But in the light of what is still to be searched for: in a utopian light. And the human being? The physical creature? In this light.

What questions! What claims! It is time to retrace our steps. I have come to the end – I have come back to the beginning. *Elargissez l'art!* This problem confronts us with its old and new uncanniness. I took it to Büchner, and think I found it in his work. I even had an answer ready, I wanted to counter, to contradict, with a word against the grain, like Lucile's. Enlarge art? No. On the contrary, take art with you into your innermost narrowness. And set yourself free.

I have taken this route, even today, with you. It has been a circle. Art (this includes Medusa's head, the mechanism, the automaton), the uncanny strangeness which is so hard to differentiate and perhaps is only one after all – art lives on. Twice, with Lucile's 'Long live the king' and when the sky opened as an abyss under Lenz, there seemed to occur an *Atemwende*, a turning of breath. Perhaps also while I was trying to head for that inhabitable distance which, finally, was visible only in the figure of Lucile. And once, by dint of attention to things and beings, we came close to a free, open space and, finally, close to Utopia.

Poetry: what an eternalization of nothing but mortality, and in vain. Allow me since I have come back to the beginning, to ask once more, briefly and from a different direction, the same question. Several years ago I wrote a little quatrain:

> *Voices from the path through nettles:*
> *Come to us on your hands.*
> *Alone with your lamp,*
> *Only your hand to read.*

And a year ago, I commemorated a missed encounter in the Engadine valley by putting a little story on paper where I had a man 'like Lenz' walk through the mountains. Both times, I had written from a '20th of January', from my '20th of January'. I had ... encountered myself. Is it on such paths that poems take us when we think of them? And are these paths only detours, detours from you to you? But they are, among how many others, the paths on which language becomes voice. They are encounters, paths from a voice to a listening You, natural paths, outlines for existence perhaps, for projecting ourselves into the search for ourselves ... A kind of homecoming.

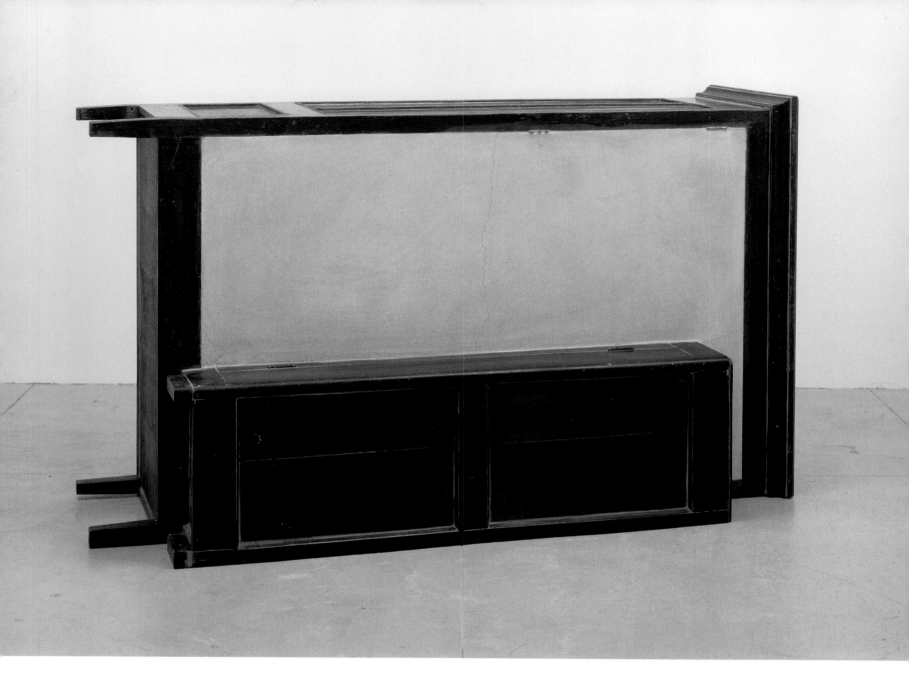

Untitled
1998
Wood, concrete, metal
124.5 × 208.5 × 88.5 cm
Collection, National Gallery of
Canada, Ottawa

I am coming to the end, I am coming, along with my acute accent, to the end of ... *Leonce and Lena*. And here, with the last two words of this work, I must be careful. I must be careful not to misread, as Karl Emil Franzos did (My rediscovered fellow countryman Karl Emil Franzos) editor of that *First Critical and Complete Edition of George Büchner's Works and Posthumous Writings* which was published eighty-one years ago by Sauerländer in Frankfurt am Main – I must be careful not to misread *das Commode*, 'the comfort' we now need, as 'the coming thing'. And yet: is *Leonce and Lena* not full of words which seem to smile through invisible quotation marks, which we should perhaps not call *Gänsefüsschen*, or goose feet, but rather rabbit's ears, that is, something that listens, not without fear, for something beyond itself, beyond words?

From this point of 'comfort', but also in the light of Utopia, let me now undertake a bit of topological research. I shall search for the region from which hail Reinhold Lenz and Karl Emil Franzos whom I have met on my way here and in Büchner's work. I am also, since I am again at my point of departure, searching for my own place of origin. I am looking for all this with my imprecise, because nervous, finger on a map – a child's map, I must admit. None of these places can be found. They do not exist. But I know where they ought to exist, especially now, and ... I find something else. I find something which consoles me a bit for having walked this impossible road in your presence, this road of the impossible. I find the connective which, like the poem, leads to encounters. I find something as immaterial as language, yet earthly, terrestrial, in the shape of a circle which, via both poles, rejoins itself and on the way serenely crosses even the tropics: I find ... a meridian. With you and Georg Büchner and the State of Hesse, I believe I have just touched it again.

[...] It is in the risky uncovering of oneself, in sincerity, the breaking up of inwardness and the abandon of all shelter, exposure to traumas, vulnerability.

Saying approaches the other by breaking through the *noema* involved in intentionality, turning inside out, 'like a cloak', consciousness which, by itself would have remained for-itself even in its intentional aims. Intentionality remains an aspiration to be filled and fulfilment, the contripetal movement of a consciousness that coincides with itself, recovers, and rediscovers itself without ageing, rests in self-certainty, confirms itself, doubles itself up, consolidates itself, thickens into a substance. The subject in saying approaches a neighbour in expressing itself, in being expelled, in the literal sense of the term, out of any locus, no longer *dwelling*, not stomping any ground. Saying uncovers, beyond nudity, what dissimulation there may be under the exposedness of a skin laid bare. It is the very *respiration* of this skin prior to any intention. The subject is not *in itself*, at home with itself, such that it would dissimulate itself in itself or dissimulate itself in its wounds and its exile, understood as *acts* of wounding or exiling itself. Its bending back upon itself is a turning inside out. Its being 'turned to another' is this being turned inside out. A concave without a convex. The subject of saying does not give signs, it becomes a sign, turns into an allegiance.

Here exposure has a sense radically different from thema-tization. The one is exposed to the other as a skin is exposed to what wounds it, as a cheek is offered to the smiter. On the hither side of the ambiguity of being and entities, prior to the said, saying uncovers the one that speaks, not as an object disclosed by theory, but in the sense that one discloses oneself by neglecting one's defences, leaving a shelter, exposing oneself to outrage, to insults and wounding. But saying is a denuding of denuding, a giving a sign of its very signifyingness, an expression of exposure, a hyperbolic passivity that disturbs the still waters, in which, without saying, passivity would be crawling with secret designs. There is denuding of denuding, without this 'reflection' or this iteration having to be added afterwards to the denuding. The passivity of the exposure responds to an assignation that identifies me as the unique one, not by reducing me to myself, but by stripping me of every

identical quiddity, and thus of all form, all investiture, which would still slip into the assignation. The saying signifies this passivity; in the saying this passivity signifies, becomes signifyingness, exposure in response to ... being at the question before any interrogation, any problem, without clothing, without a shell to protect oneself, stripped to the core as in an inspiration of air, an ab-solution to the *one*, the one without a complexion. It is a denuding beyond the skin, to the wounds one dies from, denuding to death, being as a vulnerability. It is a fission of the nucleus opening the bottom of its punctual nuclearity, like to a lung at the core of oneself. The nucleus does not open this depth as long as it remains protected by its solid crust, by a form, not even when it is reduced to its punctuality, for it identifies itself in the temporality of its essence, and thus covers itself over again. The limit of the stripping bare, in the punctual core, has to continue to be torn from itself. The one assigned has to open to the point of separating itself from its own inwardness, adhering to *esse*; it must be dis-interested. This being torn up from oneself in the core of one's unity, this absolute noncoinciding, this diachrony of the instant, signifies in the form of one-penetrated-by-the-other. The pain, this underside of skin, is a nudity more naked than all destitution. It is sacrificed rather than sacrificing itself, for it is precisely bound to the adversity or suffering of pain. This existence, with sacrifice imposed on it, is without conditions. The subjectivity of a subject is vulnerability, exposure to affection, sensibility, a passivity more passive still than any passivity, an irrecuperable time, an unassemblable diachrony of patience, an exposedness always to be exposed the more, an exposure to expressing, and thus to saying, thus to giving.

Saying, the most passive passivity, is inseparable from patience and pain, even if it can take refuge in the said, finding again in a wound the caress in which pain arises, and then the contact, and beyond it the knowing of a harness or a softness, a heat or a cold, and then the thematization. Of itself saying is the sense of patience and pain. In saying suffering signifies in the form of *giving*, even if the price of signification is that the subject run the risk of suffering without reason. If the subject did not run this risk, pain would lose its very painfulness. Signification, as the one-for-the-other in passivity, where the other is not assumed by the one, presupposes the possibility of pure

La Casa Viuda III (detail)
1994
Wood, fabric
2 parts, 258.5 × 86.5 × 6 cm;
83.5 × 86.5 × 5 cm
Installation, 'Doris Salcedo', Le
Creux de l'Enfer, Thiers, France,
1996

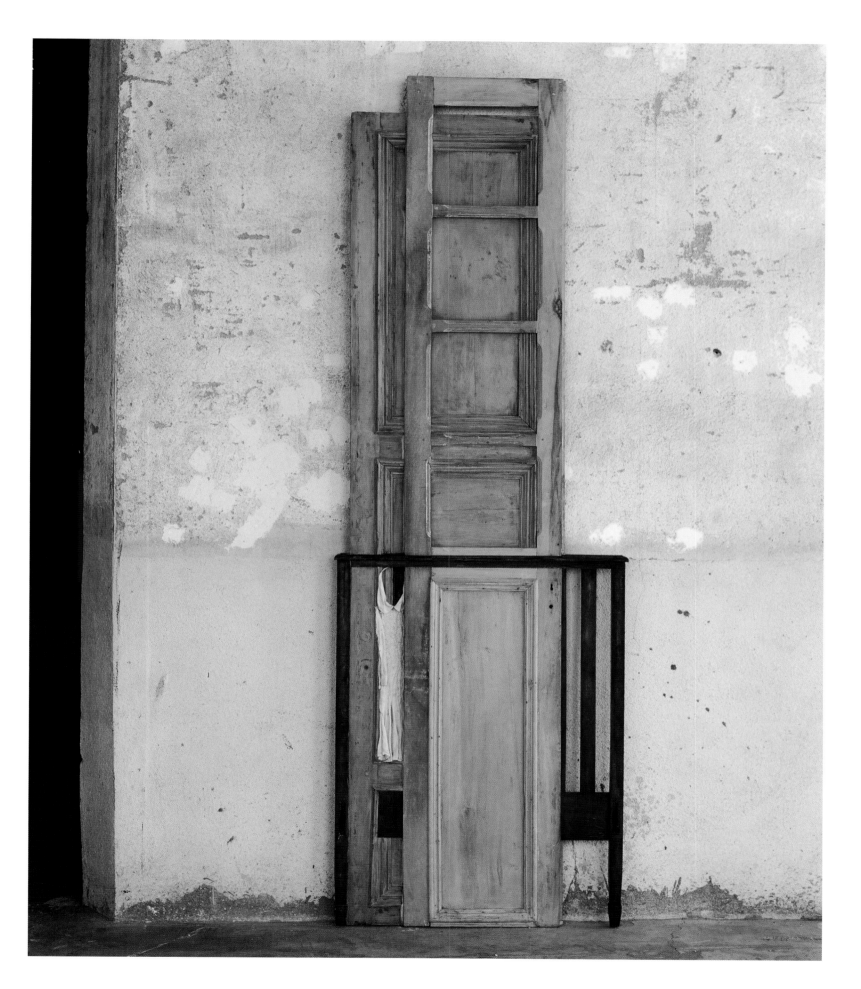

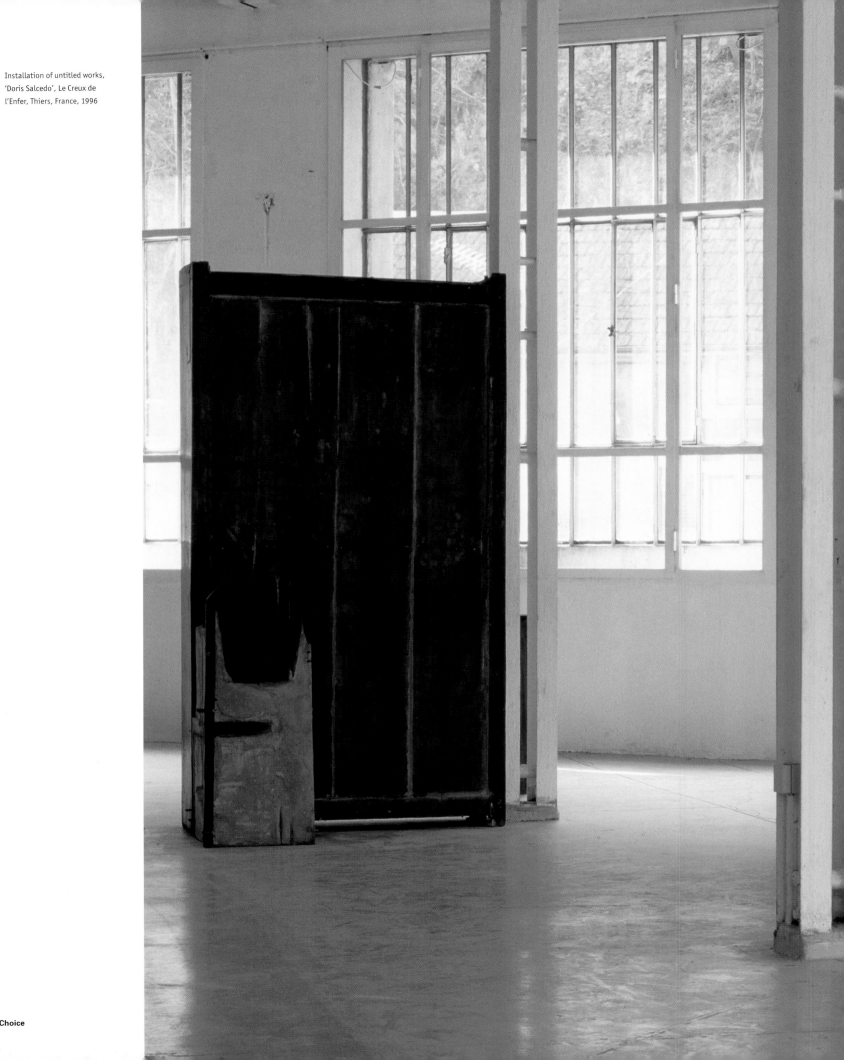

Installation of untitled works, 'Doris Salcedo', Le Creux de l'Enfer, Thiers, France, 1996

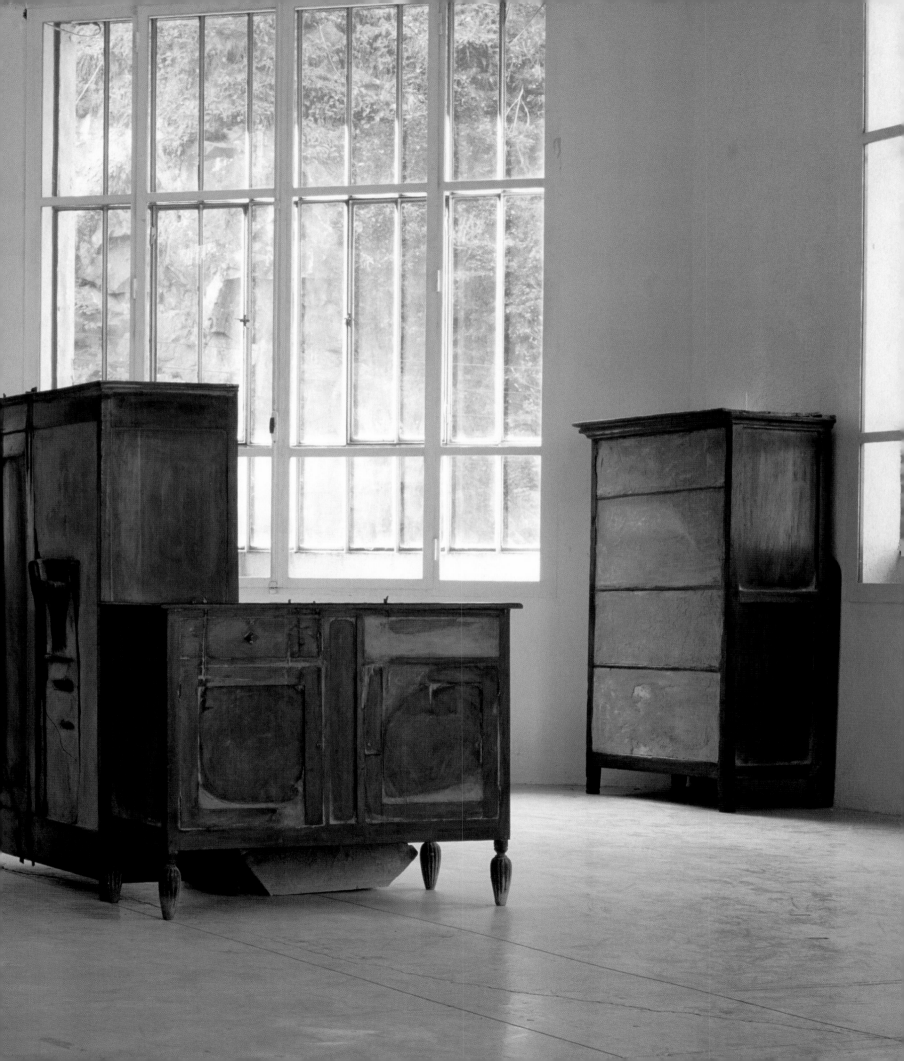

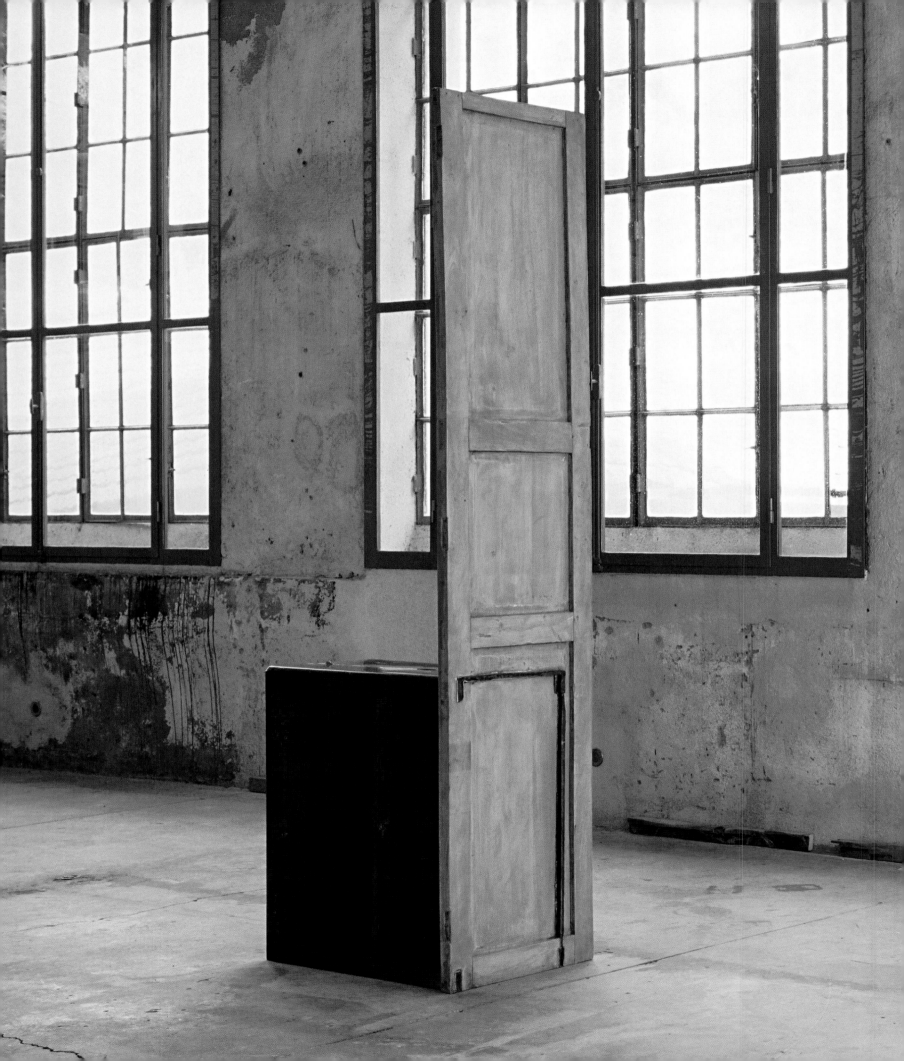

La Casa Viuda II (detail)
1993–94
Wood, metal, fabric, bone
260 × 80 × 60.5 cm
Installation, 'Doris Salcedo', Le
Creux de l'Enfer, Thiers, France,
1996
Collection, Art Gallery of Ontario,
Toronto

non-sense invading and threatening signification. Without this folly at the confines of reason, the one would take hold of itself, and, in the heart of its passion, recommence essence. How the adversity of pain is ambiguous! The for-the-other (or sense) turns into by-the-other, into suffering by a thorn burning the flesh, but *for nothing*. It is only in this way that the *for-the-other*, the passivity more passive still than any passivity, the emphasis of sense, is kept from being *for-oneself* […]

Life enjoys its very life, as though it nourishes itself with life as much as with what makes it live, or, more exactly, as though nourishing oneself had this twofold reference. Before any reflection, any return upon oneself, enjoyment is an enjoying of enjoyment, always wanting with regard to itself, filling itself with these lacks for which contentment is promised, satisfying itself already with this impatient process of satisfaction, enjoying its own appetite. There is enjoying of enjoyment before any reflection, but enjoyment does not turn toward enjoyment as sight turns toward the seen. Beyond the multiplication of the visible in images, enjoyment is the singularization of an ego in its coiling back upon itself. Winding of a skein, it is the very movement of egoism. It has to be able to be complacent in itself, as though it exhausted the *eidos* of sensibility, so that sensibility could, in its passivity, its patience and pain, signify for the other by unwinding its coils. Without egoism, complacent in itself, suffering would not have any sense. It would lose the passivity of patience, if it were not at every moment an overflowing of sense by non-sense. Enjoyment and the singularization of sensibility in an ego take from the supreme passivity of sensibility, from its vulnerability, its exposedness to the other, the anonymousness of the meaningless passivity of the inert. The possibility in suffering of suffering for nothing prevents the passivity in it from reverting into an act. Thus, the for-the-other both thwarts the subject and affects it in its inwardness through pain. Enjoyment in its ability to be complacent in itself, exempt from dialectical tensions, is the condition of the for-the-other involved in sensibility, and in its vulnerability as an exposure to the other.

This sensibility has meaning only as a 'taking care of the other's need', of his misfortunes and his faults, that is, as a giving. But giving has meaning only as a tearing from oneself despite oneself, and not only *without* me. And to be torn from oneself despite oneself has meaning only as a being torn from the complacency in oneself characteristic of enjoyment, snatching the bread from one's mouth. Only a subject that eats can be for-the-other, or can signify. Signification, the-one-for-the-other, has meaning only among beings of flesh and blood.

Sensibility can be a vulnerability, an exposedness to the other or a saying only because it is an enjoyment. The passivity of wounds, the 'haemorrhage' of the for-the-other, is the tearing away of the mouthful of bread from the mouth that tastes in full enjoyment. This is despite oneself, to be sure, but not as an affection or an indifferent surface. It is an attack made immediately on the plenitude of the complacency in oneself (which is also a complacency of complacency), on the identity in enjoyment (more identical still than any identification of a term in the said), on life living or enjoying life.

The immediacy of the sensible is the immediacy of enjoyment and its frustration. It is the gift painfully torn up, and in the tearing up, immediately spoiling this very enjoyment. It is not a gift of the heart, but of the bread from one's mouth, of one's own mouthful of bread. It is the openness, not only of one's pocketbook, but of the doors of one's home, a 'sharing of your bread with the famished', a 'welcoming' of the wretched into your house' (Isaiah 58). The immediacy of the sensibility is the for-the-other of one's own materiality; it is the immediacy or the proximity of the other. The proximity of the other is the immediate opening up for the other of the immediacy of enjoyment, the immediacy of taste, materialization of matter, altered by the immediacy of contact […]

Maternity, vulnerability, responsibility, proximity, contact – sensibility can slip toward touching, palpation, openness upon … consciousness of … pure knowing taking images from the 'intact being', informing itself about the palpable quiddity of things.

The doxic thesis, which is dormant in contact, is thematized and comes to the surface to sum up the contact in a knowing concerning the soft, rugged or whatever surface of an object, of things, living bodies or human bodies, and to embed it in the

system of significations that figure in the said. But this knowing about the exteriors of things remains in proximity, which is not an 'experience of proximity', not a cognition which a subject has of an object. Nor is it the representation of the spatial environment, nor even the 'objective' fact of this spatial environment observable by a third party or deducible by me, who am palpating the object, from the fact of this palpation. The non-thematized proximity does not simply belong to the 'horizon' of the contact, as a potentiality of this experience. Sensibility – the proximity, immediacy and restlessness which signify in it – is not constituted out of some apperception putting consciousness into relationship with a body. Incarnation is not a transcendental operation of a subject that is situated in the midst of the world it represents to itself; the sensible experience of the body is already and from the start incarnate. The sensible – maternity, vulnerability, apprehension – binds the node of incarnation into a plot larger than the apperception of self. In this plot I am bound to others before being tied to my body. Intentionality, the *noesis* which the philosophy of consciousness distinguished in sensing, and which it wanted, in a regressive movement, to take hold of again as the origin of the sense ascribed, the sensible intuition, is already in the mode of apprehension and obsession, assailed by the sensed which undoes its noematic appearing in order to command, with a non-thematizable alterity, the very *noesis* which at the origin should have given it a sense. The Gordean knot of the body, the extremities in which it begins or ends, are forever dissimulated in the knot that cannot be undone, and that commands in the ungraspable *noesis* its own transcendental origin. Sensible experience as an obsession by the other, or a maternity, is already the corporeality which the philosophy of consciousness wishes to constitute on the basis of it. The corporeality of one's own body signifies, as sensibility itself, a knot or denouement of being, but it has also to contain a passage to the physico-chemical-physiological meanings of the body. And this latter does devolve from sensibility as proximity, as signification, as one-for-the-other, which signifies in giving, when giving offers not the superfluxion of the superfluous, but the bread taken from one's own mouth. Signification signifies, consequently, in nourishing, clothing, lodging, in maternal relations, in which matter shows itself for the first time in its materiality.

The subject called incarnate does not result from a materialization, an entry into space and into relations of contact and money which would have been realized by a consciousness, that is, a self-consciousness, forewarned against every attack and first non-spatial. It is because subjectivity is sensibility – an exposure to others, a vulnerability and a responsibility in the proximity of the others, the-one-for-the-other, that is, signification – and because matter is the very locus of the for-the-other, the way that signification signifies before showing itself as a said in the system of synchronism, the linguistic system, that a subject is of flesh and blood, a man that is hungry and eats, entrails in a skin, and thus capable of giving the bread out of his mouth, or giving his skin […]

It is not a question of an effect undergoing its cause. The subjective does not only undergo, it suffers. Paining is a distance of 'negative extent' behind undergoing. It is a surplus of passivity which is no longer consciousness of … identifying this as that, ascribing a meaning. The neighbour strikes me before striking me, as though I had heard before he spoke. This anachronism attests to a temporality different from that which scans consciousness. It takes apart the recuperable time of history and memory in which representation continues. For if, in every experience, the making of a fact precedes the present of experience, the memory, history or extratemporality of the a priori recuperates the divergence and creates a correlation between this past and this present. In proximity is heard a command come as though from an immemorial past, which was never present, began in no freedom. This *way* of the neighbour is a face.

The face of a neighbour signifies for me an unexceptionable responsibility, preceding every free consent, every pact, every contract. It escapes representation; it is the very collapse of phenomenality. Not because it is too brutal to appear, but because in a sense too weak, non-phenomenon because less than a phenomenon. The disclosing of a face is nudity, non-form, abandon of self, ageing, dying, more naked than nudity. It is poverty, skin with wrinkles, which are a trace of itself. My reaction misses a present which is already the past of itself. This past is not in the present, but is as a phase retained, the past *of* this present, a lapse already lost which marks ageing,

escaping all retention, altering my contemporaneousness
with the other. It reclaimed me before I came. The delay is
irrecuperable. 'I opened ... he had disappeared.' My presence
does not respond to the extreme urgency of the assignation.
I am accused of having delayed. The common hour marked by
the clock is the hour in which the neighbour reveals himself and
delivers himself in his image, but it is precisely in his image that
he is no longer near. Already he allows me an 'as for me',
distances, remains commensurable, to the scale of my power
and of my present in which I am capable of ... capable of
accounting for everything by my own identity. The contact is
broken. When the other appears to me as an entity in the plastic
form of being an image, I am in relationship with the multipli-
able which, despite the infinity of the reproductions I make of it,
remains intact, and I can in his regard be satisfied with words for
these images without delivering myself in a saying. The proximity
does not enter into the common time of clocks, which makes
meetings possible. It is a disturbance.

Proximity as a suppression of distance suppresses the distance
of consciousness of ... The neighbour excludes himself from the
thought that seeks him, and this exclusion has a positive side
to it: my exposure to him, antecedent to his appearing, my delay
behind him, my undergoing, undo the core of what is identity in
me. Proximity, suppression of the distance that consciousness of
... involves, opens the distance of a diachrony without a common
present, where difference is the past that cannot be caught up
with, an unimaginable future, the non-representable status
of the neighbour behind which I am late and obsessed by the
neighbour. This difference is my non-indifference to the other.
Proximity is a disturbance of the rememberable time.

One can call that apocalyptically the break-up of time. But it is
a matter of an effaced but untameable diachrony of non-
historical, non-said time, which cannot be synchronized in
a present by memory and historiography, where the present is
but the trace of an immemorial past. The obligation aroused by
the proximity of the neighbour is not to the measure of the
images he gives me; it concerns me before or otherwise.
Such is the sense of the non-phenomenality of the face [...]

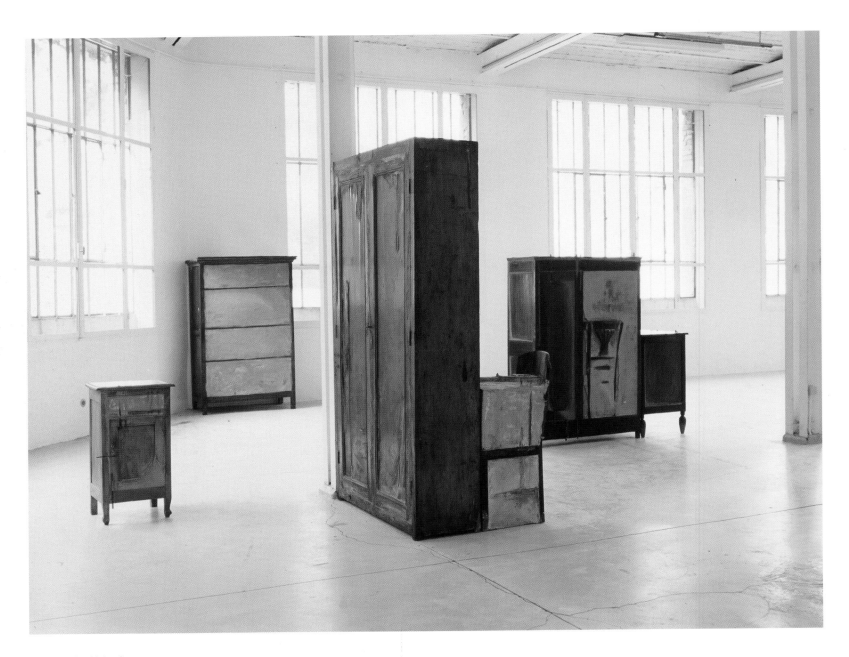

Installation of untitled works,
'Doris Salcedo', Le Creux de
l'Enfer, Thiers, France, 1996

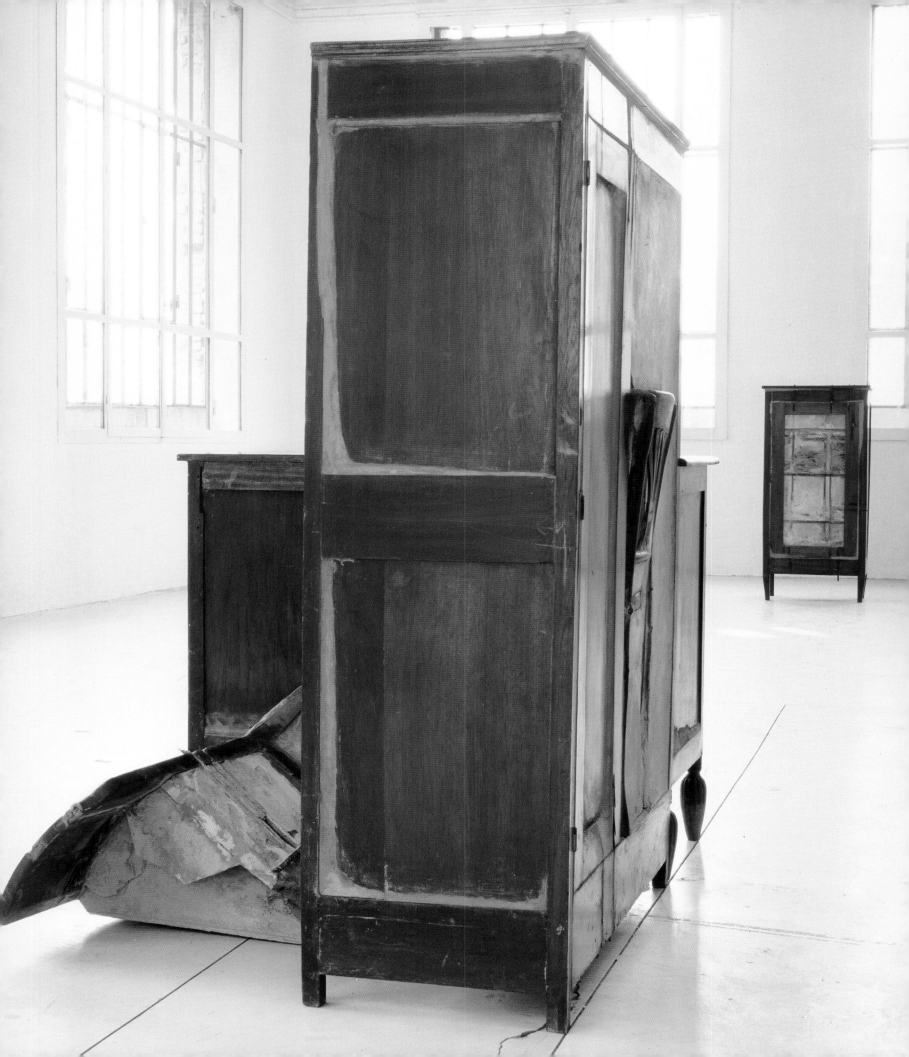

LA VIDA SE OPONE A LA VIDA Y NO A LA MUERTE.

PITYLESS SYMPATHY ——→ DAR LA MUERTE —— THISE OF NORTH

X SOBREVIVIR CON MEDIA ALMA AMPUTADA

SI EL DOLOR NO FUERA EN VANO, PERDERÍA SU RAZON
DE SER

DOLOR DEL REVES DE LA PIEL —→ UNA
DESNUDEZ MAS DESNUDA QUE TODA DESTITUCIÓN

X LO SACRIFICADO DESPUES DEL SACRIFICIO

FROM THIS ASHES NO ACT CAN BE REBORN

LO ABSURDO DE LA GUERRA SE
CONVIERTE EN UN NUEVO MOTIVO
PARA UNA GUERRA NUEVA

MACHUCA
OCTUBRE 18/1998
84 PERSONAS QUEMADAS
38 NIÑOS QUEMADOS

PALACIO DE JUSTICIA
NOV. 6/1985
MAS DE 100 PERSONAS
MASACRADAS

EL TIEMPO DE LA MASACRE ES:

IRRECUPERABLE
IN MEMORIAM
IRRECOGNOSCIBLE

EXTENSIÓN NEGATIVA = ESPACIO DE DOLOR

X EN SU PROPIO CUERPO COMO EN EXILIO

EL SER COMO BELÉN

Contents

Interview with Charles Merewether 1998

Charles Merewether Concerning your work *Unland* (1995–98) you have spoken of how each table draws upon a specific story of incidents happening in Colombia. How do you conceive your work in relation to these stories? Can you say something about the importance of art for you, that is, what you believe art is able to bring to the subject and to the viewer that is of special value?

Doris Salcedo **Anyone who has been witness to the violent death of someone else, especially of a loved one, has lived an experience similar to that of a tragic hero, such as Gilgamesh. Life's trajectory for the victims of violence in Colombia is already defined by this kind of encounter with death, the same as for Gilgamesh. Their lives acquire death as their only content. The confrontation with death, and especially with the death of a loved one, provokes what Aristotle called both terror and compassion.**

Merewether How do you make choices from peoples' testimonials, choices which are then given an aesthetic form and represent those testimonies or experiences?

Salcedo **The civil war in Colombia defines a reality that imposes itself on my work at every level of its production. The precariousness of the materials that I use is already given in the testimonies of the victims. As a result, as an artist, I don't have the opportunity to choose the themes that inform a piece. The oft-celebrated freedom of the artist is a myth.**

 The Lithuanian philosopher Emmanuel Levinas has helped us understand that the other precedes me and claims my presence before I exist. In that sense, there is a delay that can never be made up. 'My presence does not respond to the extreme urgency of its assignment. It only accuses me of having been late', writes Levinas. I work with this delay that cannot be made up. As a result, everything precedes me, everything makes its presence felt with such urgency that I am not the one who chooses; my themes are given to me, reality is given to me, the presence of each victim imposes itself.

Merewether In the installation of *Unland* the placement of each table and the lighting seem very important to creating the conditions for its viewing and for our understanding. For me, it creates an aura of silence in which to view the three tables as single, almost isolated pieces and, at the same time, as sharing something in common. Can you say something about this in view of your experience of listening to these stories, their remembrance, and the presentation of *Unland*?

Installation, 'Unland/Doris Salcedo', SITE Santa Fe, 1998
foreground, **Unland the orphan's tunic**
1997
Wood, cloth, hair
80 × 245 × 98 cm
Collection, Fundaçio 'la Caixa', Barcelona

background, left, **Unland audible in the mouth**
1998
Wood, thread, hair
74.5 × 315 × 80 cm
Collection, Tate Gallery, London

background, right, **Unland irreversible witness**
1995–98
Wood, cloth, metal, hair
112 × 249 × 89 cm
Collection, San Francisco Museum of Modern Art

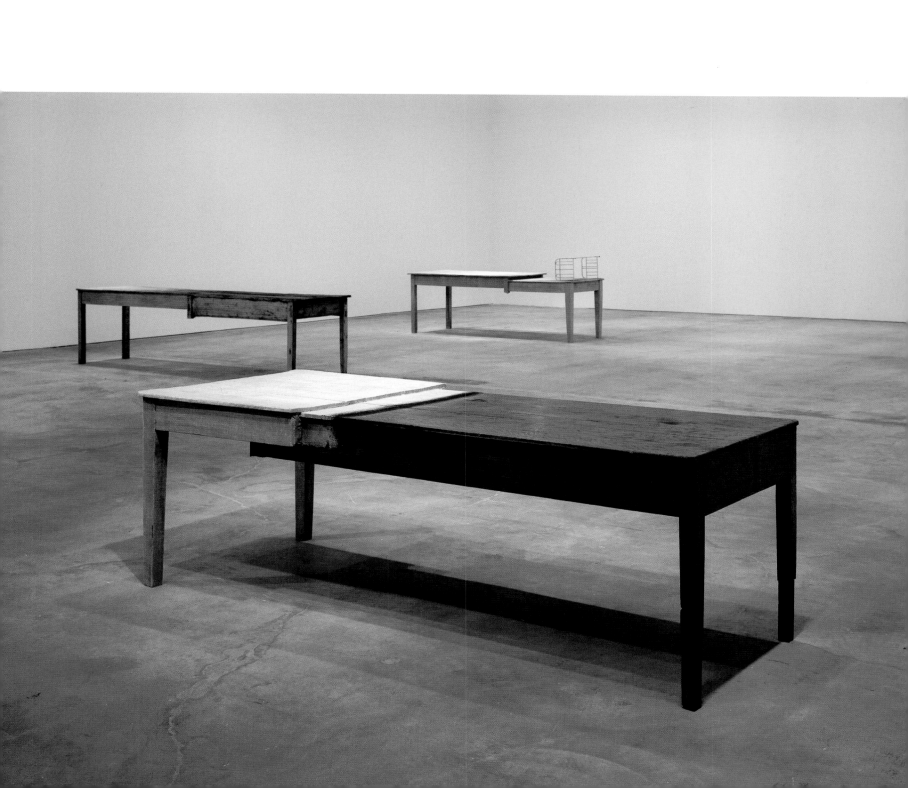

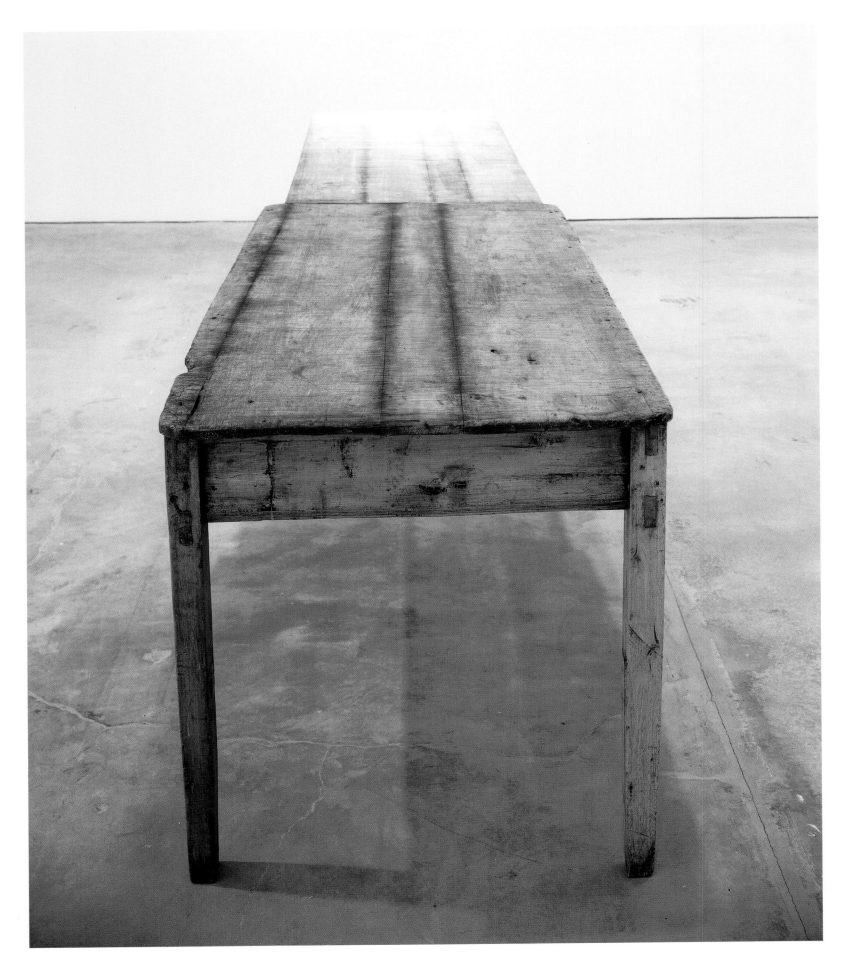

Unland
audible in the mouth
1998
Wood, thread, hair
74.5 × 315 × 80 cm
Collection, Tate Gallery, London

Salcedo **Just as it happens to heroes, for the victims of violence, the world becomes strange to them, and they enclose themselves in complete – mute – silence. Franz Rosenzweig writes in *The Star of Redemption* that the only language for a tragic hero is silence.**

In art, silence is already a language – a language prior to language – of the unexpressed and the inexpressible: 'Art is the transmission without words of what is the same in all human beings … The tragic hero's silence is silent in all art and is understood in all art without a single word.' Rosenzweig says that art does not create a community. In art, all remains silent. The silence of the victim of the violence in Colombia, my silence as an artist and the silence of the viewer come together during the precise moment of contemplation and only in the very space where that contemplation occurs.

Merewether May we not link this silence also to the duration and proximity in the viewing of the work, in so far that it is only upon closer viewing, with proximity, that the tables begin to reveal themselves? Perceiving the work then is guided by silence and duration in order to work like a slow-release chemical inside the body. Is this a metaphor for our relation to the subject, to people and to their lives, to the way trauma occurs after the fact, as if it is being experienced for the first time?

Salcedo **The silent contemplation of each viewer permits the life seen in the work to reappear. Change takes place, as if the experience of the victim were reaching out, beyond, as if making a bridge over the space between one person and another. To make this connection possible is the important thing. 'Duration is essentially memory, conscience and liberty. It is conscience and liberty because it is, primordially, memory', wrote the French philosopher Gilles Deleuze.**

The experience is intimate and can only be made visible in the space, the space permits that the experience endures. The sculpture presents the experience of the victim as something present – a reality that resounds within the silence of each human being that gazes upon it.

It is because of this that the work of art preserves life, offering the possibility that an intimacy develops in a human being when he or she receives something of the experience of another. Art sustains the possibility of an encounter between people who come from quite distinct realities.

Unland
audible in the mouth
1998
Wood, thread, hair
74.5 × 315 × 80 cm
Collection, Tate Gallery, London

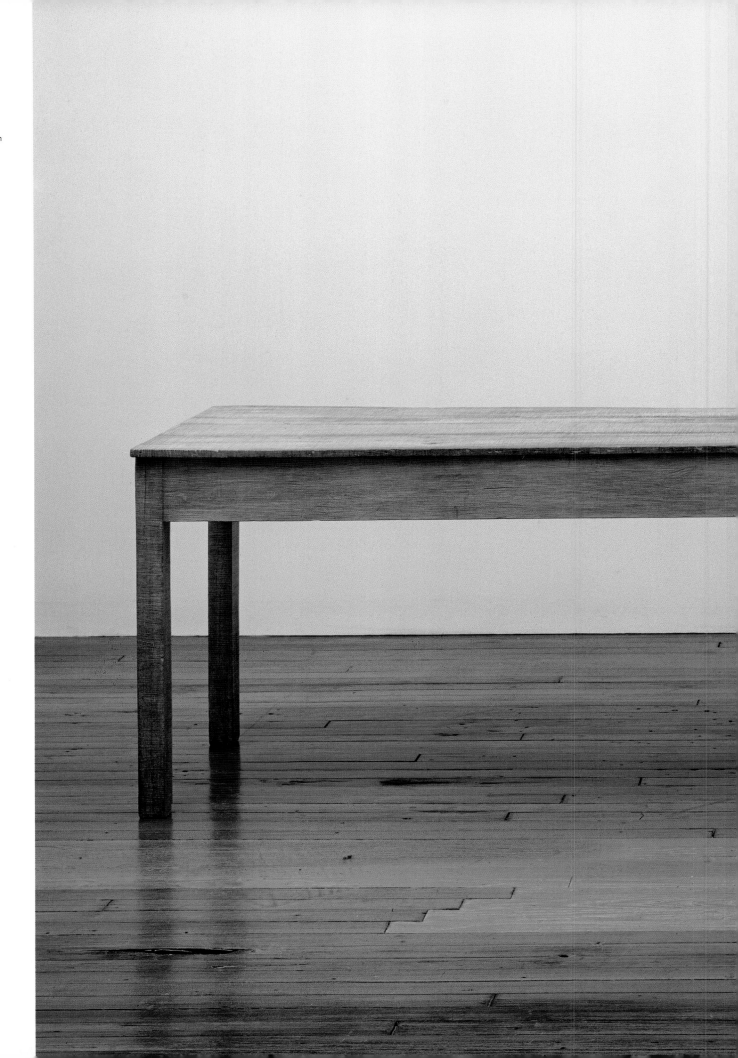

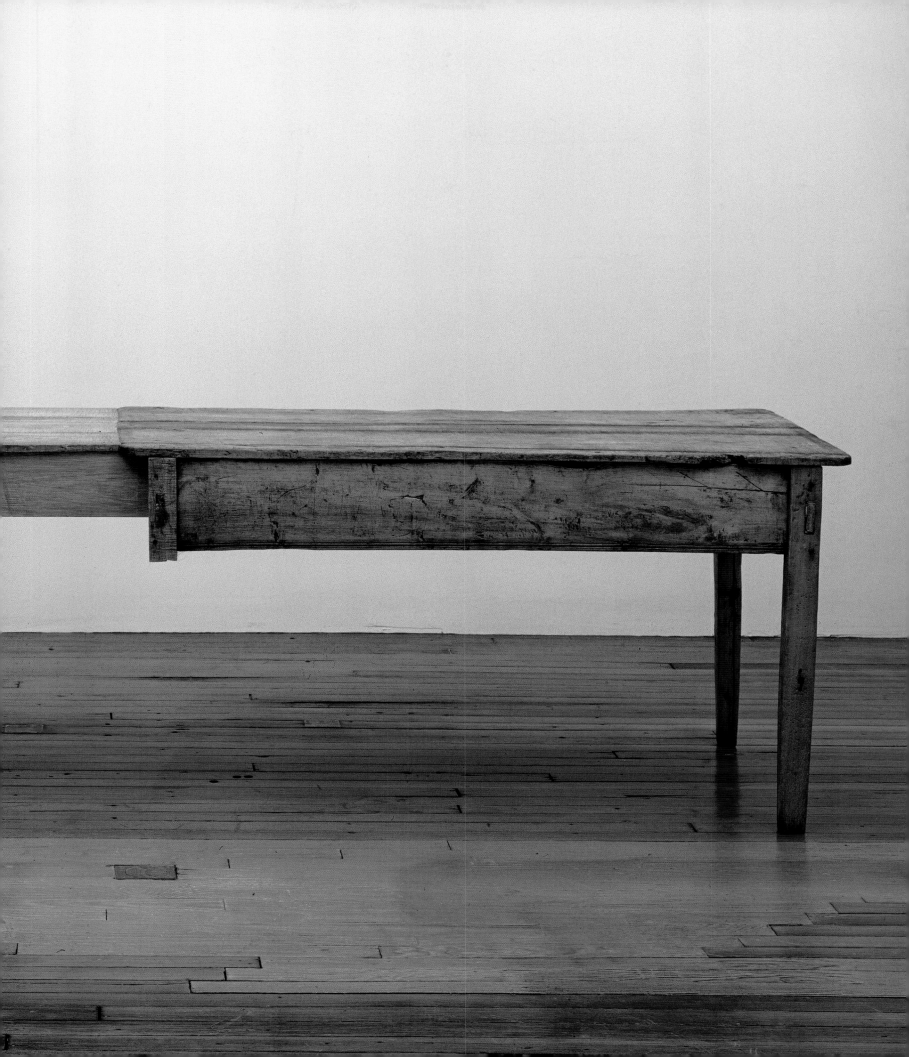

Merewether How might you speak of an ethics of remembering when there is, at times, a need to forget as much as there is an absence of memory, or amnesia? What role does memory play in your work, both in terms of your method of working and for the audience?

Salcedo **Over the past few years the question of memory has been abused and exhausted as a theme. Given that mourning is a permanent presence in my work, the notion of memory is also ambiguous, since it is always confronted with a doubt, with an aporia. One struggles between the necessity of being faithful to the memory of the other, to keep that loved one alive within us, and with the necessity of overcoming that impossible mourning with forgetting.**

My work deals with the fact that the beloved – the object of violence – always leaves his or her trace imprinted on us. Simultaneously, the art works to continue the life of the bereaved, a life disfigured by the other's death. Derrida says, 'Everything that we inscribe in the living present of our relation to others already carries, always, the signature of the memories from beyond the grave.'

My work speaks of the continuation of life, a life disfigured, as Derrida would say. Memory must work between the figure of the one who has died and the life disfigured by the death. As a result, I would say that the only way in which I confront memory in my work is to begin with the failure of memory.

Merewether I should like to ask you about what I perceive as changes in your work over the past ten years. Your work in the late 1980s seemed more overtly to represent violence, and then with *Atrabiliarios* (1991–96) and *La Casa Viuda* (*Widowed House,* 1992–94), to move towards ways of addressing the experience of absence, loss and mourning.

Do you see your work as an articulation of that loss? Is it about bearing witness and overcoming that loss, of trying to come to terms with the experience of trauma and bereavement? How would you describe your current work? Is it also about survival, about living on?

Salcedo **I take on with full responsibility the theme of violence and war. I don't think that in my work this theme develops in an evolutionary way; I simply touch upon different aspects of war. Perhaps one day I will return to more explicit images.**

As I've stated, I don't choose my themes, I accept what happens.

My works are for the victims of violence. I try to be a witness of the witness. I look for an intimate proximity with the victims of violence that allows me to stand in for

them. One must feel close to another in order to stand in for him or her and create an artwork out of another's experience. As a result, the work is made using his or her testimony as its foundation. It is not my rational intent but rather the experience of the victim that tells us about trauma, pain, loss.

As a sculptor, I am aware of every detail that informs the life of the victim: the corporeality, the feelings, the vulnerability, the failings, the space, his or her life's trajectory and language. I don't formulate the experience of the victim, rather, I assemble it so that it remains forever a presence in the present moment.

In my work, I do not try to elaborate or transform the grief or overcome the traumas of another being. I can only give form to works which, once completed, are autonomous creatures, independent of my intentions. Sculpture for me is the giving of a material gift to that being who makes his or her presence felt in my work.

Merewether You have spoken of how you don't choose the themes, but accept what happens. Does the long process of making the work – a form of immersion – play a part in this displacement of yourself and recognition of the other?

Salcedo **This process of approaching the other takes place all the way to the point that supplanting or metamorphosis does indeed occur. During the elaboration of an artwork, these victims live within me and remain in me even after the work is finished.**

But also I would like to add that the finished work of art is an autonomous creature, independent of my original intention; my work as an artist is not to illustrate these testimonies. Formal logic is not at all helpful in the formative process of making a work of art. On the contrary, it is harmful: it paralyses intuition, blocks inspiration and impedes the appropriation of the dissimilar.

Merewether Do you see the role of the artist as mediating between a witness or victim of violence and an audience that has not necessarily had such an experience or knows very little, such as an audience from outside Colombia? Could we say that the work of art might play a part in enabling us to recognize difference and commonality, in order that we might understand both the specificity of the violence on the subject to whom you refer and an experience that may be common to us all?

Salcedo **Living amidst war, my role is to think of war, both from the point of view of the victim and of the perpetrator. I am interested in war as a part of human history,**

Untitled
1999
Wood, concrete, steel, fabric
196.5 × 124.5 × 193 cm
Collection, Moderna Museet,
Stockholm
Installation, Anglican Cathedral,
Liverpool, 'Trace', Liverpool
Biennial of Contemporary Art,
1999

as a central activity of all societies in the past as well as in the present. The enemies change, the forms of annihilation change, the weapons change, but the nature of war is the same. When I take the case of Colombia, I do so because that is the reality that I know best. I do not speak of the violence in Colombia from a nationalist perspective. I focus on the individual and not on the acts of violence that define the State. I am not interested in denouncing before an international audience what is happening in my country here and now. I am aware that art has a precarious capacity to denounce.

Moreover, violence is present in the whole world and in all of us. As a result, I am interested in questioning the elements of violence endemic to human nature. Cruelty, indolence and hatred towards others are universal. I look for the possibility of making the connection between the one particular and harsh event that takes place in Colombia and the equally cruel and harsh everyday life that takes place elsewhere. Perhaps in other places it occurs in a more hidden and subtle way, yet one that is no less painful or unjust. As Levinas says, there are a thousand ways of spilling blood. For example, when we are sophisticated and cruel, one way to spill blood is to make the other person blush.

Merewether What do you want those people who know little or nothing about the specific subject to take away with them, to remember?

Salcedo As an artist, I do not try to control the experience of the viewer. I simply reveal – *expose* – an image. I use this word *expose* (*exponer*) because it implies vulnerability. The image is not finished in my studio; I complete it *in situ*, in the very space where the viewer will encounter it. What I propose is that everything that takes place in that space, once I have finished the work, occurs within the viewer's own space. Each person will – or will not – approach an artwork according to his or her spirit. What the viewers might come to feel, to remember, or to comprehend, is entirely dependent on their internal code.

Merewether Can you say more about this in relation to the notion of community? And do you see your work as a way of trying to create different forms of community based on absence, loss, shared values and responsibility to each other?

Salcedo The notion of community is born when the individual opens him or herself to others. To accompany someone to his or her death, step by step, opens us to the

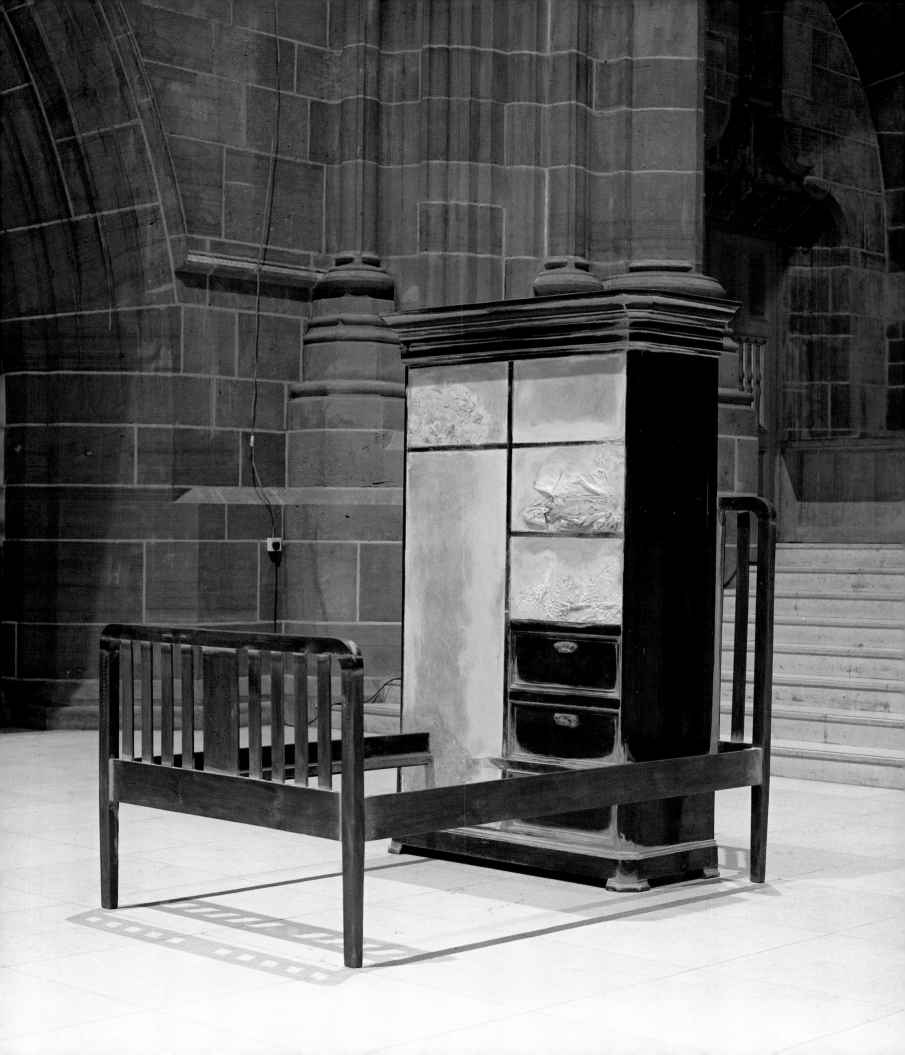

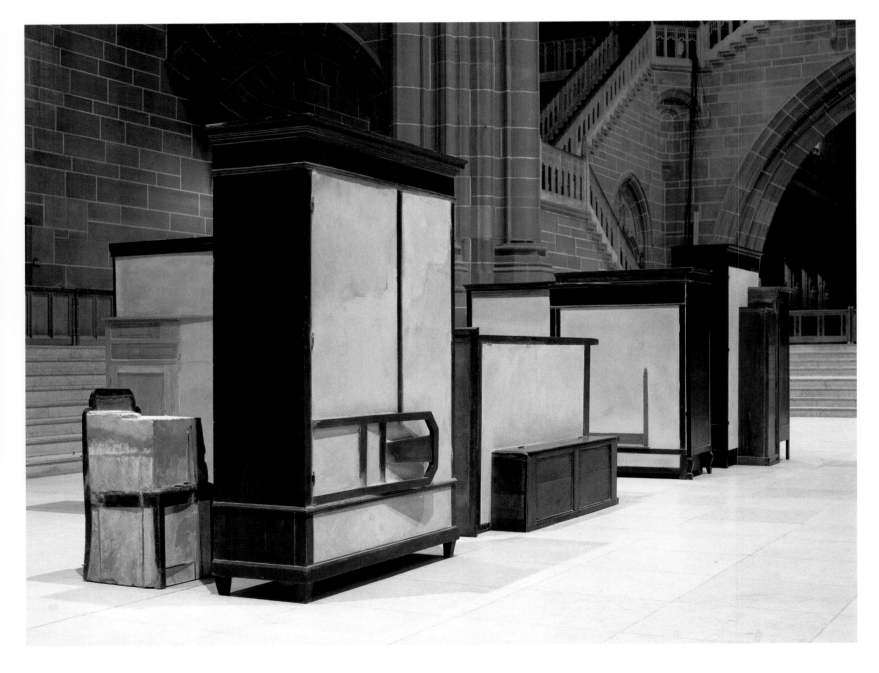

opposite, below and overleaf,
Installation of untitled works,
Anglican Cathedral, Liverpool,
'Trace', Liverpool Biennial of
Contemporary Art, 1999

other, and leads us to forget our own existence, it unites us to that other, who will then remain inscribed inside us. The exhaustive investigation that I carry out on the deaths of the victims of violence, on the actual deed of the murder, leads me to accompany them, step by step, to that death, and in that sense I feel as though they are inscribed in me. Therefore, I assume responsibility towards the bereaved.

Without responsibility an idea of a community is also impossible. That is why I try to keep in mind the famous line from Dostoyevsky's *The Brothers Karamazov* that is also so close to what Levinas writes and which seems to me a good model to emulate, a proposition that we should all make our own: 'We are all responsible for everyone else – but I am more responsible than all the others.'

First published as 'An Interview with Doris Salcedo', *Unland/Doris Salcedo: New Work*, San Francisco Museum of Modern Art, 1999. Translated from Spanish by Charles Merewether and Sylvia Korwek.

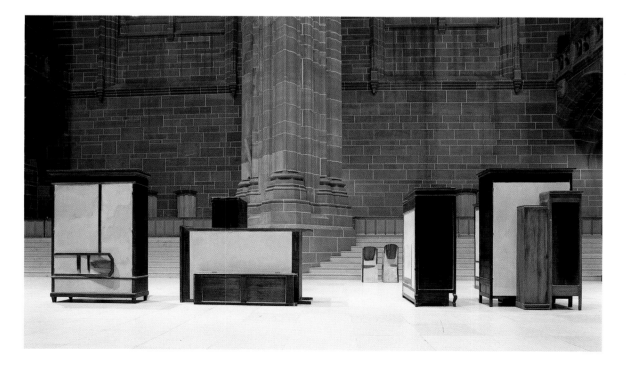

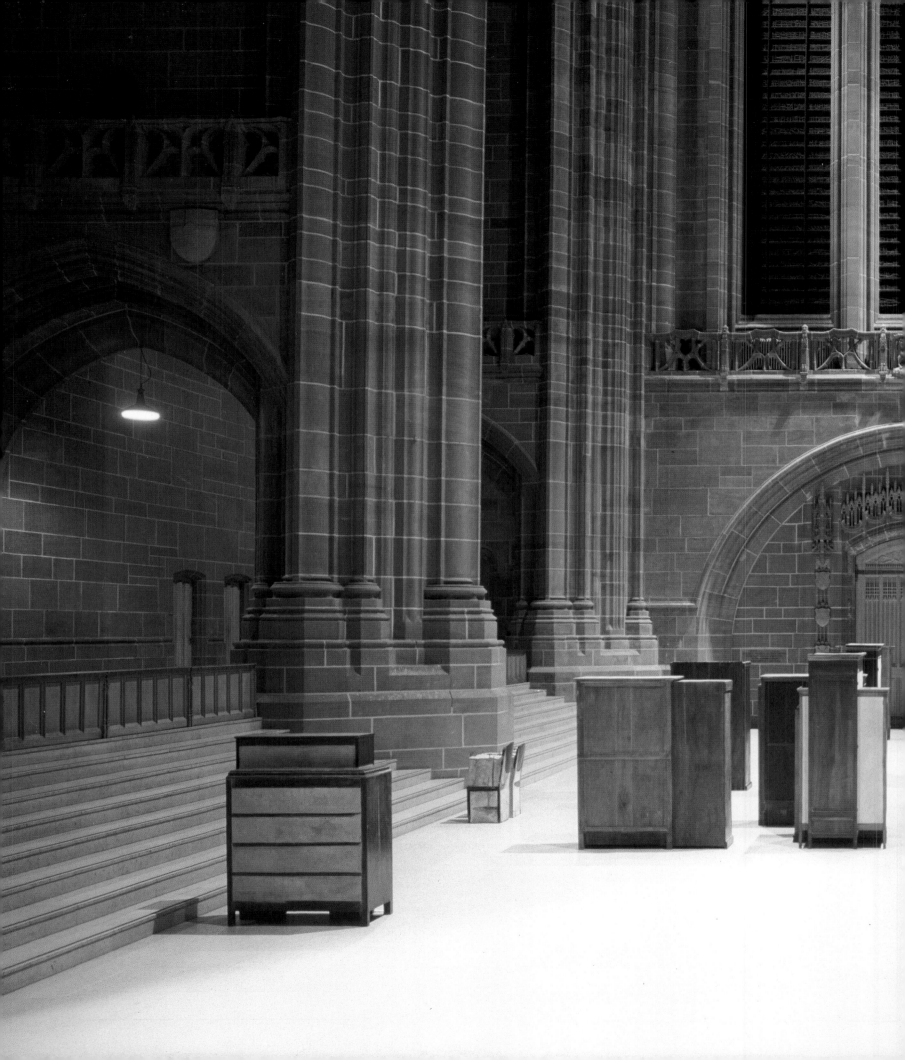

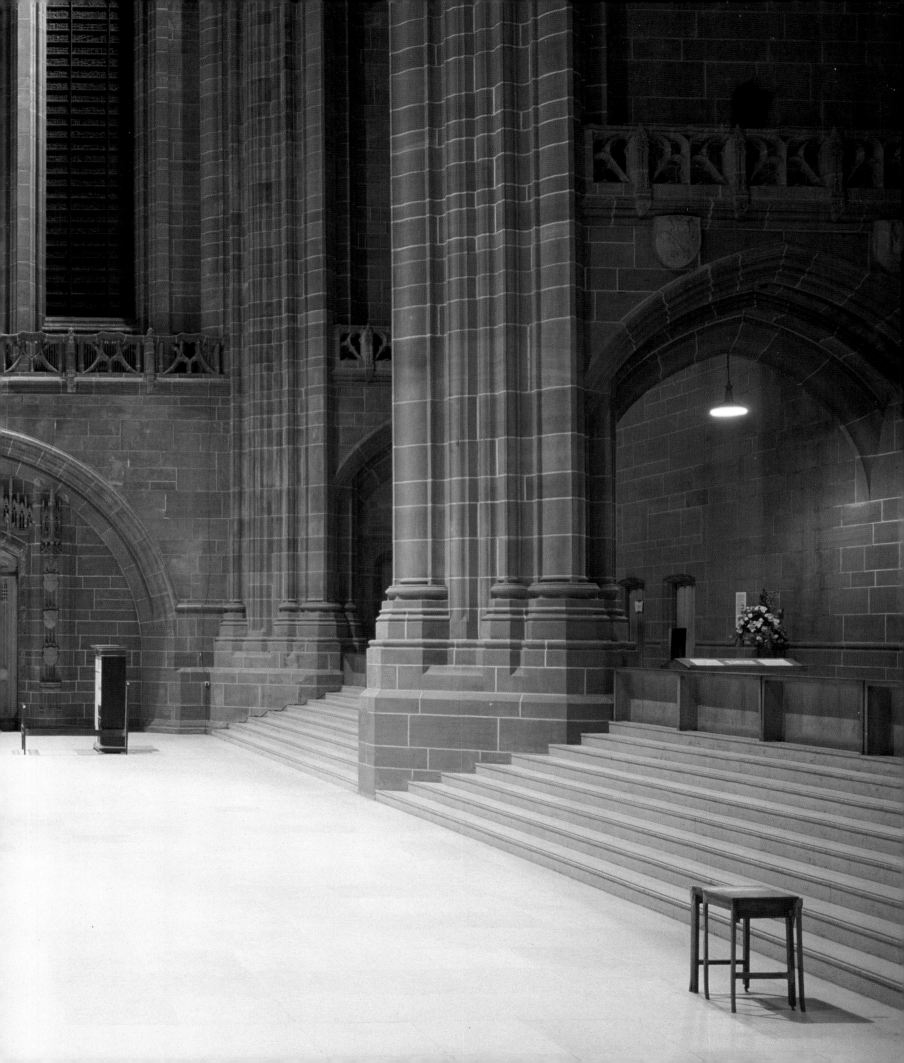